Tales

FROM THE Easel

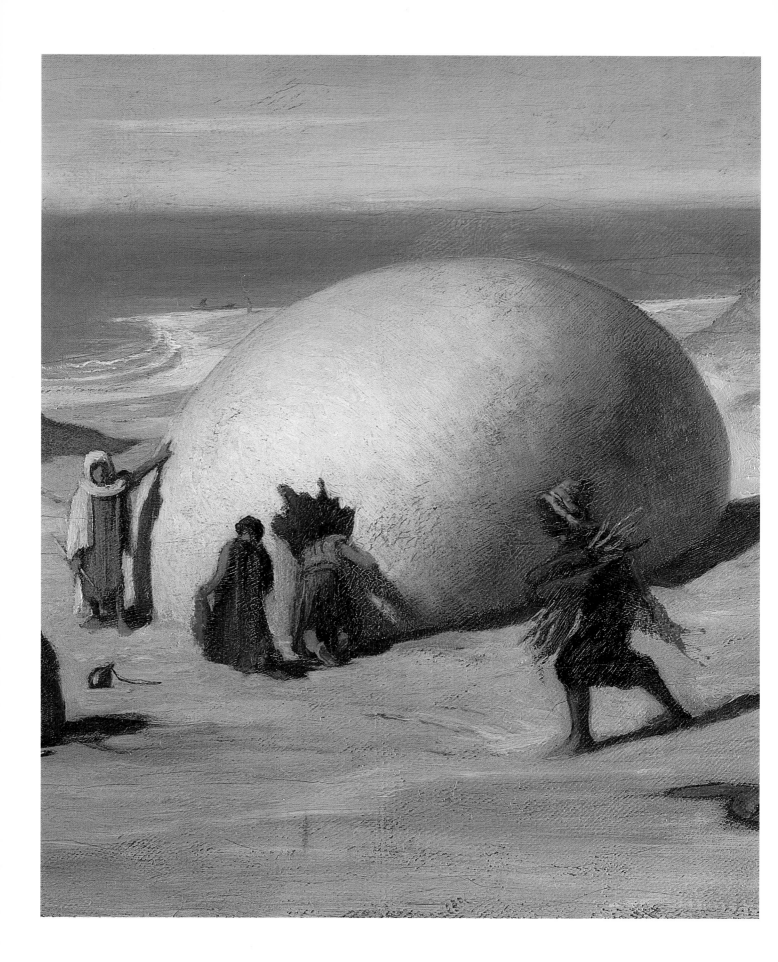

Tales

FROM THE Easel

American
Narrative Paintings
from
Southeastern Museums
circa 1800–1950

CHARLES C. ELDREDGE
with contributions by
Charles Thomas Butler
William Underwood Eiland
Reed Anderson
Stephanie J. Fox

The University of Georgia Press
Athens
Published in cooperation with the
Southeastern Art Museum Directors
Consortium

© 2004 by the University of Georgia Press
Athens, Georgia 30602
All rights reserved
Designed and typeset by Sandra Strother Hudson
and Walton Harris, University of Georgia Press
Printed and bound by Four Colour Imports, Ltd.
The paper in this book meets the guidelines for
permanence and durability of the Committee on
Production Guidelines for Book Longevity of the
Council on Library Resources.

Printed in China
08 07 06 05 04 P 5 4 3 2 1

Library of Congress Cataloging-in-Publication Data
Eldredge, Charles C.
Tales from the easel : American narrative paintings from
southeastern museums, circa 1800–1950 / Charles C.
Eldredge with contributions by Charles Thomas Butler
. . . [et al.].
 p. cm.
"This book is published in conjunction with the travel-
ing exhibition Tales from the easel: American narrative
paintings from southeastern museums, circa 1800–1950,
organized by the Southeastern Art Museum Directors
Consortium ; Columbus Museum, Columbus, Georgia,
February 8–April 11, 2004, Tampa Museum of Art,
Tampa, Florida, April 25–July 11, 2004, The Speed
Art Museum, Louisville, Kentucky, September 14–
December 12, 2004, El Paso Museum of Art, El Paso,
Texas, January 16–April 10, 2005."
Includes bibliographical references.
ISBN 0-8203-2569-4 (pbk. : alk. paper)
 1. Narrative painting, American—Southern States—19th
century—Exhibitions. 2. Narrative painting, American—
Southern States—20th century—Exhibitions. I. Butler,
Charles T. (Charles Thomas), 1951– II. Southeastern
Art Museum Directors Consortium. III. Columbus
Museum (Columbus, Ga.) IV. Tampa Museum of Art.
V. J.B. Speed Art Museum. VI. Title.
ND1451.5 .E38 2004
754'.0975'07473—dc21
2003011152

Frontispiece: Detail from *The Roc's Egg,* by
Elihu Vedder (cat. no. 65)

Contents

This book is published in
conjunction with the traveling exhibition

*Tales from the Easel: American Narrative Paintings
from Southeastern Museums, circa 1800–1950*

organized by the
Southeastern Art Museum Directors Consortium.

Columbus Museum, Columbus, Georgia, February 8–April 11, 2004

Tampa Museum of Art, Tampa, Florida, April 25–July 11, 2004

The Speed Art Museum, Louisville, Kentucky, September 14–December 12, 2004

El Paso Museum of Art, El Paso, Texas, January 16–April 10, 2005

Preface and Acknowledgments

This project begins not in the South but in southern California.

While attending a meeting of the Association of Art Museum Directors in Los Angeles in 1998, I had the pleasure of sitting with Ellen Holtzman from the Henry Luce Foundation on a bus trip to the new Getty Museum. After we exchanged a few pleasantries, she told me of her recent trip to several southern museums she had never visited before and of her immense enjoyment in discovering previously unknown works in these institutions. I noted that there were many overlooked collections and institutions in the South. Our conversation moved to theorizing why so many southern museums emphasize American art collections—often collections that deserve greater visibility. By the end of our short bus ride, the genesis for a project had taken shape.

A few weeks later at the Southeastern Art Museum Directors Consortium meeting in Charlotte, I proposed a collaborative exhibition that might be developed from the many excellent collections to be found in the Southeast. This nascent idea, more fully conceptualized through group discussions, was assigned to a committee consisting of directors from the Chrysler Museum of Art, Columbus Museum, Georgia Museum of Art, Harn Museum of Art, Speed Art Museum, and Mint Museum of Art. We agreed to review slides of paintings from our sister institutions to ascertain if there was a project worth doing; if so, we would identify a curator and submit a proposal to the Henry Luce Foundation. Over the next few months we refined the project's scope, invited additional southeastern museums to submit representative slides, and defined our curatorial project and the curator we thought could best meet the challenge.

What could be more compelling than a selection of narrative paintings from southern museums, reaffirming the long held tradition of this region's admiration and affection for good "storytelling"? And who better to reflect on that curatorial premise than Dr. Charles C. Eldredge, director emeritus of the Smithsonian American Art Museum and a Distinguished Professor of Art History at the University of Kansas. Dr. Eldredge already knew many of our museums from previous research trips, and he had an encyclopedic knowledge of American art that we all recognized and admired. We were extremely pleased when Dr. Eldredge agreed to serve as our guest curator. We also requested that one of our own consortium members, Dr. William U. Eiland of the Georgia Museum of Art, write a catalogue essay on the rich tradition of storytelling in the South. We requested Dr. Eldredge not to restrict his vision for the exhibition to southern painters or paintings about southern scenes. He first needed to define the concept of narrative painting to his own satisfaction, and in his curatorial process address the broadest review of painting of a narrative subject or intent as can be found in the permanent collections of southern art museums. Both of our authors have done a superb job in meeting their assignments.

Thus, *Tales from the Easel* was developed as a project for the Henry Luce Foundation over a two-year span. At the end of this research period, we submitted our proposal to the foundation for consideration. Through the diligent efforts and detailed research of Dr. Eldredge, this significant selection of narrative images has been assembled. A project like this is possible only through the goodwill of my fellow museum directors in the Southeast, who have worked hard to accommodate our loan requests. To their credit, they were as conciliatory as could be expected, given that the loan requests were frequently for the most popular paintings in their collections. We acknowledge this collegiality and thank our fellow museum directors and their staffs for this generosity.

This spirit of collegiality is an interesting tale in itself. The concept for the consortium began as a curatorial gathering in Augusta, Georgia, at the Morris Museum of Art in 1994. In time, this gathering evolved into an annual meeting of directors of southeastern art museums to discuss issues of mutual concern and find ways to collaborate for a common good. At each year's meeting, the host director develops an agenda that covers topics of a timely nature or specific issues related to senior management. We also get an in-depth tour of our host institution and visit other local art organizations and private collections in the immediate area.

Current participating members of the consortium include the directors of the Ackland Art Museum, Arkansas Arts Center, Art Museum of Western Virginia, Asheville Art Museum, Birmingham Museum of Art, Michael C. Carlos Museum, Cheekwood, Chrysler Museum of Art, Columbia Museum of Art, Columbus Museum, Cummer Museum of Art and Gardens, Frist Center for the Visual Arts, Georgia Museum of Art, Gibbes Museum of Art/Carolina Art Association, Greenville County Museum of Art, Samuel P. Harn Museum of Art, High Museum of Art, Hunter Museum of American Art, Knoxville Museum of Art, Memphis Brooks Museum of Art, Mint Museum of Art, Mississippi Museum of Art, Mobile Museum of Art, Montgomery Museum of Fine Arts, Morris Museum of Art, New Orleans Museum of Art, North Carolina Museum of Art, Ogden Museum of Southern Art, The Parthenon, Reynolda House, Lauren Rogers Museum of Art, the Speed Art Museum, St. Petersburg Museum of Fine Arts, Tampa Museum of Art, Telfair Museum of Art, Tubman African American Museum, University of Kentucky Art Museum, University of Virginia Museum of Art, and Virginia Museum of Fine Arts. As is evident from this list, the original vision for collaborative actions and collegial interchange has succeeded beyond our expectations.

The real strength of this informal group of art museum directors is the willingness to share with each other. Some institutions have more flexibility than others do in regard to loans, reproductions, and other specific issues. Nevertheless, all museum directors have a stake in maintaining communications with regional colleagues, easing the way for accessing each other's collections for loans and exhibitions.

Tales from the Easel is the first major project to come from this collaborative group. Not only is it an extraordinary exhibition, it also publicizes aspects of southern museum collections that may have heretofore gone unrecognized by those who live outside our region. Special acknowledgments and appreciation go to Peter Morrin and Laura Bryan at the Speed Art Museum for help during the organization of this exhibit. Our thanks go to all who have assisted to see this project succeed: Gerald Bolas and Emilie Sullivan, Ackland Art Museum; Mary LaGue, Art Museum of Western Virginia; Pam Meyers and Frank Thomson, Asheville Art Museum; Gail Andrews Trechsel and Melissa Falkner, Birmingham Museum of Art; Jane Jerry and Kaye Crouch, Cheekwood; William J. Hennessey and Catherine Jordan Wass, Chrysler Museum of Art; William U. Eiland and Christy Sinksen, Georgia Museum of Art; Elizabeth Fleming, Angela Mack, and Stacey E. Brown, Gibbes Museum of Art; Thomas Styron, Martha Severens, and Claudia Beckwith, Greenville County Museum of Art; Michael E. Shapiro, High Museum of Art; Robert Kret, Ellen Simak, and Elizabeth Le, Hunter Museum of American Art; Kathy Walsh-Piper, Rachael Sadinsky, and Barbara Lovejoy, University of Kentucky Art Museum; George Bassi and Tommie Rodgers, Lauren Rogers Museum of Art; Kaywin Feldman and Kip Peterson, Memphis Brooks Museum of Art; Charles Mo and Martha Tonissen Mayberry, Mint Museum of Art; René Paul Barilleaux and Robin Fortenberry, Mississippi Museum of Art; Joseph Schenk and Paul Richelson, Mobile Museum of Art; Mark Johnson, Margaret Lynne Ausfeld, and Pamela Bransford, Montgomery Museum of Fine Arts; Kevin Gro-

gan and Louise Keith Claussen, Morris Museum of Art; E. John Bullard, Jennifer Ickes, and Paul Tarver, New Orleans Museum of Art; Lawrence Wheeler and Carrie Hedrick, North Carolina Museum of Art; J. Richard Gruber and David Houston, Ogden Museum of Southern Art; Wesley Paine and Lila Hall, The Parthenon; Rebecca Eddins, Reynolda House, Museum of American Art; Charles Pittenger, Speed Art Museum; Diane Lesko, Holly Koons McCullough, and Stephanie Lathan, Telfair Museum of Art; and Michael Brand, David Park Curry, Malcolm Cormack, Kathleen Morris Schrader, Mary L. Sullivan, and Carol Woods Sawyer, Virginia Museum of Fine Arts.

I thank my colleagues at the Columbus Museum, especially Kimberly Beck and Aimee Brooks, and the Speed Art Museum for their support and good humor after being informed that they had "volunteered" for the organizer's role in this project and then rising to the task with consummate professionalism. To all of the creative team at the University of Georgia Press on behalf of all the partners in the Consortium, I offer our appreciation and gratitude. Finally, I offer these same heartfelt thoughts to my wife, who has been patient and understanding of the time commitment that this project has entailed.

CHARLES THOMAS BUTLER

An exhibition and publication such as this is by its very nature a collaborative venture. I am beholden to the many colleagues, friends, and students who have assisted in the genesis and development of this project. I am particularly grateful to Tom Butler, director of the Columbus Museum, and his associates, who have consistently

provided fine assistance. The invitation to participate in this project came from the sponsors, the Southeastern Art Museum Directors Consortium; I am especially indebted to its instigators, Tom Butler; Bruce Evans, former director of the Mint Museum of Art; and William Hennessey, director of the Chrysler Museum of Art. During the spring of 2001 and again early the next year, I visited more than thirty institutions in as many cities across the length and breadth of Dixie. At every stop, I was warmly received and generously assisted by consortium directors and their dedicated and knowledgeable curators, registrars, and other staff. For their many kindnesses to a curatorial carpetbagger—as well as superlative hospitality of the legendary southern variety—I am grateful.

Along the way, colleagues at institutions in the South and elsewhere kindly provided special assistance at crucial junctures, including Dr. Margaret Conrads, Samuel Sosland Curator of American Art, Nelson-Atkins Museum of Art; Dr. David Park Curry, Curator of American Art, Virginia Museum of Fine Arts; Dr. William U. Eiland, Director, Georgia Museum of Art; Christine Hennessey, Smithsonian American Art Museum; Professor Eric J. Schruers, Mesa State College; Judy Throm, Archives of American Art; Dr. Lynn Williams and Javan Frazier, Auburn University Library; and Mrs. Richard Wilt, Ann Arbor, Michigan.

At the University of Kansas, I am indebted to numerous colleagues. Susan Craig, librarian of the Murphy Art and Architecture Library, and her staff always provided efficient and helpful responses to my countless queries. Maud Morris, office manager in the Department of Art History, as always gave of her cheerful outlook and expert assistance in matters clerical and financial. Graduate student Jerry N. Smith was generous with his insights into Walter Ufer's work, the subject of his research and writing.

No project could be completed without the fine and faithful help of graduate research assistants. In this project I have been blessed with three of special merit: Matthew Bailey provided crucial help in launching the initial research several years ago, and Stephanie Fox and Reed Anderson continued his fine work and wrote the artists' biographies in this volume. To all three, I owe a special debt of gratitude. I am also profoundly appreciative of the generous support for this and all my research from the Hall Family Foundation through the Kansas University Endowment Association. The project was completed with the invaluable sabbatical leave time granted from the University of Kansas.

One of my great pleasures in life is reading stories to my grandchildren. And so, I dedicate this tale of tales to them.

CHARLES C. ELDREDGE

Lenders to the Exhibition

Ackland Art Museum, *The University of North Carolina at Chapel Hill*

Art Museum of Western Virginia, *Roanoke*

Asheville Art Museum, *Asheville, North Carolina*

Birmingham Museum of Art, *Birmingham, Alabama*

Cheekwood Museum of Art, *Nashville, Tennessee*

Chrysler Museum of Art, *Norfolk, Virginia*

Columbus Museum, *Columbus, Georgia*

Georgia Museum of Art, *University of Georgia, Athens*

Gibbes Museum of Art/Carolina Art Association, *Charleston, South Carolina*

Greenville County Museum of Art, *Greenville, South Carolina*

High Museum of Art, *Atlanta, Georgia*

Hunter Museum of American Art, *Chattanooga, Tennessee*

Memphis Brooks Museum of Art, *Memphis, Tennessee*

Mint Museum of Art, *Charlotte, North Carolina*

Mississippi Museum of Art, *Jackson, Mississippi*

Mobile Museum of Art, *Mobile, Alabama*

Montgomery Museum of Fine Arts, *Montgomery, Alabama*

Morris Museum of Art, *Augusta, Georgia*

New Orleans Museum of Art, *New Orleans, Louisiana*

North Carolina Museum of Art, *Raleigh*

Ogden Museum of Southern Art, *New Orleans, Louisiana*

The Parthenon, *Nashville, Tennessee*

Reynolda House, Museum of American Art, *Winston-Salem, North Carolina*

Lauren Rogers Museum of Art, *Laurel, Mississippi*

The Speed Art Museum, *Louisville, Kentucky*

Telfair Museum of Art, *Savannah, Georgia*

University of Kentucky Art Museum, *Lexington*

Virginia Museum of Fine Arts, *Richmond*

Tales

FROM THE Easel

Picture This

Observations on Storytelling in the South

WILLIAM UNDERWOOD EILAND

Southerners have some sort of natural or socially conditioned need to tell stories: that, at least, is the common view of most Americans. According to the prevailing stereotype, denizens of the Deep South are thought to spend their spare time hunched down on their heels in front of country stores or sitting in chairs at their bridge clubs, Tupperware parties, and ice-water teas, swapping tales. Observers, mainly Yankee commentators, suspect that the whole region is harboring some gigantic "fish tale," a whale of a whopper that breaches thousands of southern lips thousands of times a day.

The simple truth is that southerners love stories. Certainly, the fictional characters imagined by the region's writers are a unique breed. Perhaps no more bizarre than the squires, harridans, scriveners, innocents, thieves, misers, toadies, prigs, dandies, and lunatics who populate the pages of Dickens, similar types seem to dominate the region's literature, eccentrics made in the southern soil.

The urge toward narrative, that tendency to elaborate on incident, is too commonplace in the literature as a defining feature of southerners not to contain some validity. Among sociologists and anthropologists, not to mention literary critics and historians, the silver-tongued southerner is a stock type. By the same token, reticence and taciturnity, the reverse of talkativeness,

bespeak another, companion kind of eccentricity, ironic and no less typical, a trait often meant to emphasize its opposite. Southerners have always demanded an audience, even an irresponsive or disapproving one.

The peculiar historical, physical, and social conditions of the South may well have something to do with an impetus to create narrative that is one of the region's most celebrated attributes. Such is the view of John A. Burrison, whose *Storytellers* is the first real attempt at explaining why the Deep South—from the mountains and Piedmont of South Carolina to the wiregrass of Alabama—merits its reputation:

> Nowhere in the United States is storytelling more vital than in the South, where skill with the spoken word has always been emphasized. Strong traditions of storytelling from such Old World source areas of the southern population as Ulster, West Africa, and southern England, reinforced by the physical isolation of dispersed settlement and a conservative mindset that valued the old ways, certainly contributed to this tendency.[1]

According to Burrison, American authors as different as William Faulkner, Joel Chandler Harris, and Mark Twain were inspired by the South's tradition of orality and thus did much to foster the perception of the South as a pro-

foundly oral culture. For Burrison it is no surprise that two groups dedicated to tale-telling, the National Association for the Preservation and Perpetuation of Storytelling and the Southern Order of Storytellers, have their national headquarters in the South.

One of the South's most beloved storytellers is Alabama's Kathryn Tucker Windham, who characterizes her home state as "one big front porch" or an extended veranda where a "serigamy" of tales unfolds daily.[2] Eugene Walter, a writer and monologist from Mobile who was as improbable a person as any of his fictional characters, talked about what he called "porch life," where the public front part of the Dixie house, no matter how grand or humble, was the "universal agora, the outdoor parlor, the message post, the echoing chamber for countless unofficial town criers, the first act of an *opéra bouffe*, [an] endless source of gorgeous and useless information." Walter reveled in the power of stories to transform the mundane, the ordinary, into the fantastic, the extraordinary. And, whether malicious or benign, he found the traditions of jokes, trickster tales, and jest—what the more sociological Burrison defines as three of the strains of southern folk narrative—alive and well in the constant rehashing of everyday life's comedy and tragedy. Walter, himself a master embroiderer of truth and conjurer of delicious lies, wryly assesses the unex-

pected cost of southerners' weakness for taletelling: "In the South, gossip is a full-time occupation. That's why our roads are in bad condition, the bridges that were due ten years ago aren't built yet, the mail doesn't work. People are too busy tracking down versions of the story."[3]

Stories are word-pictures, and it should hardly be surprising that Kathryn Windham is also a visual artist, as was Eugene Walter. Windham's career as a journalist may have been the springboard for her photography, but she crafts her images in a fine-arts rather than a vernacular vein. What is newsworthy to her southern eye is more than the quotidian but also more than the sensational: it is a visual incident, one that sparks a chain of unseen associations and makes the watcher complicit, inviting her attentive partner-in-experience to supply an imagined past and future from the eternal present of the story-picture itself. Eugene Walter was an untrained yet somehow persuasive draftsman who used seemingly casual drawings as an outlet for his slightly disoriented stories and cockeyed observations. Truth was always a relative property in Walter's spoken and written stories, and likewise his drawings are exercises in disbelief suspended. He believed that his monkeys and cats, anthropomorphized stand-ins for human foibles, were no less fanciful or exaggerated than the people they satirized. For both Windham and Walter art was their answer to a narrative itch, a sense that relief lies in a tale like a picture, or a picture worth all the taleteller's words, a word-picture or a picture-story that need not be pretty but does have to be funny, tragic, romantic, mysterious—in short, believable, if not factual.

Neither history nor genre painting,

the one grand and pompous, the other modest and intimate, enjoyed much success in the South. In the eighteenth and nineteenth centuries, southerners principally commissioned and collected portraits as well as the furniture and objects that adorned domestic spaces: the people and things of kinship. In the twentieth century, when artists turned inward to the familiar for inspiration, southerners looked to their communities for "stories" to depict in print and paint. Inevitably influenced by the circumstances and preoccupations of regional identity, they found their subjects in race, religion, and what may be termed ruralism. This abiding attachment to the countryside itself served as inspiration for tales of family, duty, and devotion to the land. Landscape was metaphor, a symbol of regional and local identity. The Agrarians urged homegrown southern artists to reject urban culture as corrupting and degrading, and both black and white writers and painters forced themselves to deal with the myth of the antebellum plantation. Despite the extreme poverty and racial division they witnessed around them, these artists felt called on to depict in word and image a South that was beaten—and ruthlessly beaten down—yet at the same time unvanquished, if unvictorious: a place unreconstructed in the face of imposed ideas.[4]

The land itself, for these true believers, has abiding power. It is "back home" for the displaced Mississippians who gather annually in Central Park for a group repining, a stolen moment of squatterdom in a Dixie of the deracinated. It is the "homeplace," or just "The Place," for nostalgic South Carolinians who have had to move to town, and "down home" for those Volunteers who, ironically, dream of going back

"up" to the Smokies. It is a country where soil is sustenance and not merely dirt. Today, a certain sentimentality in prettified landscape painting has guaranteed success for some commercial southern artists, but in the 1930s and 1940s, mules, wagons, and shacks set against red clay and black belt, in bayou and field, were common subjects for those who wanted to evoke the ambiguity of love and despair inherent in these symbols of a shared agricultural past.

Linked to the southerner's sense of place, so manifest in both the art and literature of the region, is the idea of family. The importance of family accounts for the popularity of peripatetic portrait painters in the South and for the enduring themes of kinship in southern folklore and storytelling. No matter how much of a sinner, no matter how much of a saint, every ancestor deserves a picture on the wall—and not just a picture but a history behind it, even if only a tantalizing anecdote to tell a tale of glory or infamy. Perhaps every long-time Southerner has a skeleton in the closet, a Bertha Rochester in the attic, or little foxes in the bedroom.

Above all, southern identity and therefore southern storytelling contends with the subject of race. But as a reviewer noted in skewering an outsider's interpretation of southern storytelling, race is decidedly not a standard by which the whole tradition can be understood:

> Then I wouldn't need to disparage her banal conclusion that race is the common wound beneath all Southern narrative. In the Appalachians, where the best stories are preserved, slaves were even scarcer than Confederate patriots. To a mountaineer, The War was a deadly nuisance and race was not life's central

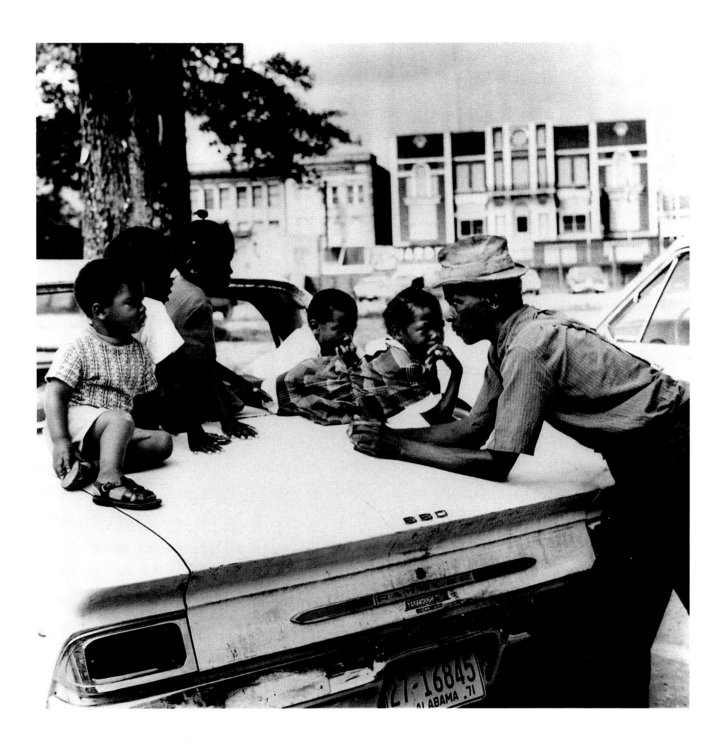

Fig. 1

KATHRYN TUCKER WINDHAM

Storytelling, 1971

Gelatin silver print

Private collection

reality, as it must have been in Charleston, but a remote abstraction indeed. The Southerner yields to no one when it comes to denial, a gift that shielded him and damaged him too. But he's no innocent savage who lives an unexamined life on the thin ice of unexamined history, who unwraps his darkest secrets for any rank stranger with a tape recorder.[5]

Binding both southern black and southern white is religion. The theme permeates southern fiction, whether in the formal literature of Flannery O'Connor or the preacher stories that are commonplace in jokes and tales. As John Burrison points out, "Southerners—many of whom subscribe to the fundamentalist brand of Protestantism—have taken their religion very seriously, yet no other subject has been so well developed in their jokelore, possibly as an escape valve for the pressures of intense belief."[6] For example, the connection between the contemporary outsider artist, whether black or white, and the religion that permeates southern narrative is clear. Yet it is no less true for being obvious that the yard artist depends on his or her interpretation of scripture to unravel God's mysteries and expose man's sinfulness. For these so-called outsiders or visionaries, who depend on stories heard for a lifetime, religion is true as received, yet open to, if not interpretation, then elaboration. Not interested in such fine distinctions, these folk artists ground the source of their inspiration in Biblical truth and expound in text and image to fit the modern world.

Charles Eldredge finds a series of themes in the paintings in this volume not unlike those in southern storytelling: religion, history, literature, fantasy, mystery, and romance. Although one can make a convincing case that early American landscape painting, with its search for the sublime in the New World, appropriated the aims and rhetoric of history painting, generally absent in the present selection are examples of portraiture or "pure" landscape, both of which may have implied narrative while eschewing temporality and causality. The psychology of the sitter for a portrait, the time of day in a landscape, the inspiration or cause of the picture itself, all may be interpreted as "story," but the continuum of narrative, its very structure, is usually absent or at least so opaque as to be irrelevant to the viewer. Plentiful, however, in Eldredge's selections are genre and history painting, both of which are governed by explicit narrative demands. The artist has selected a moment in time, and his or her "story" has meaning insomuch as the stilled moment of the sequence is seen to have origin and consequence. Context is supplied by the viewer, who is either familiar with the story or astute enough to find clues to its past or future in the image itself. Just so, in much of southern storytelling, the outsider may feel as if he or she has stepped into the middle of an extended narrative that depends on the listener's shared history, sense of place, or family connection with the storyteller. Even the very idiom in which the story is told, the dialect of black or white, aristocratic or proletarian narrator, requires a certain familiarity with regional idiosyncrasies of grammar, syntax, and vocabulary.

While it is difficult to find a southern school of painting that specifies narrative as a raison d'être, another art provides an analogue, one that illustrates the narrative urge for southerners. Country music, with its philandering husbands and wives, its lonesome journeys on trains in the night, its pining for home, is the collateral art form to southern storytelling, at least for white southerners. For black musicians, the blues is dependent on a similar storytelling tradition; no less plaintive is the wail for a rainy night in Georgia than the tears of a good woman deserted by a baby who's grown up to become a cowboy.

And just as the blues and country music are essentially didactic, even moralizing, so too history painting can aim for something beyond its more immediate commemorative and celebratory aims. Many a southern tale is cautionary and ends with the words, "Now the moral of this story is . . ." As sympathetic as the southern audience should be to history painting, likewise it must find in genre pictures a comforting sense that a story is somehow behind these scenes of domestic or rural life so popular in the nineteenth century. The reasons for genre's success with the nation's audiences will have special resonance for southern viewers. As Peter C. Marzio has observed, "First, the popularity of genre art in America was based in large part upon a visceral love of storytelling. . . . This oral tradition, with its wide range of vernacular types, emphasized that real knowledge—truth—came from everyday life."[7] The triumph of genre painting, which had connections to the populist realm of graphic arts, thus proceeded from its value in the 1800s as a vehicle of American nationalism in the face of decadent European neoclassicism, which placed its subjects in a remote, idealized past. Those same characteristics of antielitism, patriotism, and a certain xenophobia toward "outsiders" are all part of the southern narrative tradition.

It should come as no surprise that the pictures from this exhibition are

among the most popular with local audiences at their home museums. While not so unsophisticated as to disparage abstract or nonrepresentational art out of hand, many southern viewers prefer their realism unsullied by conceptualist tenets. At the beginning of the twenty-first century, moreover, a new symbolism is evident, analogous to an artistic current that flourished at the end of the nineteenth century. The narratives evoked by contemporary realists are subjective, idiosyncratic, and charged with highly personal symbols; these artists may create whole systems of visual metaphors with primary meaning for themselves rather than for the audience. These images recount stories from within, individual responses to a world where traditional aesthetic values seem inadequate. The figurative and the naturalistic have resurfaced as methods appropriate to these allegorical or symbolic narratives.

So, too, has southern storytelling undergone a metamorphosis: the country store and front porch have been replaced by the fern bar and the office kitchen. Urban legends spread at cyber speed. The grotesque and the gothic, so often elements in the fiction and folklore of the South, are less remarkable now that animals in formaldehyde and sculptures molded in frozen blood appear in museums and galleries as art. Issue-driven art maintains that it is tied to history through its "commenting" on current events, but often it is as brittle or unsubtle as the artist's—or storyteller's—bias. It is the rare native southerner who has truck with subtext without text: thoroughly immersed in word-pictures from infancy, the southern viewer is liable to be heard muttering in the galleries, "Spin me a yarn. I'll be glad to pass it along, in my voice, on my terms." Thus, while the story and the locale of its narrative may have changed with the times, in many ways the southern storyteller remains faithful to a hallowed pattern, a deeply rooted tradition of tales and legends real enough, timeless enough, that they can pass as history.

Tennessee Williams was a master at peeling away lies and gossip to find truth. Big Daddy in *Cat on a Hot Tin Roof* certainly knows better than to trust everything he hears and sees. Maggie may be all bursting-at-the-seams desire, but she and Brick have a rot at the heart of their marriage that portends nothing but tragedy. *History* and *story* have common linguistic roots, but for the southerner, the fact of the former need not interfere with the delight of the latter. Painters and photographers are equally manipulators, shapers of truth, but decidedly not a single one. Southerners know that a story, told and retold by tellers and by listeners who become tellers, is a living thing, that it is sometimes, oftimes, indeed, never the same, that a good story acquires as much pleasure as it had to begin with: sweet indeed are the uses of mendacity.

NOTES

1. John A. Burrison, ed., *Storytellers* (Athens: University of Georgia Press, 1989), 2.

2. See Kathryn Tucker Windham, *Alabama: One Big Front Porch* (Tuscaloosa: University of Alabama Press, 1991), and *A Serigamy of Stories* (Oxford: University Press of Mississippi, 1988). According to Windham, the word *serigamy* is a family coinage and means "a goodly number" while also connoting a gallimaufry.

3. Eugene Walter, as told to Katherine Clark, *Milking the Moon: A Southerner's Story of Life on This Planet* (New York: Crown, 2001), 24. In presenting this posthumous collection of Walter's "conversations" to the public, Katherine Clark specifically responds to the cynic who finds Walter's tales suspect: "After all, these stories were the central and most important 'truth' of Eugene's life. It was through storytelling that he invented himself and created a life for himself out of nothing. . . . Eugene is best understood and appreciated as a mythmaker, as a teller of tall tales, as a yarn spinner from the Southern oral tradition. As such, he never allowed the facts to get in the way of a good story" (xvii).

4. See *The American Scene and the South*, exh. cat. (Athens: Georgia Museum of Art, University of Georgia, 1996).

5. Hal Crowther, "Into the Brier Patch," a review of *Sitting Up with the Dead: A Storied Journey through the American South*, by Pamela Petro (Arcade, 2002), *New York Times Book Review*, Aug. 11, 2002, 23. Crowther sees Petro's first mistake as trusting her interpretation of the tale to fit a foregone conclusion about the region: "Petro, a writer who lives in Northampton, Mass., takes her first misstep when she decides that the stories she covets are inseparable from the identity and history of the South. It may be true that the Southern states can claim the best surviving storytellers, or the most. But it was a mischievous voice that told Petro she could decipher the South—assuming it's a puzzle—by taping storytellers and running their tales through her personal software."

6. Burrison, op cit., 5

7. Peter C. Marzio, "The Not-So-Simple Observation of Daily Life in America," in *Of Time and Place: American Figurative Art from the Corcoran Gallery*, exh. cat. (Washington, D.C.: Smithsonian Institution and Corcoran Gallery of Art, 1981), 179.

Tales from the Easel

American Narrative Paintings, circa 1800–1950

CHARLES C. ELDREDGE

Prologue

One of my daughter's favorite children's books was the story of a photographer who was frustrated in his effort to take a family's portrait. His subjects repeatedly interrupted the sitting to add, one by one, a treasured bibelot, a favorite pet, or some other superfluous thing to the ensemble, so much so as finally to obscure the family members beneath a pile of clutter. We read Nancy Willard's book over and over again, savoring the silly story and Tomie de Paola's charming illustrations, until the text was committed to memory. The lesson of the tale gave the title to the book: "Simple pictures are best."[1]

This simple truth came to mind as I was pondering how to introduce this survey of narrative paintings by American artists. In preparation for the exhibition and this text, I immersed myself in recent literature on literary theory: postmodern analyses of texts, both visual and verbal; competing definitions of "narrativity"; considerations of the "allegorical impulse" in art and literature. (Walter Benjamin writes, "It is the 'common practice' of allegory 'to pile up fragments ceaselessly, without any strict idea of a goal.'"[2] Just like the photographer's family portrait!) This reading, both heady and heavy, unexpectedly reminded me of Nancy Willard's story, which I'd not thought about for many, many years. With

that memory came the realization that indeed, simple pictures are often best.

Some literary specialists would apparently agree. Robert Scholes and Robert Kellogg, for example, identified *narrative* simply, defining it by its two primary characteristics: "the presence of a story and a story-teller. . . . For writing to be narrative no more and no less than a teller and a tale are required."[3] I wondered, by extrapolation, would a painter and a painting suffice?

And so I start with the object: in this case paintings that, simply put, somehow tell a story, using pictorial means to project a narrative. This study does not purport to be exhaustive or definitive, but rather aims to represent some of the narrative themes that engaged American painters over a century and half, from around 1800 to 1950. Although that time frame is somewhat arbitrary—paintings might have been chosen of earlier or later dates—the period in question seems marked by a continuing concern for such representational and narrative themes. Eighteenth-century examples are scarcer among the institutions participating in the project, as they are in general in American art; history painting and related imagery did not capture artists' attention until late in that century, and never found here the same favorable reception as in Europe. At the midpoint of the twentieth century, the high tide of abstract expressionism at least

momentarily overshadowed narrative subjects in many quarters. Painters of the New York school and their apologists placed a premium on spontaneity and contemporaneity. For them, narrative themes drawn from literature, history, or religion seemed decidedly old fashioned.

Norman Rockwell, narrative painter *par excellence*, chafed at that critical stance. In a jibe at the prominent critic Clement Greenberg and his fraternity, Rockwell lamented "the critics [who] say that any proper picture should not tell a story but should be primarily a series of technical problems of light, shadow, proportion, color and voids. I say that if you can tell a story in your picture, and if a reasonable number of people like your work, it is art. . . . I feel that I am doing something when I paint a picture that appeals to most people. This is a democracy, isn't it?"[4]

By the late decades of the twentieth century, a democratic cultural climate brought changed fortunes to narrative art—and to Norman Rockwell. Representational imagery—"realism" of various sorts—reemerged to compete with abstraction for critical acclaim. (It had always enjoyed popular acclaim, even during the heyday of abstract expressionism.) With this reinvigorated representation, narrative modes, even long-disparaged history painting, came once again to enjoy attention. The new pluralistic climate in the studios

encouraged the attention of critics, curators, and collectors to our artists' varied fare.

This survey of narrative subjects, of pictures that tell a story, of tales from the easel, is but one result of that climate change. Some of these stories told in paint are rather straightforward, easily read by most viewers: simple pictures. Others convey content through more obscure symbols, using details freighted with personal, often cryptic meaning—complex images that perhaps reflect the complex circumstances of their creation. But all suggest a basic and enduring fascination with a story well told, with a tale well painted.

My sample was drawn from the collections of member institutions of the sponsoring organization, the Southeastern Art Museum Directors Consortium. Although it comprises work from public collections in the South, this is not a study of southern art *per se*. Rather, I have tried to draw conclusions about American art in general, albeit wherever possible welcoming the introduction of a southern accent or flavor in works perhaps less familiar to audiences outside that region.

The premise of narrative subjects was inspired by the well-known tradition of storytelling in southern literature, from Joel Chandler Harris's *Bre'r Rabbit* to Eudora Welty, the subject of William Eiland's essay. Viewing American painting through such a lens perforce eliminates many important types; still life, portraiture, landscape, and abstraction are among the absent here. I recognize that consideration of subject matter may eclipse some issues, especially formal ones of style; others, such as the consideration of patronage, may be implicit, but relegated to the margins of curatorial attention. I hope, however, that from this selection viewers might infer something about the nature of southern taste, about patterns of collecting and a penchant for stories.

The narratives related in these American paintings are as diverse as their artists. My essay is divided into sections suggested by the artists' themes. Another curator might, probably would, organize the selection of topics and paintings differently. But in whatever arrangement, a special exhibition drawn from the collections of these southeastern museums would demonstrate the rich variety and strong quality of those regional holdings.

Many years ago, the South's native son H. L. Mencken famously maligned the region as "the Sahara of the Bozart," where "a poet is now almost as rare as an oboe-player, a dry-point etcher or a metaphysician."[5] Today, in the vaunted New South, circumstances have happily changed, a situation that I hope this exhibition and publication help in some measure to document.

1. Introduction

There he stands, straight and strong as the column behind him, blessing the attributes in whose midst he poses, yet lacking in expression or ceremony: the Father of His Country, the hero of the Republic, the subject of admiration, even adulation, from painters and patriots alike. But aside from the gesture of his right hand, directing attention to the symbols of national leadership, the figure portrayed in Gilbert Stuart's "Lansdowne" portrait of George Washington (fig. 2) doesn't *do* anything. He simply exists, the symbolic embodiment of his creation, the new American nation, an image familiar to generations of his compatriots.[6]

The Lansdowne portrait tells us nothing about the personality behind the official pose. Turned only slightly from a full frontal stance and positioned at almost the center of the large canvas, Stuart's subject is presented as a sort of secular saint: hieratic, powerful, remote. That attitude is reinforced by the portrait's composition. Meyer Schapiro recognized the importance of the frontal and profile as symbolic forms, attributing to the former the character of "the generalized, the abstract man"—usually Divinity or saint, or potentially monarchical—"outside any context and without the subjectivity implied in a glance."[7] By presenting his subject nearly front and center—the slight deviation from that pose being the painter's (or perhaps the president's) concession to the secular man, neither sacred nor royal—Stuart enhances the symbolic perception of Washington as national icon, a view that led the artist to repeat the Lansdowne design on several occasions.[8]

More than fifty years later, by which time Stuart's and other likenesses of Washington had become part of the American visual culture, Junius Brutus Stearns initiated what was to become a cycle on his subject's life with *The Marriage of Washington*, 1848 (Virginia Museum of Fine Arts). In a marked departure from Stuart's iconic image, Stearns presents his subject as bridegroom in a scene that democratizes Washington by domesticating him.[9] The wedding painting was followed by similar historical tableaux: *Washington as a Captain in the French and Indian War*, circa 1851 (Virginia Museum of Fine Arts), *Washington as a Farmer at Mount Vernon*, 1851 (cat. no. 56), *Washington as a Statesman, at the Constitutional Convention*, 1856 (Virginia Museum of Fine Arts), and *Washington on His Deathbed*, 1851 (Dayton Art Institute). Individually the Stearns paintings

depict incidents from a life and imply virtues and values associated with each; collectively they provide a biography in paint, a worthy lesson for the nation to emulate. In each, Washington is the central character, although never in the central position. In the harvest scene at Mount Vernon, for instance, Washington stands at the far right, in a pose that slyly echoes Stuart's Lansdowne pose without copying it; the planter is shown conversing with his overseer, whose profiled figure suggests attentive engagement with the landowner. Stearns's Washington is still rich in symbolic associations; the Roman warrior hero Cincinnatus, who abandoned his weapons to take up the plow, comes immediately to mind. Yet he does not simply exist; he acts. And he is humanized: the First Farmer in an agrarian nation, engaged with the seasonal rites of harvest. Unlike the earlier Stuart painting, which may symbolize power and nation but relates little of the man, Stearns's tells a story of the sort that appealed to midcentury Americans, presenting Washington as citizen, not hieratic and unknowable, but usefully involved with agricultural pursuits familiar to his fellow Americans.[10] It was that very familiarity that made Washington accessible, as hagiographers of Stearns's day knew. "Washington on his farm at Mount Vernon, performing his duties as a virtuous and useful citizen, is not less worthy of contemplation than Washington leading his country to independence," advised one writer in 1845. Indeed, Washington as farmer was "more extensively useful, because it comes home to the business and bosoms of ordinary men, and is within reach of their imagination."[11]

The story of George Washington was familiar to audiences of Stearns's day and, despite the woeful lack of

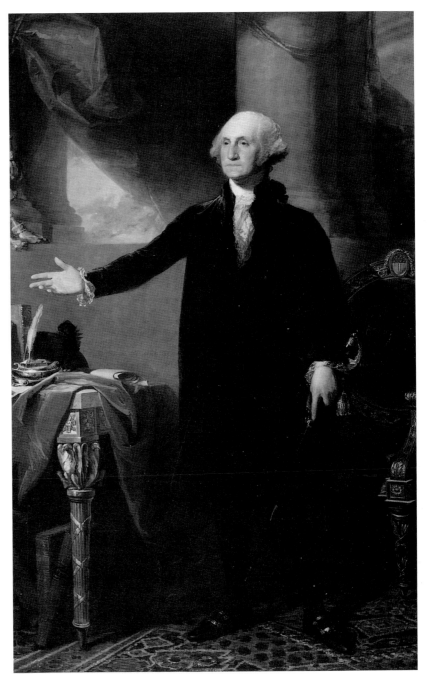

Fig. 2
GILBERT STUART
George Washington (Lansdowne Portrait), 1796
Oil on canvas, 97½ x 62½ inches
National Portrait Gallery, Smithsonian Institution
Acquired as a gift to the nation through the generosity of the Donald W. Reynolds Foundation
NPG.2001.13

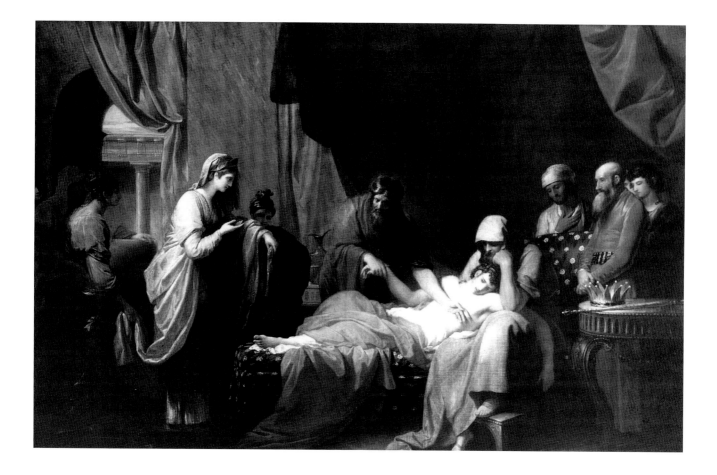

historical literacy of many Americans today, presumably remains so. Over time, it has been embroidered with recountings factual and imaginative to become the stuff of legend as well as history, narrated in paint and statuary as well as in prose. Historical incidents, such as those involving Washington, constitute one aspect of narrative painting, imagery that tells a story.[12] But such historical accounts related through visual form are scarcely limited to Washington's life, or even to the nation's.

The vogue for historical compositions dates well back into the annals of European monarchies and societies. The Bible provides an even more ancient inspiration for a pictorial record, as do classical legend and mythology, sources that were popularized in eighteenth-century London by Benjamin West (fig. 3), among others. Literature, in its diverse forms, has prompted imagery specifically illustrative of its sources, as well as inventions that may take off from some particular text but not be narrowly illustrative of it.

Imaginative fantasies, sometimes broadly familiar within a culture but often unique to an individual, may also prompt storytelling paintings. Some observers have argued that Americans' "leading characteristic has been an earnestness of character, which militated much against any purely imaginative work."[13] Imaginative compositions, often with a narrative character, have, however, had a long history in American art and letters, from novelist Charles Brockden Brown and painter Washington Allston to authors and artists of recent years (fig. 4). Such imagi-

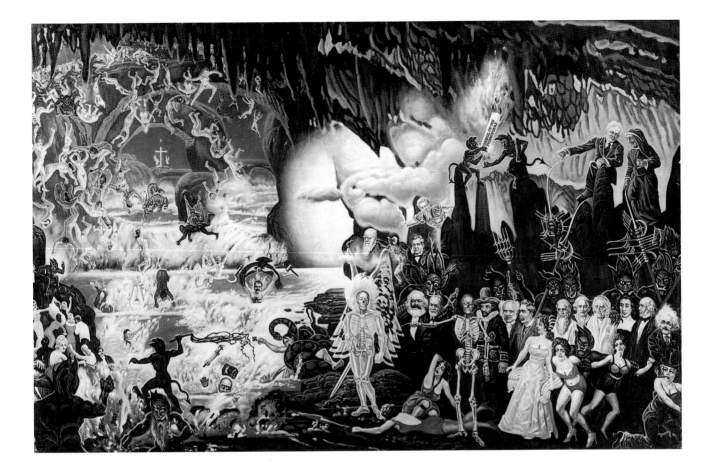

Fig. 4

MCKENDREE ROBBINS LONG

*Apocalyptic Scene with Philosophers and
Historical Figures,* ca. 1959

Oil on masonite board, 47⅞ x 72¼ inches

North Carolina Museum of Art, Raleigh

Purchased with funds from the William R.
and Frances M. Roberson Endowment for
North Carolina Art

native pictures and stories, whether
sweetly dreamlike or nightmarish in
effect, were the delight of romantics in
the late eighteenth and early nine-
teenth centuries, and they remained
a potent force through the age of
Sigmund Freud and modern psycho-
analysis. In this respect, they parallel
developments in Britain, where critic
Sanford Schwartz detected continu-
ities between Hogarthian narratives
of the eighteenth century and works
from the modern School of London
(Francis Bacon, Lucian Freud, and
others); he thought paintings by the
latter group "represent a kind of work
that . . . [is] traditionalist but not timid
. . . where the figure is of paramount
importance and where we can sense a
story being told."[14]

Incidents drawn from the quotidian
experiences of artists and audiences
might also constitute the inspira-
tion for narrative images. Actually, as
Lesley Wright has pointed out, genre
paintings of the nineteenth century
are "not really scenes of daily life at
all, but scenes of a devoutly desired
daily life that existed among all those
who cherished and created genre
paintings."[15] However realistic or
idealized, these genre scenes—often
depicted with painstaking detail so as
to enhance their legibility—enjoyed a
particular vogue in the middle decades
of the nineteenth century but have
remained a constant in other eras as
well, even during the abstract heyday
of the mid–twentieth century. In lieu
of exceptional moments drawn from
religious, historical, or mythic sources,
the genre artists concentrated on the fa-
miliar to illustrate the changing aspects
of contemporary life or the unchang-

ing aspects of human nature. Some of the motifs exhibited in this catalogue involve social commentary on the artists' times, praising or decrying certain behaviors; others relate behaviors of city or country folk, of community or family life, with intents ranging from the judgmental to the humorous to the affectionate. Through such imagery, an artist's contemporaries might have gleaned insights into their time and society. Today, the attentive viewer or historian might garner comparable insights into the past, for, as one nineteenth-century critic observed, "like the intimate studies of our greatest fiction, it [genre painting] is itself history, and itself analysis."[16] Sometimes this relationship is obscured by the apparent subject matter of an image, but, as Susan Danly explained with reference to nineteenth-century examples, a narrative painting "not only illustrates a specific story but also illuminates, sometimes unintentionally, broader issues. . . . Important national concerns such as western expansion, cultural identity, social class, literacy, and urbanization were often imbedded in scenes of classical Greece, storm-tossed ships, and European peasants."[17] Or, for more recent examples, in scenes of the modern metropolis, train wrecks, or American soldiers.

Media critic David Thorburn, speaking of television's role in modern American life, identified a type of narrative system common to most societies, which he called "consensus narrative." Its chief feature is "the ambition or desire to speak for and to the whole of its culture, or as much of the whole as the governing forces in society will permit." He explained that consensus narrative "operates at the very center of the life of its culture and is in consequence almost always deeply

conservative in its formal structures and in its content. Its assignment—so to say—is to articulate the culture's central mythologies, in a widely accessible language." This is "always a deeply collaborative enterprise," involving interactions between a text and its audience, between a text and its ancestors, between a text and constraints of subject or form imposed by the dominant culture, and even between or among the community of creators.[18]

By extrapolation, might we discover similar consensus narratives in images as well as texts? As in television programming, so too in paintings, both historical and modern? Is there a similar dynamic among makers and viewers of art as between producers and consumers of television? And in those images and interactions might we find similarly "complex mirrors of their societies"? It is to consensus narratives, Thorburn advises, to such "essential artifacts . . . [that] we must turn if we wish to understand ourselves, our ancestors, and our filiation with the past."[19]

In light of the historical popularity of stories, and in view of the recent resurgent interest in representation and storytelling imagery, our understanding of ourselves would seem to be enhanced through the consideration of American narrative paintings.

2. *Texts*

"The narratives of the world are numberless," wrote Roland Barthes, who discovered them in many forms: "myth, comedy, mime, painting. . . , stained glass windows, cinema, comics, news items, conversation. Moreover," he added, ". . . narrative is present in every age, in every place, in every society; it begins with the very history of

mankind, and there nowhere is nor has been a people without narrative."[20] Indeed, folklorist John Burrison believes that "the narrative impulse—the need to tell of or listen to experience and imagination structured into plot—is one of the traits that make us human."[21] Given the universality of narrative, an impulse fundamental to human nature, it is no surprise to find it in the most ancient of texts. "Narrate" derives from the Latin *narrare,* related to *gnarus,* "to know, to make known." To narrate, to tell a story—whether of contemporary manners or of Creation itself—is a way of knowing the world. The tales of how the world originated, the creation accounts of diverse civilizations, including the Old Testament, are among humans' primal narratives.

Henry T. Tuckerman, a prominent art and literary critic of the mid–nineteenth century, recognized the imitative nature of much in American culture. "Scenery, border-life, the vicinity of the aborigines, and a great political experiment were the only novel features in the new world upon which to found anticipation of originality; in academic culture, habitual reading, moral and domestic tastes, and cast of mind, the Americans were identified with the mother country."[22] Prominent among these traits, imported with the earliest colonists, was a "moral taste," a bias toward the good, that infused crucial aspects of the fledgling culture, including its visual arts: "Above all there should be a pleasing or instructive moral presented" in art, advised one southern journalist. "A picture, like a book, loses its mission when this is lacking."[23]

Even for landscape painters, the first significant native school of artists, the subject was motivated by a moralizing impetus and was critiqued in similar terms. "In the early nineteenth century

in America," as Barbara Novak aptly observed, "nature couldn't do without God, and God apparently couldn't do without nature."[24] Neither could Americans, or God, do without narratives.

The American woodlands provided a "text" for Ralph Waldo Emerson and like-minded transcendentalist writers and painters, whose works were tinged with a Nature-derived pantheism. For most members of the Christian society that was the young United States, the urtext was not the wilds but the Word, the Bible. Its parables provided guidance for acceptable behavior; homilies inspired the pious, and dramatic passages excited their passions. By the early nineteenth century, scriptural motifs had become a favorite subject for narrative painters and their audiences.

Edward Hicks, whose parallel careers as Quaker minister and coach-and-sign painter flourished in Pennsylvania during the second quarter of the nineteenth century, created numerous compositions on the biblical theme of the Peaceable Kingdom (Isaiah 11:6), of which sixty-two are known today. The scriptural passage presages the day when the wolf and the lamb, the leopard and the kid, the calf, young lion, and fatling shall all lie down together, their peaceful flock led by a little child, a prefiguration of Christ. Hicks faithfully illustrated Isaiah's menagerie and Child and then paired them with various subjects drawn from landscape or American history. In *Peaceable Kingdom of the Branch* (cat. no. 32), he combined animals and Child with a landscape scene and distant historical figures, both relating to the fractious history of the Quakers in the United States. The Quaker separatist movement arose in the 1810s, initially prompted by Americans who opposed union with British members of the faith; the schism, which later broadened to issues of orthodoxy, was aggravated by social or class distinctions between rural and urban Quakers. Among the chief proponents of tradition and of separation from the British church was Edward Hicks's cousin, the Reverend Elias Hicks, a leading Quaker cleric of his day; in his campaign he was joined by cousin Edward. In this divisive climate, which peaked in 1827 with the Hicksites' withdrawal from the Philadelphia yearly meeting, the painter was moved by the passage from Isaiah, discovering in its pacific imagery a balm for the pains of religious controversy and the inspiration for pictorial peacemaking.

Edward Hicks's Peaceable Kingdom paintings were charged with meanings related to the separatist controversy. The animals might represent human traits that could be ascribed equally to Hicksites and their opponents. The landscape is determinedly American, implying distance from those favoring union with the British branch of the faith. Its blasted tree trunks are of the sort that appeared in romantic Hudson River school views of the period; the famous Natural Bridge, which stood on property once owned by Thomas Jefferson and celebrated by him in *Notes on the State of Virginia* (1784), is equally identified with the New World. The geological oddity not only bespoke America; its origins in a natural event of great force also symbolized the church, once united but now divided. In the distance, beneath the arch, diminutive figures represent William Penn signing the treaty with the Indians, an event that fulfilled Isaiah's prophesy of a peaceful kingdom in this world. Penn also stands for Edward Hicks's world of Pennsylvania, the birthplace, he explained, of "our Quaker revolution . . . which originated in a contest between the republicanism of William Penn, planted in America and watered and cherished by the free institutions of our country, and the aristocracy of the Yearly Meeting of London, under the influence of the British hierarchy."[25] The "branch" of the title, which occurs in three other Peaceable Kingdom paintings of the period, refers to the scriptural passage describing the Messiah's descent as a branch from the royal line of David, son of Jesse and an offshoot of his tree. As Barbara Millhouse has noted, the branch held by the Child is rhymed in the branch that erupts from the blasted stump, "new growth on old wood [that] represented the prevalence of the Hicksites over the Orthodox Quakers."[26] The rich autumnal foliage on this sturdy oak branch also connotes America, where the seasonal brilliance was notable. In sum, then, Hicks's Peaceable Kingdoms were sermons in paint, pictorial narratives directed to the painter's partisans. "Both in their whole composition and in their individual components," explains Carolyn Weekley, "the Kingdom pictures provide highly symbolic allusions to the artist's position. They can be fully understood only if one knows the history of the period and Edward's sources of inspiration."[27]

Elsewhere, the Bible told of less pacific moments, particularly in the Old Testament, as when a wrathful God pronounces judgment upon Gog (Ezekiel 38–39), or when sinful Sodom and Gomorrah are laid waste by heavenly brimstone and fire, leaving "the smoke of the country [going] up as the smoke of a furnace" (Genesis 19:24, 28). Scriptural scenes like these captured the imaginations of painters

Fig. 5

ASHER B. DURAND

God's Judgement upon Gog, ca. 1851–52
Oil on canvas, 60¾ x 50½ inches
Chrysler Museum of Art, Norfolk, Virginia
Gift of Walter P. Chrysler Jr.
71.499

as well as preachers, providing Asher B. Durand with inspiration for *God's Judgement upon Gog*, 1851–52 (fig. 5). The prophet Ezekiel stands on a promontory, a stony pulpit overlooking a valley where an unseen God orchestrates the destruction of Gog's army, which was arrayed against the chosen people of Israel. Gog's Lilliputian soldiers are dwarfed in the enormous landscape, emblematic of God's enormous powers, and vanquished in fulfillment of divine prophecy: "I will give thee unto the ravenous birds of every sort and to the beasts of the field, to be devoured" (Ezekiel 39:4). The dramatic subject appealed to Durand's audience for, as Tim Barringer has noted, "many Americans of the 1840s and 1850s believed in the providential destiny of their nation, a new chosen people performing God's work," and would therefore have identified with the Israelites.[28] The motif also would have resonated with midcentury viewers, Millerites and others, who were infused with the millennial spirit and anticipated the imminent Second Coming and the end of the world. That romantic spirit was not unique to the 1840s and '50s, however, but has surfaced in various periods through the last two centuries.

In the late 1920s in Paris, the aged expatriate Henry Ossawa Tanner turned to a similarly momentous motif, God's destruction of Sodom and Gomorrah (cat. no. 59). The painting was one of several versions of the biblical tale that he produced, exceptions to his customary reliance on subjects from the Gospels of the New Testament. The specifics of landscape and humans are even less detailed in Tanner's design than in Durand's, as the artist concentrates on the contrast of blue-green smoke above and the ochres that flow like molten lava across the ground

plane. The holocaust is suggested by the sooty sky overhead, dark plumes that led the eminent scholar W. E. B. Du Bois to propose their genesis in recent events: "this seething, convoluted mass of smoke," he wrote, was probably inspired by "the sight of some such terrific scene during the [First World] war. Nothing in natural events, indeed, could be imagined to typify more fittingly the wrath of God in the biblical story than the aspect of the sky after a great explosion."[29]

The New Testament also inspired painters with narratives of Christ's miraculous birth, death, and ascension. Robert Loftin Newman's imaginatively conceived figure subjects were drawn from Scripture and from secular literary and mythological sources, in what Albert Boime called "a bizarre amalgam of the Old and New Worlds."[30] The painter particularly favored incidents of Christ's life as related in the Gospels, from the Nativity to Jesus' entombment and the Resurrection. Newman's romantic style, rich in shadows and nuance, was derived from his study with Thomas Couture and the Barbizon school and was well suited to evocative moments suffused with mystery. Such was surely the mood in the miraculous appearance of the risen Christ to Mary Magdalene, a subject depicted in Titian's famous *Noli me tangere* (National Gallery, London). While that and other Renaissance treatments of the theme were familiar to American artists in Europe, the subject rarely figured in their work; John La Farge was probably the first to paint it, in his mural decorations for New York's St. Thomas Church, in 1878. Within a short span, however, the motif appeared in easel paintings by Newman and his friend Albert Pinkham Ryder (fig. 6), suggesting their mutual attrac-

tion to the awesome moment told in the Bible, as well as to La Farge's murals. In Newman's canvas (cat. no. 49), a white-robed figure spectrally emerges from the mysterious darkness, dramatically illuminated from an otherworldly source, while another, reddish figure cowers before it. Newman's subject and his title—*Rabboni*—come from the Gospels, describing the Magdalene's encounter with the unascended Christ, whom she does not recognize until "Jesus saith unto her, Mary. She turned herself, and saith unto him, Rabboni, which is to say, Master" (John 20:16).

The story of the Ascension provided equally dramatic narrative material for other painters, both in Newman's time and later. The appeal of the biblical subject persisted well into the secular century that followed, when Maltby Sykes painted *The Ascension* about 1940 (cat. no. 58). During the 1930s, Sykes had been a student and associate of Mexican muralist Diego Rivera, whose influence is apparent in Sykes's painting. In a sere desertscape like those of Rivera's native land, with Calvary's crosses in the background, the two Marys stop agape at the opened sepulchre. Overhead, against a stormy sky worthy of El Greco (whom Sykes considered "the superb master," capable of "wizardry"),[31] the dead Christ is borne aloft by two angels, whose "countenance was like lightning" and "raiment white as snow" (Matthew 28: 3). On his unfurled linen shroud, he fairly rockets to glory; the miraculous speed of the ascent is suggested by the windswept hair and beard of the angelic bearers—an Art Deco stylization, like some heavenly hood ornament.

The Bible was scarcely the only text to stir the minds of readers, or the brushes of painters. Emily Dickinson knew that "There is no frigate like

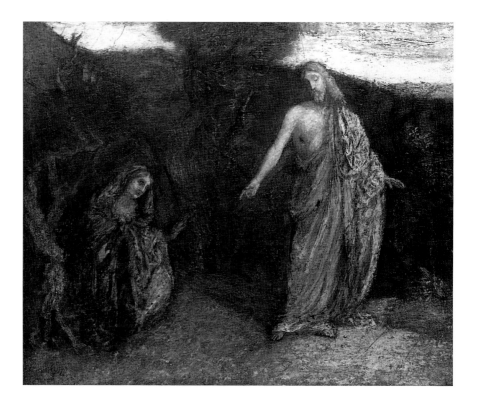

a book, / To take us lands away," no finer vehicle for the ramble of imagination.[32] Secular literature also figured as impetus for artists' creations; these sometimes faithfully followed the textual inspiration, sometimes departed imaginatively from it. Sources might range from classical mythology and ancient legends to Shakespeare, from contemporary literature to timeless fairy tales. The last, for one example, inspired Gari Melcher's large portrait of *Little Red Riding Hood,* 1897 (Maier Museum, Lynchburg, Virginia), which suppressed narrative elements to concentrate on the pretty young model; Robert Newman treated the same subject in multiple canvases whose shadowy mysteries hint at the drama of the tale. By contrast, George de Forest Brush, a contemporary of Newman and Melchers, was inspired by Bret Harte's Gold Rush adventures; his painting of *Miggles* (Chrysler Museum, Norfolk), for instance, depicts Harte's heroine from the story of the same title.

In the early nineteenth century, well before Harte and Brush, James Fenimore Cooper's novels enjoyed pride of place in the libraries of many educated Americans. *The Pioneers* (1823), the first of his Leatherstocking series, provided the inspiration for Charles Deas's *Turkey Shooting* (cat. no. 20), painted in 1836. The painting is based on a passage describing a marksmanship contest run by a free black man in Cooper's native Otsego County, New York, though Deas loosely interprets his literary source. Through gestures and expressions, he provides a study of character centered on Abraham "Brom" Freeborn, manager of the contest, whose profit is threatened by a sharpshooter's keen aim. The agitated Freeborn, restrained by a contestant, "exhibited [wrote Cooper] all that violence of joy that characterizes the mirth of a thoughtless negro"[33]—a racial caricature, common in Cooper's and Deas's time, that was captured by the painter.

Other secular texts provided motifs more distant in time or place. Elihu Vedder was one of the most imaginative of American artists in the late nineteenth century. Over a long and prolific career, his productions in diverse media were inspired by literary fantasies of various sorts, including his own verse. Most famously, he produced a series of illustrations for Edward Fitzgerald's text of *The Rubaiyat of Omar Khayyam* (published 1884), a number of whose scenes he also treated in oil paintings.

In *The Roc's Egg,* 1868 (cat. no. 65), Vedder displays a young man's fascination with mystery and marvel, drawing on Sinbad the Sailor's account of the "prodigious height and bigness" of a white egg laid by the Roc, a "bird of monstrous size."[34] Vedder's interest in the *Tales of the Arabian Nights* (which includes stories of Sinbad) grew out of his delight in the improbabilities they relate, which he depicted with a literalness that belies their fantastic nature. *The Roc's Egg* and Vedder's *Fisher-*

man and the Genie (Museum of Fine Arts, Boston), also derived from *The Arabian Nights,* both "combine the observed with the marvelous without stylistic apology" (in Joshua Taylor's felicitous phrase). In them, "Vedder seemed to delight in pushing possibility to the point at which it devastates reason. . . . Mystery was the complement of a persistent materialism."[35]

Albert Pinkham Ryder shared the romantic temperament that characterized much of Vedder's finest work and that flourished in the late nineteenth century. His reveries in paint were prompted by an eclectic array of sources, many of them literary: ancient mythology, the Bible (including the *Noli me tangere* subject that his friend Newman and the younger Elliott Daingerfield also tackled), Chaucer's *Canterbury Tales,* Shakespeare, La Fontaine's fables, German legends, the poetry of Heinrich Heine, Longfellow's "Evangeline," Edgar Allen Poe, Wagnerian opera—and the artist's own verse. In *Childe Harold's Pilgrimage* (cat. no. 53), Ryder takes his cue from Lord Byron's enormously popular poem of the same title. The painted image's relation to a specific poetic passage is uncertain; also vague and uncertain is the materiality of Ryder's pilgrim, who in that respect suggests the shadowy, brooding figure who moves through Byron's four cantos. Less an illustration than an evocation, Ryder's image might reflect the artist's temperamental association with the poet and his subject. Elizabeth Broun has speculated that the painter, whose 1882 European tour followed an itinerary similar to that actually and poetically traveled by Byron, "may have fancied himself, like Childe Harold, on a pilgrimage to the great cities and monuments to seek out the meaning of art and life."[36]

3. Fantasies

The narrative paintings that illustrate, or at least draw their inspiration from, written texts are not always easily deciphered, but even more challenging can be those that derive from the maker's own personal history or private reveries. Such incidents may or, more likely, may not have any basis in a shared culture or experience. Carroll Cloar's *Story Told by My Mother,* 1955 (cat. no. 17), is one such painting. While it demonstrates the survival of the romantic imagination well into the modern, scientific age, it also cloaks its story in personal terms not immediately intelligible to the viewer. When he was young, Cloar's mother told him fantastic tales of wild panthers that used to roam his native Arkansas, a vivid childhood impression that years later reappeared in his paintings. Sometimes, as here, the cat is accompanied by Mother; more often it is alone or in the company of other panthers. Father also played a role in the artist's painted reminiscences; in *My Father Was Big as a Tree,* 1955 (fig. 7), Cloar *père* looms larger than life, in a manner reminiscent of Giorgio de Chirico's child's-eye vision of paternal power (fig. 8). In these and other paintings from what Cloar called his Childhood Imagery series, the artist sought to paint "how I visualized those things when I was told about them. . . . I've tried to keep a child's point of view, the simplicity, the wonder."[37]

The stories that moved Bryson Burroughs were, by contrast, less personal in nature. He generally drew his themes from familiar sources—mythology, the Bible, medieval legends—and retold them in paint, often with subtle, humorous additions. His early Parisian training gave him a taste for the symbolic and decorative work of Puvis de

Chavannes, and Burroughs adapted the French master's manner and classical subjects to new circumstances. In *Eurydice Bitten by the Snake* (Metropolitan Museum of Art), for instance, the wound is bound in modern, one-inch gauze bandage; in *Island of Naxos* (1928; Whitney Museum of American Art) Theseus sails away from the ancient island on a nineteenth-century schooner, abandoning Ariadne to her fate. Such anachronisms were noted by contemporary critics, some of whom complained, others of whom, like Henry McBride, found them charming. "If you have any real learning or humanity in your make-up," he wrote, "you will be entertained rather than annoyed by the fact that the drowsy servant in the picture of *The Sleeping Beauty in the Wood* [cat. no. 12] bears a turkish towel upon her arm that came newly from Macy's."[38] In addition to the issue of linens, Burroughs's *Sleeping Beauty* conflates medieval legend with current events in other ways, both national and personal. The medieval maiden slumbers on a bed covered with a symbolic cloth decorated with the Tudor Rose and the sign of the Crown of England, a venerable monarchy newly threatened by world war. Surrounding the maiden are sleepy attendants, some reclining in poses reminiscent of figures painted by the British pre-Raphaelites, Ferdinand Hodler, or Arthur B. Davies; their slumberous state enhances the dreamlike quality of the scene. Intruding into the idyll, an American doughboy slumps beside a tree in the darkened woods beyond, providing a reference to the belated U.S. entry into World War I in April 1917, the year the painting was made, and to the bloody battles on the Western Front, where Allied casualties were high. Overhead, like some escapees

Fig. 7

CARROLL CLOAR

My Father Was Big as a Tree, 1955

Casein tempera on masonite, 30⅛ x 21⅞

inches

Memphis Brooks Museum of Art,

Memphis, Tennessee

Gift of Mr. and Mrs. Marshall F.

Goodheart

68.11.1

Fig. 8

GIORGIO DE CHIRICO

The Child's Brain, 1914

Oil on canvas, 31½ x 25⅝ inches

Moderna Museet, Stockholm

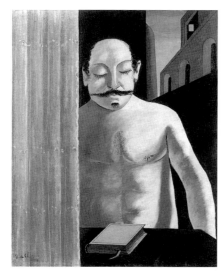

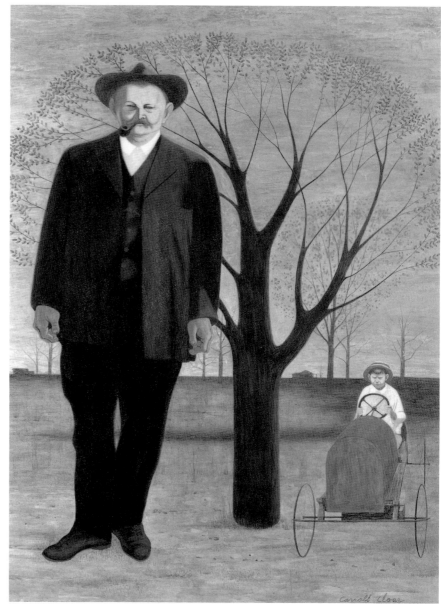

from a Puvis mural, angels flutter. The red blossoms they bear may symbolize continued life among the bleak circumstances of modern war; conversely, the flowers may refer to bloody Flanders fields, where the poppies grow, for the flower was also an ancient symbol of death, accounting for its prominence in Elihu Vedder's funereal *Memory (Girl with Poppies)* (cat. no. 64). Such a reading might have personalized the subject for Burroughs. His Sleeping Beauty is laid out like a corpse on a catafalque;

that pose might recall the artist's own young wife, who had died just the preceding year. His multivalent modern image masquerades as a medieval fairy tale, a trait that earned praise from his contemporaries for "invest[ing] classic tales with the same lively spirit which must have animated their original telling, rather than the stiff, soulless treatment which is characteristic of most academic portrayals."[39]

Elliott Daingerfield, like Ryder and Vedder, created with poesie as well

as paint. His fanciful imagination was especially stirred by a memorable visit to the Grand Canyon in 1911. The Santa Fe Railroad Company sponsored his visit, as it did for several prominent artists, in an effort to stimulate tourism in the Southwest; but Daingerfield's patron could scarcely have anticipated his eventual visionary conceptions of the region. The railroad's other guests limned the country's geological drama and its ancient, exotic peoples. Unlike them, Daingerfield imagined a race

of giants along the canyon's brink, and land forms morphing into golden temples, shimmering in what the artist called "the light of the spirit, the presence of the something which has no material or objective expression."[40] In *The Sleepers,* 1914 (cat. no. 19), recumbent figures draped across the canyon's near edge appear to be asleep, but according to the poem Daingerfield composed to accompany the picture, these Amazons, though shut-eyed, actively imagine. They "see in spirit" what others cannot or will not:

> Age on age the Sleepers rise
> To see in dreams the Canyon's splendor rise
> Height on height, from river bed to golden crest.
> Gods are they!—as you and I,—
> Who see in spirit what the eyes deny.[41]

The dream state celebrated by Daingerfield was part of the cultural legacy of the turn of the century, an escape from the mundane into personal reveries, often filled with fantastic events and creatures. Daingerfield's sleepers, like those by Burroughs, merge considerations for the perceived world, for actual events, with unique personal fantasies, creating pictorial narratives of a distinctive sort.

The dream state painted by Thomas Hart Benton a generation later perpetuated this type of fantastic tale but imbued it with more calamitous overtones. His *Engineer's Dream* (cat. no. 6), painted in 1931, had its immediate inspiration in a country music ballad of the sort Benton enjoyed collecting and performing. However, the apparently straightforward musical narrative of a bridge collapse and train wreck could be read as having larger implications. Painted in a year of great economic peril and social upheaval, the sleeping

engineer might represent the nation's leader, President Herbert Hoover, literally asleep at the switch, heedless of and powerless to stop the nation's impending catastrophe represented by the nightmare behind him. The simple lyrics of a country song might be an allegory of the Great Depression and national calamity.

4. History

Every society has its narrative of formation. Some call it a creation myth, others call it history. But by whatever name, the tale seems essential to the sense of national identity. And just as members feel the need to relate the tale verbally—in sagas and ballads, dramas, histories and verse—so, too, are they compelled to illustrate it with pictures. "Nations and societies," claim historians Patricia Burnham and Lucretia Giese, "have a fundamental need to tell stories about themselves in art: to recount their past, make sense of their present, and project their future. Their desire is to embody their concerns, achievements, and aspirations as a people in visible form." This compulsion is "certainly true," they observe, of Americans.[42]

Sometimes this visible form appeared as allegory, a traditional form that occurs, as described by critic Craig Owens, "whenever one text is doubled by another"; it is a technique in which "one text is *read through* another, however fragmentary, intermittent, or chaotic their relationship may be." In the visual arts, that "doubling" may occur when "the image becomes something other (*allos* = other + *agoreuei* = to speak)." Owens deconstructs the techniques of contemporary artists who appropriate existing imagery, draining it of its original significance

and substituting another meaning. But the allegorical impulse, although long scorned by modernists before its recent resurrection by Owens and others, had a distinguished lineage in earlier Western visual art. There, the depicted thing (person, object, even a nonobjective form) stands for some other thing. It might be the personification of an abstract quality (Democracy, Faith) or an activity, such as the figures in Benjamin West's *Agriculture,* 1789 (Mint Museum of Art), representing Husbandry aided by Arts and Commerce. It might be the symbol of a specific trait (a profession, a region or place). Or it might be something in between—but something that is more than or other than the thing or figure depicted. Something "doubled." The pictorial allegory becomes a hieroglyph awaiting deciphering, an image with an "essentially pictogrammatical nature."[43]

Specific figures—from myth or Scripture, historical or allegorical—might be indicated by particular attributes, which clarify their reading. For instance, in a painting by Luther Terry (fig. 9), three elaborately costumed women, seated before a distant landscape vista, suggest a meaningful masquerade. The central woman has draped striped fabric over a white tunic, while blue fabric with white stars encases her lower body; on her head is a red cap of distinctive form, and she holds a curious implement of wood and metal. The stars and stripes, of course, are the national flag, the headdress is a Phrygian or Liberty cap, and in her left hand are the bound fasces of the Roman republic—a collection of attributes that add up to a personification of America (or possibly Liberty, symbolic of the United States). She is flanked by contrasting blonde and brunette women. The former holds a

tome entitled *Useful Arts and Sciences* and is posed before a typical New England village, with steeple and factory, the embodiment of the North. Her counterpart leans on a cotton bale with abundant harvest at her feet and slaves working the fields beyond, an allusion to the American South. These three figures combine in *An Allegory of the North and the South.* This visual allegory was painted in Rome by a Connecticut expatriate, a pictorial plea for preservation of the Union in the troublesome years immediately preceding the outbreak of Civil War. Following the war, Constantino Brumidi similarly used female protagonists in his painted allegory of reconciliation, *Columbia Welcoming the South Back into the Union,* circa 1876 (Morris Museum of Art), and in Atlanta James Moser exhibited a large allegorical painting, *The New South Welcoming the Nations of the Earth,* at the International Cotton Exposition in October 1881.[44]

The painters' responses to mid-nineteenth-century military events and disunion might have appeared exceptional when compared with those in other creative fields. "[A]mong the surprises" from the Civil War, wrote one literary historian, for instance, "is the fact that out of so convulsing, so overwhelming a tragedy there came so little good poetry."[45] But if poets—at least, good ones—passed, painters did not. Reckoning with divisive North-South issues in their work became a strong motivation for numerous artists on both sides of the conflict. Some, like Terry or Brumidi, dealt with the national schism in allegorical terms, with personifications. Others took different approaches, some treating specific incidents with documentary precision (or its approximation), some with

propagandistic intent, some in images rich in genrelike detail or suffused with sentiment.

Years after the war, Gilbert Gaul, painter, illustrator, and National Academician, was commissioned by several gentlemen of Nashville to create a series of paintings that would "crystalize on canvas the magnificent deeds of daring and love which distinguished the Confederate soldier." The series depicted the warriors' "courage, sacrifice, heroism, sufferings, and home life" in images that were to be reproduced in a portfolio, *With the Confederate Colors,* ostensibly to stimulate regional pride.[46] *Leaving Home,* ca. 1907 (cat. no. 23), from that commission, is a rumination on time-honored traditions of valor: a handsome, young Confederate soldier bravely bids adieu to his proud father, leaving his weeping mother, anxious sisters, and faithful servants and pets. Painted two generations after the outbreak of Civil War, Gaul's mise-en-scène is staged in a domestic setting that enhances the bathetic moment, drenched in the sentimentalism of the late nineteenth century.

Domestic settings were found in other historical subjects dealing with war; though of a different sort, such environs, as they did in Gaul's painting, added a poignant note to depictions of the home front. Tompkins Matteson was among the best known genre and history painters of the mid–nineteenth century. His reputation was made early with a patriotic subject, *The Spirit of '76* (unlocated). In *The Making of Ammunition,* 1855 (cat. no. 46), another subject from the Revolutionary War, Matteson, like Gaul, depicted a family gathered in a domestic interior, where colonials of several generations urgently prepare for hostilities with the unseen British: children cast bullets

from melted pewter, making ammo from heirlooms; earnest young men take up arms, while a legless elder, his amputation suggesting earlier acts of military bravery, pays rapt attention to reports read by another; women help to arm and inspire the patriots who, like Gaul's young Confederate, will soon leave home for an uncertain future. It was a moment rife with uncertainty, just as was the antebellum moment in which Matteson painted; his historical wartime motif seems to reflect, even to illustrate, the tensions in mid-nineteenth-century America.

In modern times, the home front continued to play an important role in warfare; Rosie the Riveter of World War II was the most familiar of these subjects, but scarcely the only. In American fields as well as factories, patriotic citizens saluted the national cause, such as the black sharecropper's family in Richard Wilt's *Low Altitude Formation (Farewell),* 1943 (cat. no. 67). Like southerners in earlier wars, those of the "greatest generation" rallied to the cause, but now traveling from home in bombers that roared above the rust red land. In 1943, in the depths of the struggle, several artists were inspired by the unusual sight of military aircraft flying low over the southern landscape. That year, the Savannah carver Ulysses Davis made a painted relief, *Farmhouses with Airplanes* (coll. Mr. and Mrs. David E. Miller Jr.), and Lamar Baker published his lithograph *Wings over Mississippi* (Columbus Museum), depicting a black field hand arrested by the sight of planes overhead. In Wilt's painting the fliers similarly capture the attention of observers below, eliciting a farewell salute from one woman, and frightening children and livestock. Wilt's planes, B-25 Mitchells—a craft

Fig. 9

the artist knew well—were among
the workhorses of World War II. Wilt
began his pilot's training on the plane
in Georgia in 1942, and the following
year he flew a B-25 during World War
II's North African campaign. Early in
1945, after fifty-five missions overseas,
he returned to Greenville, South Caro-
lina, to train other pilots on the aircraft
until the war's end.[47] His experiences
in Georgia and South Carolina gave
him familiarity with the southern
landscape depicted in his painting. His
sympathy for African Americans, who
figure prominently in that and other
paintings, arose from the same experi-
ence in the South and from the influ-
ence of subjects favored by his close
friend Robert Gwathmey. Beginning
in September 1943, B-25s were used in

training flights by the legendary Tuske-
gee Airmen, heroic African American
pilots schooled at the historic Tuskegee
Institute in Alabama. This association
potentially adds a note of racial and
regional as well as nationalist pride to
Wilt's poignant patriotic subject.

The Civil War had a long hold on
the American imagination, particu-
larly in the South. It was not, however,
just a chivalric memory, a sentimental
indulgence, represented by Gilbert
Gaul's *With the Confederate Colors*
paintings or in the pages of Margaret
Mitchell's *Gone with the Wind.* Like
many modern conflicts, the Civil War
inspired some artists to record events
in a documentary fashion. Artist-cor-
respondents such as Edwin Forbes
or Winslow Homer made sketches

Fig. 10

JOHN ROSS KEY

Bombardment of Fort Sumter, Siege of Charleston Harbor, 1863, ca. 1865

Oil on canvas, 29 x 69 inches

Collection of the Greenville County Museum of Art, Greenville, South Carolina Museum purchase with funds donated by Suzanne Cochrane Austell; Dorothy Hipp Gunter; Buck and Minor Mickel; Dorothy P. Peace; John I. Smith Charities; Ball Unimark Plastics; First Union National Bank of South Carolina; Michelin Tire Corporation; 1988 Museum Antiques Show, Elliott, Davis, & Co., CPAs, sponsor; 1989 Collectors' Group

of camp life and battlefield exploits. Their sketches were reproduced as wood engravings, providing Northern newspaper readers with firsthand images of the war. Soldier-painter Conrad Wise Chapman, who served at Shiloh, similarly provided an eyewitness account of life in the Confederate military. Later, Chapman's sketches and paintings documented Confederate military fortifications, particularly those at Charleston, of which he produced a series of thirty-one oil paintings (Confederate Museum, Richmond).

Charleston was famous as the cradle of the rebellion, the site where the war began in April 1861 with the bombardment of Fort Sumter. In 1863, it was the scene again of fierce bombardment, less famous than the first, but symptomatic of the Confederacy's determined endurance, even in the face of overwhelming odds. Despite the best efforts of Union forces to win back the strategic and symbolic site, Fort Sumter did not

finally surrender until near the end of the war, when the infantry protecting it were withdrawn to defend the city against Sherman's anticipated attack. It was during this second siege that Chapman began his documentation of the region; but he was not the only artist to witness the scene. John Ross Key, trained as a draftsman and cartographer, served as an officer with the Confederate Engineers. Key's professional training gave his works an exacting accuracy of the sort that would satisfy both military and aesthetic needs. His large panoramic view of the bombardment in the late summer of 1863 (fig. 10) was painted two years later based on the artist's personal surveillance of the battle and his on-site sketches.

William Aiken Walker, a native of Charleston, also served the Confederacy; in the army, his duties included drawing maps and sketching the defenses of his hometown. Such works are not merely picturesque views but,

like Key's or Chapman's, documents intended to provide specific information crucial to officers and engineers. From this practice of utilitarian draftsmanship Walker developed the habits of exacting detail that figured in his later paintings, such as the *Bombardment of Fort Sumter, Charleston Harbor, Charleston, 1863* (cat. no. 66). The expansive harbor view was painted in 1886 based on sketches Walker had made of another unsuccessful Union attack on Fort Sumter on April 7, 1863, a preliminary to the late summer assault portrayed in Key's view. Walker's painting, which was commissioned by the Confederate States Corps of Engineers, details the battle as viewed from East Battery with topographic accuracy, showing Castle Pinckney at the left, Fort Sumter in the center, Fort Moultrie in the distance, and Fort Johnson at the extreme right. Watching from the Battery are citizens from various strata of Charleston's society—aristocrats,

slaves, flower women—all attracted by the spectacle of bombardment, a tourist's-eye view of the war.

While Walker brought a trained hand to his task, other documentary views were the product of untutored artists struggling to bring accuracy to their painted depictions of specific incidents. Jean-Hyacinthe Laclotte was one such witness to history. A combatant in the Battle of New Orleans in January 1815, he later painted that bloody conflict (cat. no. 38), painstakingly diagramming the placement of British and American troops (including General Andrew Jackson), the cannons, the tents of the encampment. Though vastly outnumbered, Jackson's American forces enjoyed the advantage of elevated position—and of British military misjudgments—which led to a glorious victory and the end of America's "second war of independence," all carefully documented in Laclotte's canvas.[48]

Of course, not every history painter was eyewitness to his subject; indeed, most were not. The wanderings of early European explorers across the North American landscape went unpainted by their contemporaries, but the absence of such historical visual records did little to deter later generations of artists who were wont to imagine and re-create incidents of yore. Though best known today for his renderings of western scenery, Thomas Moran also painted other locales, including Florida, which he first visited in 1877 on assignment for *Scribner's.* But the artist aspired to more than picturesque subjects for magazine illustration. Encouraged by the unprecedented purchase by Congress of his two grand paintings of Yellowstone and the Grand Canyon, Moran sought to repeat that success with a southern subject, one that combined the landscape and its ex-

otic flora with events from human history. The Floridian exploits of Ponce de León and his quest for the Fountain of Youth provided the inspiration for Moran's large canvas of 1878 (fig. 11) in which natural history obscures human, the towering trees and lush vegetation nearly overwhelming diminutive Spaniards and Native Americans alike.

The protagonists are more easily discerned in *The Coronation of Powhatan* by John Gadsby Chapman (cat. no. 15). In this work from early in his career, Chapman (father of the aforementioned Conrad Wise Chapman) described Captain John Smith's crowning of the Virginia chief, who was the father of Pocahontas. American artists had for several generations—from Benjamin West to Chapman's own time—sought to emulate the European vogue for history paintings. Their compatriots, however, generally proved resistant to such subjects, which often required sophisticated knowledge of the classics, Scripture, and European literature and history, a mastery that many in the fledgling nation lacked. As the society matured, a new appetite for historical motifs developed. However, in lieu of the arcane themes that often appeared in European works, Americans patrons increasingly were drawn to subjects from their own national past. As early as 1812, one magazine editorialized that "It is extremely gratifying to the lovers of the fine arts in this country, to see a taste and disposition to encourage historical painting and engraving, by introducing among us a taste for subjects from our own history. It is certainly the most proper method to establish schools of art in America."[49] With victory in the War of 1812 and the Monroe Doctrine of the 1820s, the sense of a distinctive American nation and tradition gained new enthusiasm

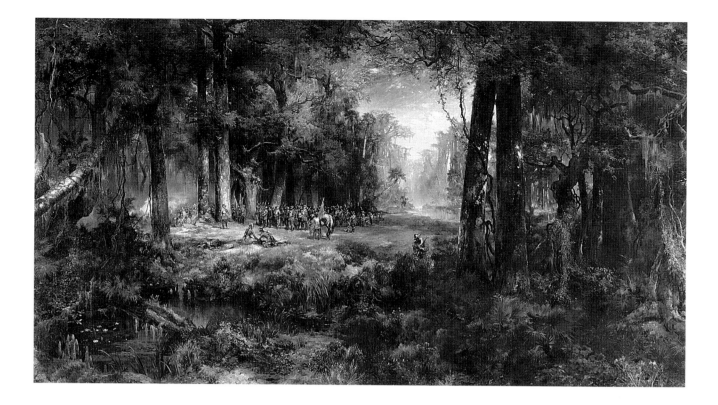

Fig. 11

THOMAS MORAN

Ponce de León in Florida, 1878

Oil on canvas, 64¾ x 115⅞ inches

The Cummer Museum of Art and Gardens, Jacksonville, Florida

Acquired for the people of Florida by The Frederick H. Schultz Family and NationsBank, Inc.; additional funding provided by the Cummer Council

AP 1996.2.1

from its citizens, and artists responded in kind. In the 1830s, the most important governmental commission awarded to date, the decoration of the U.S. Capitol rotunda, drew the lively interest of many painters. In an earlier generation, they might have opted for biblical themes or more abstract allegories, but now many were fueled by patriotic fervor to depict distinctively American subjects. The winners portrayed the landing of Columbus (John Vanderlyn), de Soto's discovery of the Mississippi (William H. Powell), the embarkation of the Pilgrims for the New World (Robert Weir), and the baptism of Pocahontas. The last, by John Gadsby Chapman, was related—in theme and by blood—to his earlier depiction of the coronation of Pocahontas's father, Powhatan, a painting that might be seen as a rehearsal for the Capitol competition.

Subjects from the settlement period motivated other artists, both in

Chapman's generation and later. About the same moment that Chapman was painting Powhatan, Chapman's distant cousin George Cooke, a son of Maryland and resident of numerous southern locales over his lifetime, also turned to Virginia history with *The Coming of the Maidens as Wives for the Settlers,* circa 1830 (fig. 12). Although Cooke failed in his effort to win a commission for a southern subject, the Battle of Cowpens, in the U.S. Capitol rotunda, his regional loyalties were suggested in other themes tackled during the period, such as *Patrick Henry Arguing the Parson's Cause at Hanover Court House,* circa 1834 (Virginia Historical Society, Richmond).

Dramatic themes from southern history—recent incidents as well as those from the distant past—have attracted attention from many painters, and they continue to do so to the present day. Bernice Sims, for example, was stirred by momentous events from what has

Fig. 12

GEORGE COOKE
The Coming of the Maidens as Wives for the Settlers, ca. 1830
Oil on canvas, 28 x 36 inches
Chrysler Museum of Art, Norfolk, Virginia
Gift of Walter P. Chrysler Jr.
90.67

been called "the quintessential Southern story, the civil rights movement" of the 1960s,[50] to create a memory painting recording that difficult history (fig. 13). Combining three vignettes on a single panel—a triptych format commonly associated with sacred images, but now secularized and upended, organized vertically—Sims records the 1965 confrontation of white police and black marchers at the Edmund Pettus Bridge in Selma, Alabama; police fire-hosing black marchers in Birmingham; and, in the center, the Lorraine Motel in Memphis, site of Dr. Martin Luther King's assassination in 1968. Though Sims was not an eyewitness to the

Memphis shooting, she was actively involved with the civil rights struggle in her native South; hence, for her these motifs from recent history have personal as well as a larger societal meaning.

Southern history could affect visitors as well as natives. In 1918, the Missouri artist Thomas Hart Benton was stationed with the navy in Norfolk, Virginia, near where the bride ships, the subject of Cooke's early-nineteenth-century painting, had arrived almost three hundred years before. Benton shared earlier artists' historical interests and their delight in distinctive regional traits of the American people, who by

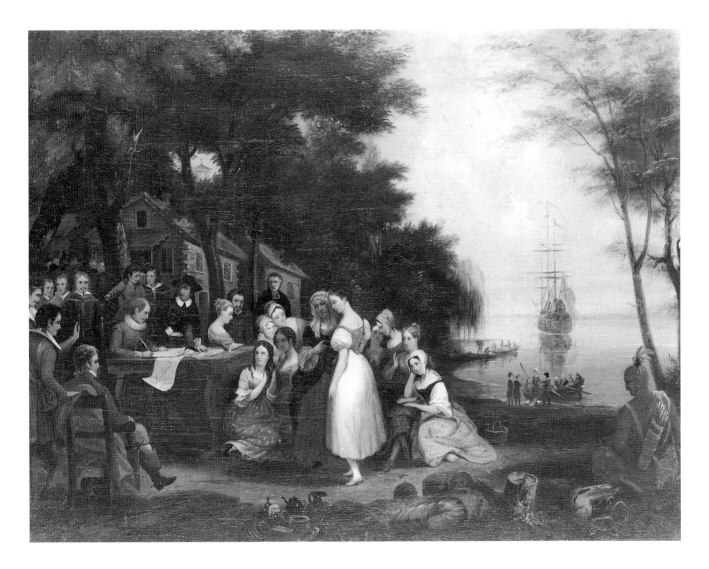

Fig. 13

BERNICE SIMS

Civil Rights Memory, 1996

Acrylic on canvas, 36 x 24 inches

Courtesy of the Tubman African American
Museum

pleted) with the collective title The
American Historical Epic. The series
was conceived in three "chapters," the
first devoted to European settlement
and conflicts with the native tribes, the
second to the conquest of the conti-
nent's mountainous interior, and the
third to the economic life of the young
colonies. It was the first chapter that
inspired Benton's *Brideship (Colonial
Brides)* (cat. no. 5), which dates from
late in the development of the cycle
(and is possibly a postlude to it).

If Powhatan and colonial brides are,
to most Americans, relatively unfamil-
iar figures, George Washington is the
opposite. His is a visage, as painted by
Gilbert Stuart and countless others,
that is so ubiquitous as to be invisible.
The good, truth-telling boy of Parson
Weems's fable; the surveyor of the
Virginia wilderness; the hero of the
Revolution, bravely leading his troops
across the Delaware, as portrayed by
Emmanuel Leutze or George Caleb
Bingham (cat. no. 7), and on to triumph
at Yorktown; an American Cincin-
natus, the squire of Mount Vernon (as
depicted by Junius Stearns, cat. no.
56); the first president and the Father
of His Country: Washington alone
provided enough of both history and
myth to occupy generations of patriotic
artists, who told and retold his life story
in paint and print.

his day were considerably more diverse
and widespread than in Cooke's. While
in Virginia, Benton conceived the
idea of painting a series on American
history. Inspired by a volume of J. A.
Spencer's *History of the United States*
and informed by his own travels across
much of the American landscape, Ben-
ton embarked on what he envisioned
as a suite of seventy-five paintings (of
which fewer than twenty were com-

5. Politics

Ralph Waldo Emerson recognized the
value of contemporary subjects for the
creative mind. He found significance
in the ordinary and the quotidian, in
"the philosophy of the street" as well as
"the meaning of household life." In his
famous essay "The American Scholar"
(1837), he wrote: "I ask not for the
great, the remote, the romantic; what is

doing in Italy or Arabia; what is Greek art, or Provencal minstrelsy; I embrace the common, I explore and sit at the feet of the familiar, the low. Give me insight into today, and you may have the antique and future worlds. What would we really know the meaning of?" he asked, and famously answered: "The meal in the firkin; the milk in the pan; the ballad in the street."[51]

Even as Emerson wrote, the meal and the ballad, the commonplace rites and sights of American life, were providing inspiration to a new generation of American genre artists. Although perhaps few in relation to those who celebrated their countrymen's mores and priorities, there were some who used their creative talents to critique the practices of the larger society. Such commentaries—in paint or print, photography or song—became especially familiar a century after Emerson's essay, during the desperate years of the Great Depression, when "social realists" decried the political and economic circumstances of the 1930s. But such socially motivated imagery had a long and noble tradition in this country, dating well back into our history. The impetus for the artist's pictorial statement—which might be propagandistic or ironic, angry or bemused—could come from within the society, or from outside but with effect felt here at home.

During the second quarter of the nineteenth century, urbanization and industrialization began the dramatic transformation of the young nation that was to culminate in great economic and political power a hundred years later. The changing aspect of American society, particularly its urban centers in the North and in newer states of the interior, was the result not only of internal migrations but of a rising tide

of trans-Atlantic immigration as well. Charles F. Blauvelt, portraitist and genre painter active in New York from the late 1840s, based several compositions on the immigrant's experience; *The Immigrants,* circa 1850 (Hunter Museum of American Art) depicts the soulful guise of the uprooted newly arrived in America, while *A German Immigrant Inquiring His Way,* 1855 (fig. 14), features a colorfully garbed veteran of the midcentury European revolutions asking help from a black laborer, to the bemusement of passersby. About the same time, Pittsburgh painter David Gilmore Blythe, himself the son of Scottish immigrants, tackled similar issues but with very different effect. In *Land of Liberty,* circa 1858–60 (cat. no. 8), the artist treats the Irish immigrant in a genre scene that suggests Blythe's familiarity with European, especially British, caricature as it had evolved from William Hogarth's time. The scene uses the title of a *Punch* illustration by Richard Doyle, and like the British cartoonist, Blythe invests his image with a heavy dose of irony.[52] The new arrival, disembarked from the ship in the background, is met by a cigar store Indian offering a peace pipe filled with "native leaf," presumably sweeter than the foul variety smoked by the immigrant. The implicit critique of Irish immigrants and of treatment of the Native American is characteristic of Blythe's reformist views, rendered in his unique style, one of the most distinctive of the mid–nineteenth century.

If race relations between whites and Native Americans provided some artists with inspiration for social commentary, those between whites and blacks, whether enslaved or freed, inspired others even more so. The Kentucky-born Thomas Noble, who trained with Thomas Couture in Paris before

returning to fight as an officer in the Confederate Army, earned appreciative notice with his postwar images of the atrocities of the slave system. *The Price of Blood,* painted in 1868 (cat. no. 50), is among his best known paintings on the racial theme, which also included *John Brown's Blessing Just Before His Execution,* 1867 (New-York Historical Society), and a trio on the history of blacks in America, the *Past, Present and Future Conditions of the Negro* (unlocated). *The Price of Blood* features a slave-owner father and his mulatto son, a subject that raises the midcentury fascination with, yet repulsion toward, miscegenation. Between them stands the slave buyer, who purchases the offspring with the gold coins stacked on the tabletop. The son's diffident air and averted gaze contrast with his hand-on-hip pose, a quotation from Gainsborough's elegant *Blue Boy* that some viewers took as an ironic, even inappropriate guise for a black. By contrast, his father-and-master's confrontational glare challenges the viewer. Behind him, we glimpse a portion of a Sacrifice of Isaac scene, in which Abraham offers up his son to Yahweh, a subject that reinforces the horror of the moment and lends poignant urgency to Noble's abolitionist theme.[53] Noble's painting, in short, is redolent of social issues that embroiled generations of Americans before, during, and after the Civil War.

The peace effected at Appomattox in 1865 paradoxically brought enormous change yet initiated the perpetuation of racial attitudes that had divided compatriots for years. The emancipation of the slaves and postwar policies of Reconstruction provided northern artists as well as former Confederates with themes for their paintings. Thomas Waterman Wood of Vermont, where he

Fig. 14

spent much of his career, had also lived in the South. It was in antebellum Baltimore that he began the genre paintings that brought him considerable notice in his lifetime, themes that he continued during his European sojourn and while living in Nashville (1859–62) and Louisville (1862–66) before returning to New York and Montpelier. His genre subjects generally extol the virtues of small-town life as he knew it in his youth in New England; within this class, however, there is a notable group of paintings of blacks, the subjects for which Wood is best remembered today—sympathetic portrayals of the freedmen and -women who elsewhere were often the subject of pictorial caricature and derision. *His First Vote* (cat. no. 68), in its focus on a single black figure, is similar to the series, *A Bit of War History* (Metropolitan Museum of Art), that Wood painted two years earlier. The three small canvases of Wood's series depicted stages in the life of a black Civil War soldier—as contraband, recruit, and veteran—and earned critical praise for their sensitivity and the story they relate: "their best qualities consist of the clearness with which they tell their story," wrote one admirer, "and the evident sympathy of the artist with his subject."[54] Wood's black voter, painted in 1868, similarly tells a story with clarity and sympathy, describing the dramatic changes during the early years of Reconstruction; but unlike the soldier portraits, which were conceived as single figures, *His First Vote* is based on a larger, multifigure composition painted the preceding year, *American Citizens (To the Polls)* (fig. 15). In that watercolor, Wood presents an optimistic tableau of the nation's diverse electorate, all of equal standing in postwar America. Four types are represented by character studies that a contemporary identified as (right to left) "the Negro with his swelling eyelids . . . the Dutchman with his face and form square-built, indicating resolution; the Irishman, his facial lines short and nose turned up indicating mirth and good humor, and the Yankee with a face full of craft, which is implied by the sharp nose and thin eyelids."[55] With *His First Vote,* Wood reprised the African American subject, which was the basis for his acclaim during his lifetime and underscored the importance of the freed black as part of the reconstituted American society.

The changes brought by Recon-

struction, which Wood sensitively and optimistically depicted, were neither universally enduring nor endearing. Jim Crow laws, enacted in the late nineteenth century and upheld in the Supreme Court's *Plessy v. Ferguson* decision of 1896, led to generations of segregation and racial strife. The Ku Klux Klan and other societies initiated a reign of terror even before Congressional reconstruction began, and although the Klan formally disbanded in 1869, its secretive program of intimidation continued well into the twentieth century.

Lamar Baker, painter and printmaker, treated these difficult racial themes in his Negro Spiritual series of 1943. Painted in New York during the dark days of World War II and taking inspiration from the social realists and regionalists of the preceding decade, the series reflects on the injustices African Americans suffered in Baker's native South. Baker admired the work of fellow southerner John McCrady, whose best-known painting, *Swing*

Low, Sweet Chariot, 1937 (St. Louis Museum of Art), may have suggested the source material for his own series even as it deterred him from tackling that well-known spiritual.[56] In *Nobody Knows the Trouble I've Seen but Jesus* (cat. no. 3), the first of the series, Baker provides a stage on which are enacted various incidents of Negro life: a police beating, Klan torture, arson, hospitalization, escape from a chain gang, baptism in a river, and, in the far distance, the hanging of a lynch victim's body from a bare tree. These vignettes surround an elaborate architectural set. A brick factory, probably a southern textile mill, and a white clapboarded church of the sort seen in rural settlements throughout the Black Belt are partially obscured by an ornate facade from whose shadowed depths emerge the cast-off shackles of slavery. The cathedral's jamb figures, in lieu of the usual medieval saints, are Africanized sculptures; above the portal, a frieze includes more standing figures and a craft like a dhow, further suggestions of

Fig. 15
American Citizens (To the Polls), 1867
Watercolor on paper, 18 x 36 inches
T. W. Wood Gallery and Arts Center,
Montpelier, Vermont

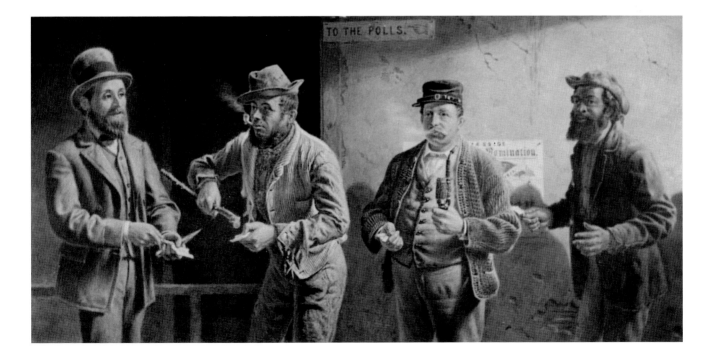

distant cultural origins. In the gable, a circular inset presents a black man and woman isolated on a patch of ground, waiting with Job-like patience for deliverance from the troubles they've seen, as an angel swoops in to deliver divine intervention via modern telephone. Jesus is calling.

Gertrude Abercrombie responded to the racial politics of the modern era with a similar intensity. *Charlie Parker's Favorite Painting*, 1946 (cat. no. 1), is part of a sizable group of paintings dealing with lynching. That grim subject motivated many American artists from early in the twentieth century, reflecting a preoccupation with incidents of racial discrimination and injustice. But instead of Baker's narrative constructed through multiple vignettes, Abercrombie's is stark in its simplicity. With no representation of human form, dead or alive, it is even more radically minimal than Jacob Lawrence's treatment of the subject in his Migration series, *"Another Cause Was Lynching . . ."* (1940–41; Phillips Collection), which included a hunched figure grieving beneath an empty noose. On Abercrombie's empty stage, illuminated by silvery moonlight that gives it a dreamlike, even surreal effect, a bare tree, noose, and ladder tell the story of another casualty in the racial strife that sadly provided the occasion for pictorial protests by generations of American artists.

6. Agrarian America

"Those who labor in the earth are the chosen people of God."[57] So wrote Thomas Jefferson in his *Notes on the State of Virginia* (1784). In *Letters from an American Farmer*, published only two years earlier, French émigré Hector St. John de Crèvecoeur concurred. Describing the young American society, he wrote that, with "some few towns excepted, we are all tillers of the earth, from Nova Scotia to West Florida." It was this work in the soil, this closeness to nature, this democracy of tillers that made America's "the most perfect society now existing in the world."[58]

The Jeffersonian ideal of the yeoman farmer had a long hold on the American imagination, perhaps nowhere more so than in Jefferson's native South. The manifesto of the Southern States Art League, established in 1928, called for artists to celebrate "those relations to the soil which have made us what we are."[59] Two years later, at Nashville's Vanderbilt University, a group of writers calling themselves Twelve Southerners voiced similar concerns in their manifesto, *I'll Take My Stand*, a landmark in American letters and regional identity. Opposed to the dehumanizing encroachments of modern industrialization and urbanization, the Twelve took a stand in Dixieland and looked away from the present. Theirs was a clarion call for a return to the values of an agrarian, Jeffersonian past. "Suddenly we realized to the full," wrote Donald Davidson, one of the Vanderbilt Twelve, "what we had long been dimly feeling, that the Lost Cause might not be wholly lost after all. In its very backwardness the South had clung to some secret which embodied, it seemed, the elements out of which its own reconstruction—and possibly even the reconstruction of America—might be achieved."[60]

Davidson, like his Vanderbilt collaborators, decried "an industrialized society [that] will extinguish the meaning of the arts, as humanity has known them in the past." He saw the arts, in all their rich variety, as the products of "societies which were for the most part stable, religious, and agrarian . . . where men were never too far removed from nature to forget that the chief subject of art, in the final sense, is nature."[61] Or as another of the group put it when contemplating modern, industrialized agriculture, "A farm is not a place to grow wealthy; it is a place to grow corn."[62]

The agrarian life and the American farm were not, of course, unique to the South, but rather provided a common basis for the development of American culture from its colonial period well into the nineteenth century. About 1850, Jerome Thompson began garnering kudos for his genre paintings of rural life, predominantly picnic and harvest scenes that distinctively combined figurative groups in idyllic landscape settings. His *Noonday in Summer*, 1852 (cat. no. 61), is a typical example. These celebrations of the virtues of rural life appeared at a moment of rapid transition for American agriculture and, with it, American society. Urban centers, the home to an expanding industry, were growing in number and size, drawing populations from the countryside and immigrants from overseas; by 1850, the annual output of our mills and factories surpassed the value of American agricultural products.[63] Thompson's pastorals were, then, a purposeful anachronism, a nostalgic return to once-upon-a-time designed for and marketed to audiences of urban professionals, not to the farmers themselves. The nostalgic note of *Noonday in Summer* anticipated a post–Civil War outpouring of such rustic reveries. Winslow Homer's *Song of the Lark*, 1876 (fig. 16), for instance, is a Centennial-year paean to the agrarians who had shaped the nation. The impetus continued into the next decade, when William Bliss Baker painted

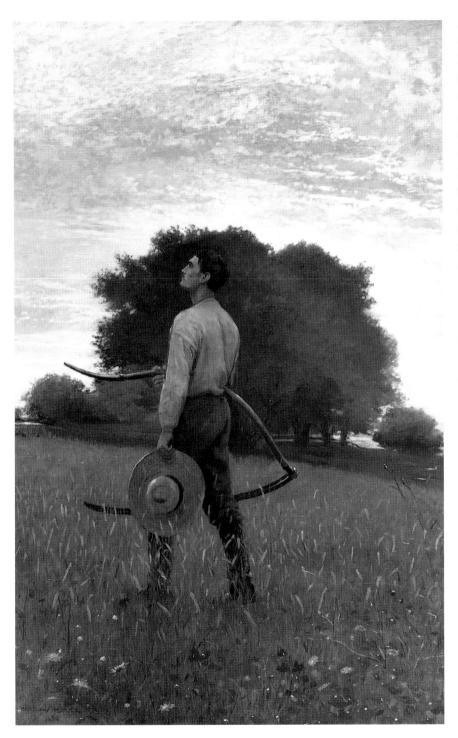

Fig. 16
WINSLOW HOMER
Song of the Lark, 1876
Oil on canvas, 38⅝ x 24¼ inches
Chrysler Museum of Art,
Norfolk, Virginia
Gift of Walter P. Chrysler Jr.
83.590

Hiding in the Haycocks, 1881 (cat. no. 4). The children who play in Baker's haycocks—who play *at* rural life—are far removed from the field labors depicted in rustic genre scenes of a half century earlier. Roxana Barry found significance in the youthful populations of such late-century scenes as Baker's. Equating the children with innocence and associating the farm setting with an earlier epoch, she noted, "To the sophisticated audience, these children in rustic landscapes represented their own lost innocence, and by extension, that of the country itself."[64]

The decline in rural populations and the eclipse of agrarian traditions had begun even before the Civil War. "Once upon a time . . ." began an 1858 *Harper's Weekly* story about a dying farm town in rural Connecticut, "no less than three 'stores' made it a place of commercial importance. But this Augustan age has passed forever. In the valleys round about thriving factory villages have sprung up, and business has slid down into them."[65] The "slide" away from an "Augustan" era of rural communities and country stores, the transition from field to factory, continued through the nineteenth century and into the next, gathering momentum in the years following World War I. Industry offered new economic opportunity to legions of southern blacks, drawing them to northern cities, and in the process transforming both their former homeland and burgeoning urban centers from New York to Pittsburgh, Chicago, and beyond.

In the 1930s, the agrarian ideal was further challenged by catastrophic Dust Bowl conditions in the nation's heartland and by crop failures elsewhere. For many farmers, the toil of reaping and harvesting became a struggle for survival, one that many

lost. Many of those who remained on the land faced deprivations and hardship, and their trials provided subjects for artists. George Biddle, for one example, painted *South Carolina Landscape* in 1931 (Columbia [S.C.] Museum of Art); his experience of the blighted rural landscape may subsequently have helped shape his concept for federal relief programs for artists, which his friend, President Franklin D. Roosevelt, implemented soon after his inauguration in 1933. The hardship was especially acute for landless southern sharecroppers, such as the white Mississippi pair painted by Marie Hull (cat. no. 35) or the African American subject in Jacob Lawrence's *The Plowman* (cat. no. 40). In his typical fashion, Lawrence reduced the elements of his little picture to simplified patterns of man, mules, and land. "The more you reduce something," he once explained, "the more it can become suggestive, dynamic."[66] Painted in 1942, immediately after the completion of his best-known work—the Migration series of sixty panels depicting the exodus of southern blacks—*The Plowman* is a separate and unique piece, not part of an extended narrative scheme. But it shares with the Migration images a distinctive modernist style and the empathetic relation to his racial subject. Both diminutive man and oversized beasts bow to the burden of turning ground; the curious overhead vantage causes the land behind them to heave upward in a striated pattern suggesting both abstract design and the patterns of contour plowing, then being advocated for land conservation. In a single and somber panel, Lawrence is able to summarize the difficult plight of the beleaguered sharecropper, far removed from Jefferson's divinely favored yeoman farmer.

Other visions of rural America from the same decade suggest the transformation of that arena, once the locus of democratic virtues and strength. The pastoral landscape grows nightmarish in Carlos Moon's *Moonlight on Pickle Hill,* ca. 1948 (cat. no. 48). The artist explained that his conventional depiction of the landscape failed to express what he felt on coming upon this hill around a curve in the road. He therefore exaggerated its height and the narrowness of the rise—as well as the spooky clouds and rickety buildings—to produce "something that looks like a picture out of a fairy book."[67] But this is no comforting country tale; Moon does not deal in the happily-ever-after. The scene is veiled in the mysteries of night. A skeletal scarecrow replaces the human presence in a Charles Addams–esque landscape of agitated, writhing forms. In this scene, farm structures totter, suggesting the instability of agrarian tradition. The peace and prosperity implied by Thompson's antebellum harvest here yield to anxieties of the Cold War era transferred to the rural landscape.

Robert Gwathmey made his reputation with depictions of the rural South, particularly of its African American population. Gwathmey painted *Marketing* (cat. no. 27) in the difficult years of World War II, as rural America, particularly in Gwathmey's native South, struggled with problems of race and caste aggravated by war and a troubled economy. A product of his early career, *Marketing* precedes his familiar mature style of stylized dark linear patterns; yet like his later, socially engaged works and like the works of his friend Jacob Lawrence, it features an African American. (Gwathmey rather enjoyed being referred to as the "white Jacob Lawrence.") When he

returned to Virginia after his first trip out of the region, he "was shocked by the poverty. The most shocking thing," recalled Gwathmey, "was the Negroes, the oppressed segment" of American society.[68] In *Marketing,* a lone black man—to judge from his dress, a farmer or sharecropper—stands outside a rude structure, a rural store; beside him, a mislettered sign invokes the complicated symbolism of the apple: the temptation in the Garden, the symbol of harvest bounty, the ubiquitous offering of impoverished Great Depression–era vendors. Empty cans, the detritus of modern commerce, litter the hard red ground from which a single corn stalk struggles to emerge. The side of the building is plastered with commercial advertisements, appropriations from the popular culture that Gwathmey used similarly in numerous works to provide a poignant contrast of have-not subjects with their materialistic surroundings. The tattered posters, suggestive of time's ravages, promote various enticements seemingly remote from the sharecropper's hardscrabble existence. Many of these have symbolic associations that inform and enrich the narrative implicit in the painting: Coca Cola (a southern product) and (southern fried) chicken; a blonde siren from the movies' dream world; the number "666," referring to a favorite southern elixir—for Gwathmey, a metaphor for the region's self-deception—but also the apocalyptic symbol for the Antichrist (Revelation 13:18); a circus poster with lion and elephants (like the black man, with origins in Africa) of the sort that reappeared the following year in *Bread and Circuses* (Museum of Fine Arts, Springfield, Mass.), whose lone black man, struggling corn crop, and rickety building are all prefigured in *Marketing*. With a striking economy of

means, Gwathmey tells of the suffering economy and impoverished dreams of rural America at the mid–twentieth century.

7. *Urban America*

The promise of America, early envisioned by Jefferson and Crèvecoeur in an agrarian, rural society, was redefined in the nation's booming cities and suburbs by the middle of the twentieth century. If well-being had abandoned rural America by that date, if noble tillers of the soil had been eclipsed by new legions of production-line workers and a burgeoning middle class, the transition was neither sudden nor, to many urban denizens, unwelcome. One hundred years earlier, a sense of that trajectory, already under way, had infused the rural idylls of Jerome Thompson and his contemporaries with their distinctive notes of nostalgia.

By the start of the twentieth century, marketing—and daily life—in urban America was very different from that in its rural precincts. And the excitement of the crowded cities captured the attention of artists such as George Luks and his fellow members of what came later to be known as the "Ashcan school" due to their proclivity for urban motifs. In Luks's *Allen Street,* circa 1905 (cat. no. 42), the marketing takes place on the crowded street in New York's lower East Side immigrant neighborhoods. Piles of goods—colorful textiles, furniture, brassware, and framed pictures—attract the attention of female shoppers. In the second-story windows of a dressmaker's shop, slender mannequins draped in colorful fabrics contrast with the bulky and largely monochromatic immigrant women on the street, suggesting different traditions in dress and different economic status.

Also contrasting with Luks's women are those who provide the subject for Kenneth Hayes Miller's *Shoppers* (Weatherspoon Art Gallery, Greensboro) and for a large canvas by Luks's fellow Ashcan painter, William Glackens (cat. no. 24). Their shoppers make their purchases uptown and indoors, in the expensive emporia that catered to a new class of affluent urban dwellers with discretionary income and leisure time. Although Miller and Glackens featured American women shopping, the lure of the marketplace was not confined by gender or geography. For example, the narrator of H. G. Wells's novel *Tono-Bungay,* which dates from the same period as the Glackens painting, found himself and his family part of "that multitude of economically ascendant people who are learning how to spend money." His British uncle excelled at the pastime, becoming "a furious spender; he shopped with large unexpected purchases, he shopped like a mind seeking expression, he shopped to astonish and dismay; shopped *crescendo,* shopped *fortissimo, con molto espressione.*"[69]

The central figure in Glackens's *The Shoppers* is the artist's wife, Edith Dimock Glackens, an artist in her own right and the wealthy daughter of a Hartford tycoon; at the right is Mrs. Everett Shinn, wife of another Ashcan painter. Their fashionable garb, and the prominent positions of their purses, suggests the good life. As analyzed by David Curry, the painting tells much about the changed character of city life, about new fortunes in the new century. He notes that the shop girl holding the lingerie for the ladies' scrutiny wears a brooch at her neck, "emblematic of rising fortunes, while a shadowy figure of a woman in the background may signify the waning of a centuries-old system of close bargaining between buyer and seller. This woman . . . wears a subdued outfit that is eclipsed by the splendid hats and cloaks of the Mmes. Glackens and Shinn. Holding one gloved hand to her chin, she seems to contemplate a parallel eclipse of the old way of doing business."[70] An apparently simple moment of shopping reveals much about the new urban mores that were to dominate in a changed twentieth-century America.

Glackens's broad stroke and dark palette, which were characteristic of his early works, recall paintings by Velázquez or Édouard Manet, both of whom were greatly admired by modernists at the turn of the century. Later, in urban scenes like *The Green Car,* 1912 (Metropolitan Museum of Art), and in portraits and still lifes, Glackens resorted to the more delicate touch and broken stroke of the impressionists, particularly Renoir. Impressionist painters, in both France and America, discovered in the city multiple inspirations for their art, a congruence of modern metropolitan motif and modern artistic style. William Merritt Chase was among the first to seize such opportunities in the American city. Beginning in 1886, he delighted in painting the New York cityscape, particularly the public spaces that had been created in Manhattan and Brooklyn parks. In *An Early Stroll in the Park,* circa 1890 (fig. 17), he celebrated Frederick Law Olmsted's landscape art, as well as Emma Stebbins's sculpture of the Bethesda Fountain. The scene took on contemporary significance as well: the area depicted had lately been refurbished and the fountain's hydraulics updated, suggesting that the white-gowned stroller is symbolic of the purity of Central Park's waters and, in a larger sense, the restorative powers of Central Park's urban oasis.

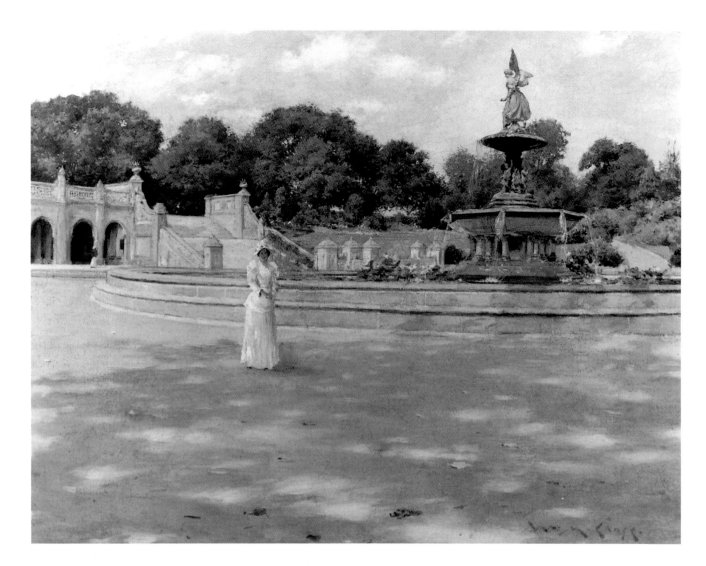

Fig. 17

Impressionist technique that served Chase so well in his paintings of Central and Prospect Parks was also employed by his associate Childe Hassam. During World War I, Hassam, inspired by patriotic displays in New York City, embarked on a series of flag paintings, to which *Avenue of the Allies (Flags on the Waldorf),* 1917 (cat. no. 29), is conceptually and formally related (although never exhibited as part of the series). Here, towering structures, rendered with flickering stroke, provide a backdrop for the varicolored banners of the allies, Britain, France, and the United States dominating the foreground. Beneath these large and colorful forms, the street level is crowded with urban masses simply rendered in elongated vertical strokes that rhyme with the building's columns and the stripes of Old Glory. Though the young modernist Albert Gallatin applauded the manner in which Hassam's flag paintings captured New York's "bannered beauty," he faulted the older artist because "in none of them does there appear among the crowds a soldier or a sailor [which] would have given a certain note" of patriotism and truth.[71]

Despite the light and colorful flag subject, there is a density and compactness to Hassam's painting that reflects the nature of urban space that by the twentieth century was home to an

increasing number of Americans. This spatial quality could be expressed in figurative terms as well as architectural, and it could be found also in the El or the subways, both favorite subjects of New York's urban scene painters. About 1910, in *The Under World* (fig. 18) Samuel Woolf painted a diverse cast of urban characters—uniformed bellhop and public servant, young parents with children, fashionably dressed nocturnal celebrants—who speed through the subterranean darkness in a democratic vehicle that, by that date, traversed boroughs, bringing together passengers of various classes and races. A generation later, Reginald Marsh captured an even more diverse crowd of passengers in *Subway—14th Street* (cat. no. 45); shop girls and clerical workers of the "pink collar" trades, African Americans, an aged Jewish gentleman, and other ethnic types populate Marsh's city scenes, suggesting the transformation that immigration, transportation, and commerce brought to the modern metropolis.

The city as subject has inspired numerous artistic responses, from abstractions by various visitors; to the immaculate architectural forms of precisionists like Charles Sheeler or Charles Demuth; to the social concerns of realists like Ben Shahn or Jack Levine; to Edward Hopper's haunting images of city buildings and their occupants (fig. 19); to the imaginative fantasies of surrealists and their allies, including O. Louis Guglielmi. Levine's *City Lights*, 1940 (cat. no. 41), and Guglielmi's *Tenements*, 1939 (cat. no. 25), provide striking responses to the urban scene at the end of the Great Depression. The former focuses on huddled human forms, rendered with agitated, expressive strokes and topped by a death's head, suggesting a somber

Fig. 18
SAMUEL J. WOOLF
The Under World, ca. 1909–10
Oil on canvas, 22½ x 30½ inches
Virginia Museum of Fine Arts, Richmond
Museum purchase, with funds from a
private Richmond foundation
95.101
Photo: Katherine Wetzel, © Virginia
Museum of Fine Arts

Fig. 19
EDWARD HOPPER
New York Office, 1962
Oil on canvas, 40 x 50 inches
Montgomery Museum of Fine Arts,
Montgomery, Alabama
The Blount Collection

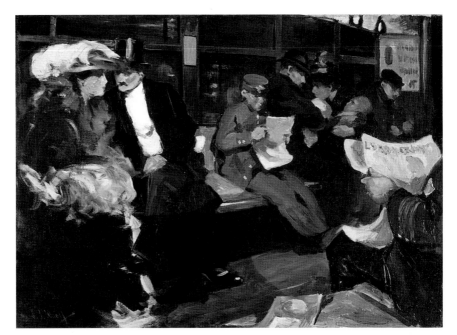

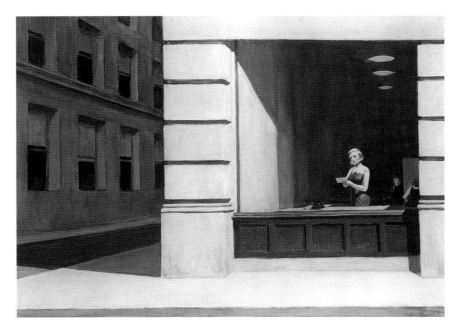

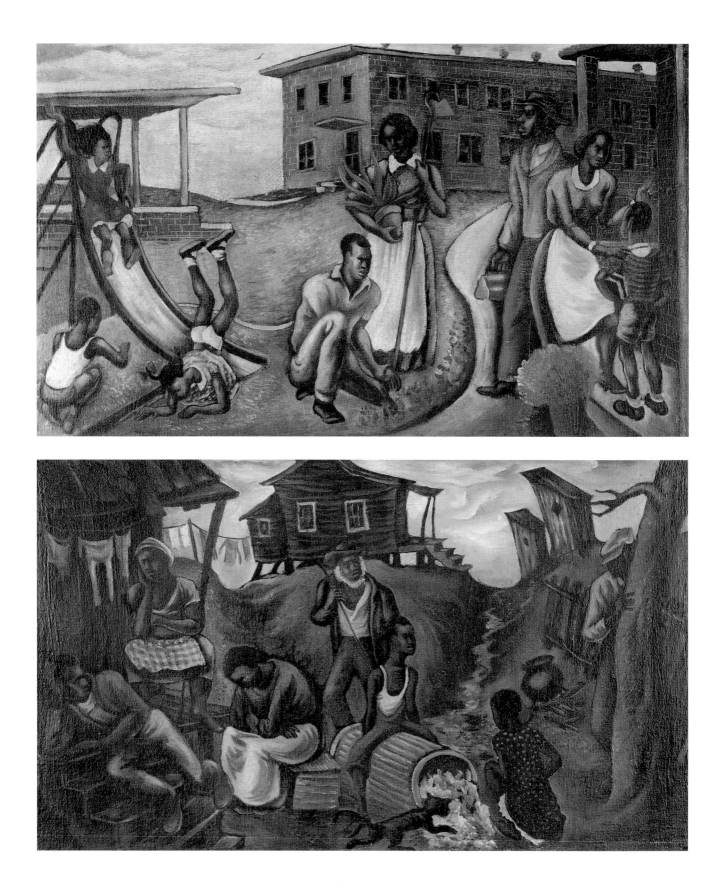

Fig. 20

Fig. 21

view of the city scene. Guglielmi's impression of the metropolis is equally funereal, but rendered without the human form. Human concerns, however, are implied through the vacant dwellings crowned with funeral wreaths and in the parade of coffins that leads across the street and into the picture. It is a strange design, one that Guglielmi repeated in *One Third of a Nation* (Metropolitan Museum of Art). Both of Guglielmi's works were likely inspired by Franklin Roosevelt's second inaugural address in March 1937, in which the President railed against the vision of "one-third of a nation ill-housed, ill-clad, and ill-nourished."[72] The issue and Roosevelt's stirring rhetoric inspired other creators, resulting, for instance, in the stage play *One Third of a Nation,* which advocated federal action to improve substandard housing, and in Hale Woodruff's didactic pair of paintings, *Results of Good Housing* and *Results of Poor Housing,* circa 1941–43 (figs. 20–21); but none was as incomparably strange and memorable as Guglielmi's surreal view of modern urban life, or death.

8. Community

The figures who crowd the urban scenes of William Glackens and the Ashcan school, of Reginald Marsh and countless other painters of the city scene, may interact, may constitute a community. Or, like those in Edward Hopper's views, they may not. "The lonely crowd" had roots in the urbanization of the United States beginning well before David Riesman so characterized it in his best-seller of the Cold War years.[73] As described by sociologist Michael Harrington, mid-twentieth-century American life might be,

and often was, "lived in common, but not in community."[74]

If sometimes lacking in modern cities, the ideal of community has elsewhere long been a powerful motivation in human society. "No man is an island," John Donne reminded us. The fellowship of the like-minded has been celebrated in song and verse, in paint and prose for generations. "What life have you if you have not life together?" asked T. S. Eliot. "There is no life that is not in community."[75] D. H. Lawrence voiced a similar ideal. "Men are free," he wrote, "when they belong to a living, organic, *believing* community, active in fulfilling some unfulfilled, perhaps unrealized purpose. Not when they are escaping to some wild west."[76] While Lawrence's believing community might differ in some particulars from Eliot's moral gathering, both writers sought the realization of their ideal in human association, not isolation.

So too did Walt Whitman. Concluding a remarkable inventory of individuals and types, Whitman the democrat asserted:

*And these tend inward to me, and I tend
 outward to them,
And such as it is to be of these more or less
 I am,
And of these one and all I weave the song
 of myself.*

The poet contains multitudes: "In all people I see myself, none more and not one a barley-corn less."[77] Out of the many, he discovers the self. As with political entities, so too in associations of sentiment; the statesman's *E pluribus unum* becomes the poet's *E pluribus ego.*

Whitman's merger of self and multitudes, like his "barbaric yawp," had no equals in American letters. But

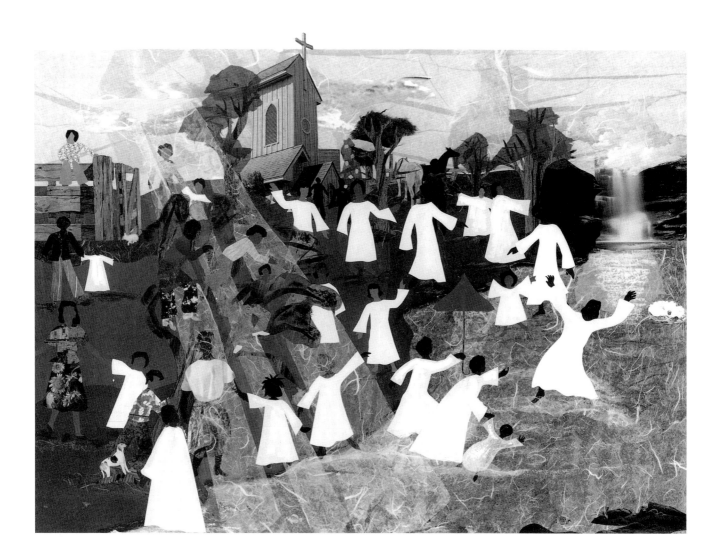

Fig. 22

ALLEN STRINGFELLOW
Red Umbrella for the Youth, 1994
Mixed media on Arches paper, 23⅛ x 30⁷⁄₁₆
inches
Muscarelle Museum of Art, College of
William and Mary, Williamsburg, Virginia
Gift of Essie Green Galleries with the
permission of Allen Stringfellow
E1996.005

the communitarian ideal toward which he strove, as did Eliot and Lawrence, was manifest in many forms in the American experience. A shared faith, profession, or education; race or class; gender; or mere propinquity—the catalysts for such affiliations are numerous. And notwithstanding the stereotype of the starving artist alone in the garret, creative types often coalesced in such groups. Some were bound by social and professional affiliations, such as the denizens of New York's Tenth Street Studio Building or of early-twentieth-century art colonies; members of artistic fraternities; or simply those who shared stylistic persuasions. Other

communities were drawn together by utopian ideals, from Bronson Alcott's Fruitlands experiment to the Oneida colony or the Roycrofters, both based in upstate New York, to hippie communes of the 1960s and beyond. Not surprisingly, depictions of such communities or communal activities often occupied American artists.

In his painting based on the Negro spiritual *Nobody Knows the Trouble I've Seen* (cat. no. 3), Lamar Baker included a vignette of a baptism ritual in a southern stream. It is a subject that has occupied a number of painters, both in Baker's day (for example, J. Kelly Fitzpatrick, William H. Johnson, Cle-

Fig. 23

PETER HURD
Baptizing at "Three Wells," ca. 1937
Tempera and oil on masonite panel,
21 x 29⅝ inches
Georgia Museum of Art, University of
Georgia
Eva Underhill Holbrook Memorial
Collection of American Art, gift of
Alfred H. Holbrook
GMOA 1945.52
Photo by Michael McKelvey

mentine Hunter) and our own (fig. 22). Immersion figured in white congregations as well as black, and in places far from the South, providing subject matter for John Steuart Curry's famous *Baptism in Kansas,* 1928 (Whitney Museum of American Art), and Peter Hurd's New Mexico scene, *Baptizing at "Three Wells,"* circa 1937 (fig. 23). These modern examples were preceded by a century or more in *Baptism in Virginia,* 1836 (cat. no. 54), an early work by W. T. Russell Smith. Smith witnessed the event while he was in the nation's capital on an assignment with the old Washington Theatre to paint scenery, a field in which he enjoyed renown. He depicted the baptism with great attention to details of the landscape—another of his specialties—par-

ticularly evident in the trees that tower over the fashionably dressed congregation gathered at the river.

Jacob Marling, the first professional artist to practice in Raleigh, North Carolina, documented a seasonal ceremony at the Raleigh Academy in *The Crowning of Flora,* 1816 (cat. no. 43), one of the earliest pictorial records of the education of young women in the young republic. The academy trained both boys and girls but did so separately. Marling portrayed the May Day crowning of Flora, festivities that were subsequently reported in a Lynchburg, Virginia, newspaper; the journalistic account parallels Marling's painting in key details, permitting us to identify the speaker addressing her classmates and the May Queen being decked

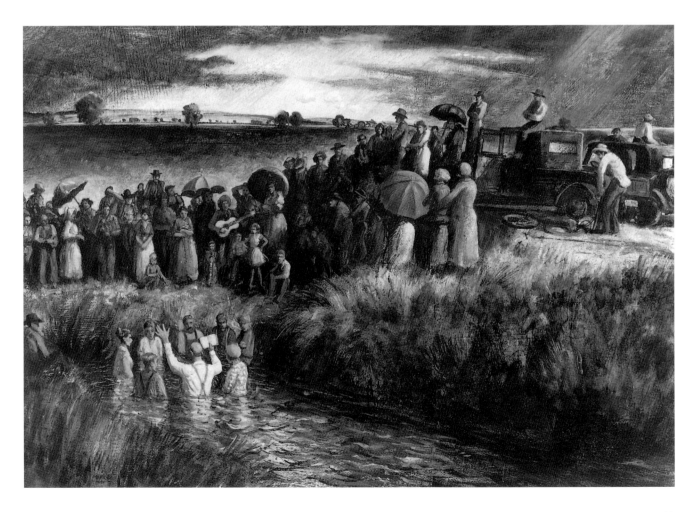

with flowers. Other precisely drawn details—the weather vane and cupola of North Carolina's first statehouse, the red brick of the first State Bank of North Carolina, the music master with instrument—further suggest the artist's pains to document the scene faithfully.

Also concerned with education, but depicted in a more impressionistic, less documentary manner, is William Wotherspoon's sun-dappled *Scene outside a Southern Schoolhouse* (cat. no. 69). The education of young black children, such as Wotherspoon depicted, would have been unlikely in the antebellum South, when literacy among slaves was discouraged; the subject, as well as the sparkling plein-air style, suggest a postwar date, in the late 1860s or later in the artist's life (1821–1888).

The quasi-impressionist manner of Wotherspoon's painting clearly places it later than W. S. Hedges's outdoor scene *A Race Meeting at Jacksonville, Alabama*, 1841 (cat. no. 30), in which details of the festive crowd, the coursing thoroughbreds, and especially the towering clouds are all crisply drawn. This sporting picture documents an early race—perhaps the inaugural—of the Jockey Club in Jacksonville, one of several such clubs that flourished in Alabama and throughout the South in the mid–nineteenth century. The Jacksonville group was made up of horse breeders who used the annual races as promotion for their stock's abilities. As evident in Hedges's view, the races were lively affairs that drew the attention of large crowds, including journalists as well as painters. A newspaper account that detailed the event confirms the essentials of the painting: "There was a half mile or more of low buildings, stables and jockey's quarters; and all about were the pleasure loving crowds, the fashionably dressed

and the poorly clad, mingling in a kaleidoscope of controlled confusion. In the judges' stand were the moguls of the racing circles, their eyes turned to the mile long oval of the tract, to the rippling-muscled thoroughbreds pitting speed against steed as they thundered down the track to the roar of the crowd."[78]

Nothing is known of the artist Hedges, nor of the circumstances surrounding this painting's creation. It might have been commissioned by a Jockey Club member as a memento of the Jacksonville races or as promotion for the event. The painter clearly was familiar with British sporting pictures, a genre that flourished in the eighteenth and early nineteenth centuries; beyond the general source for Hedges's subject, British paintings also provided specific details, such as the nearly airborne steeds (as they were commonly depicted before chrono-photography allowed analysis of the animal's body position at a full gallop) and the counterclockwise direction of the race. (The artist may even have been a Briton traveling in America, as a number of Europeans did in the 1830s and '40s, a surmise suggested by the painting's English provenance.) More than any "British" aspect of the scene, however, what seems most striking today is the depiction of an antebellum crowd in which blacks and whites seem to mingle easily, which was not always the case in Alabama or elsewhere in the United States.

A century later, crowds of mixed races appeared in the urban scenes of Reginald Marsh and other New York painters. In Marsh's *Lifeguards*, 1933 (cat. no. 44), the bronzed gods of Coney Island or Far Rockaway preside over a scantily clad assembly of bathers, black and white. The painting—

strongly pyramidal, and stable, nearly classical, in its composition—features a summertime community worshiping sun and surf and fine physique.

While Marsh's beach scene might be considered typical of shores in any metropolitan coastal area, John Mc-Crady's city crowd motif is decidedly localized in its references. *The Parade*, 1950 (cat. no. 47), depicts the annual Mardi Gras festivities in New Orleans, the artist's home for more than thirty years. In 1938, McCrady was instrumental in founding A New Southern Group, an association of New Orleans artists who favored motifs of regional significance. In line with this priority, some of his works were inspired by Negro spirituals (including *Swing Low, Sweet Chariot*) and biblical tales, and many of them depict the southern black, rural or urban. In *The Parade* his attention is directed to the city, New Orleans at its most famous and flamboyant moment of Mardi Gras. The pre-Lenten festivities provided the subject for several paintings and prints in the late 1940s, as well as masks that the artist fashioned for the annual frolic. *The Parade* juxtaposes the streetscape of krewes and revelers with interior spaces of the artist's studio building. McCrady also used the curious device of a cutaway structure in *I Can't Sleep* (Morris Museum of Art), which he began in the mid-1930s but did not finish until 1948. The cutaway had appeared earlier in various works by other artists. Diego Rivera, for example, used it as a compositional device in murals, such as the one at the San Francisco Art Institute (1931). American easel painters also used the transparent or missing wall in their works, where it seemed surreally to divide past and present or dream and reality, or more generally to represent depression-era

decrepitude.[79] In McCrady's case, the missing wall reveals the private creative precinct of the artist's studio, where a painter (presumably McCrady himself) concentrates at his easel, in contrast to the communal celebrations one floor above and outside in the Vieux Carré.

The painter at his easel amid the gaiety of Mardi Gras suggests a level of concentration, and sometimes isolation, required for his art. In her *Café Fortune Teller*, 1933 (cat. no. 2), Mary Aiken painted a divinator similarly apart from a crowd—in her case, the working-class patrons of a Spanish bar. The difficulties of global economic collapse reached even to the sunny Mediterranean isle of Ibiza, where Aiken spent two years in the early 1930s, following art studies in Madrid and as she began her professional career. As an American who spoke no Spanish and a woman in the masculine world of the café, Aiken may have identified with the lone woman in her composition; whether or not she intended the pun, the fortune-teller, seen from the vantage of the painter-client, is, like the visual artist, a seer. Fate, forecast in the chance turn of a card, was queried in the midst of the anxious era's economic and political uncertainties, when foretelling the future would have been a special gift, indeed.

At earlier periods of cultural anxiety, other artists had turned to representations of Fate—sometimes personified as the Roman goddess Fortuna, sometimes as a Greek oracle, sometimes as the mysterious Sphinx—as if answers to the uncertainties of their age might be found there. Elihu Vedder was early to explore such mysterious and emotionally charged imagery, as in his *Questioner of the Sphinx*, 1863 (Museum of Fine Arts, Boston). From the late 1870s, he was compelled by the

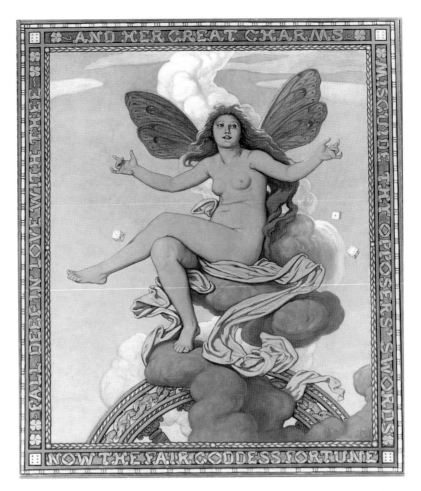

figure of Fortune, a theme that led him to explorations of iconography, the language of symbols. This preoccupation culminated in his large canvas of a winged figure who sits atop a wheel of fortune showering dice, the symbols of chance, upon the world below (fig. 24). (The dice replaced what Vedder called "'good luck' pearls" that fell from Fortune's hands in earlier compositional studies.)[80]

Over the course of the nation's history, Fortuna or Lady Luck was often invoked, particularly during moments of stress. Vedder's preoccupation with the subject climaxed in the anxious atmosphere of the fin de siècle, having begun in the uncertainties of Civil War and its aftermath. The mid-1870s, when Vedder's fascination with the subject blossomed, were difficult years, both

Fig. 24

ELIHU VEDDER

Fortune, 1899

Oil on canvas, 82 x 69 inches

Collection of The Speed Art Museum, Louisville, Kentucky

Gift of Mrs. Hattie Bishop Speed

1929.29.1

for the artist and for the nation at large, punctuated by the collapse of Reconstruction and the financial panic of 1873, which led to a depression lasting three years. In the midst of this political and economic calamity, the search for good luck took on new urgency.

It did so again during the difficult years surrounding World War I, when George Luks, for instance, painted his *Fortune Teller,* 1920 (Memphis Brooks Museum of Art). In the drear years of the Great Depression the quest for Fortune appeared (in the American vernacular) as a crapshoot, a subject for several prominent artists of the period. Earlier in the century, craps and games of chance had figured prominently in James Weldon Johnson's novel, *The Autobiography of an Ex-Coloured Man* (1912), in which the narrator, newly arrived in New York City, is seduced by "the caprices of fortune at the gaming table," particularly "the ancient and terribly fascinating game of dice, popularly known as 'craps.'" Enchanted by tossing dice, accompanied by the players' "mystic incantations," the newcomer succumbs, with predictable outcome. Only after surviving the giddy highs and lows of the gambler's life—"that dark period"—did the narrator escape, to "look back upon the life I then led with a shudder. . . . But had I not escaped it," he preachily concluded, "I should have been no more unfortunate than are many young coloured men who . . . fall under the spell of this under life" that leaves "will and moral sense so enervated and deadened."[81]

Of course, Johnson's narrator need not have left his native South to discover the game that seemed universal by the time Thomas Hart Benton sketched African American deckhands shooting craps on a Mississippi River boat in 1928. Benton's initial pen-and-ink sketch became parent to a group of images in watercolor and an eventual oil (Nelson-Atkins Museum of Art); the crapshooters subsequently resurfaced in a vignette in Benton's *Arts of the South* (New Britain Museum of American Art), part of his mural cycle The Arts of Life in America, originally painted for the Whitney Museum in 1932. Four years later, in Charleston, South Carolina, Andrée Ruellan painted eight blacks engaged in a game of craps (fig. 25). Christopher Clark also turned to the subject in 1936, when he painted *The Crapshooters* (cat. no. 16) in Tampa, Florida. Five black players, pivoting around the central blue-shirted man, are drawn and brushed with precision, their muscular contours and lively poses suggesting affinities with Benton's "bumps and hollows" manner of figurative drawing. Clark was among the team of muralists assembled by Donald Deskey to decorate interior spaces in Radio City Music Hall, and the crisp contours of Clark's figures suggest the influence of the stylization evident in that Art Deco landmark. Like Reginald Marsh, Ben Shahn, and other social realists of the period, Clark used newspaper headlines to provide a commentary on his subject; in this case an ironic note is introduced as one gambler tosses a lucky seven across a headline that reports [J]URY PROBES VICE.

Clark's *Crapshooters* has been called an example of the regionalist art that flourished in the 1930s.[82] The claim is reinforced by the general setting, and more so by the specific Tampa journal upon which dice and dollars lie. But in a larger sense, and perhaps paradoxically, the painting of Florida gamblers presents a tale universal in its connotations. Like Aiken's Ibiza café scene, it deals with a particular time and place but also with the larger issues of fate and fortune, so elusive across this nation and abroad during the troubled 1930s.

The figures in Marie Hull's *Share-croppers,* 1938 (cat. no. 35), were certainly short on luck and fortune. The pair were part of a group of figure studies made of destitute farmers in Hull's native Mississippi during the bleakest years of the depression. Her out-of-luck sharecroppers and tenant farmers were rendered with a sensitivity worthy of Walker Evans, as in his photographs of the rural poor from the same troubled time and region: closely observed, with details telling of hard labor, yet with a sense of human dignity intact.[83] The models for this painting captured the artist's eye and her sympathy; they had been reduced to wandering around Jackson sharpening scissors or performing other menial day jobs for meager pay until hired by Hull to pose for her series of approximately twenty Sharecropper paintings.

The hard times of the 1930s were not peculiar to the South, but rather were felt across the nation, including New Mexico. There, in 1935, Walter Ufer painted *Bob Abbott and His Assistant* (cat. no. 62), the last major canvas by this early member of the Taos art colony. The artist initially referred to this portrait of his good friends—auto mechanic Abbott and Jim Mirabel, a member of the Taos Pueblo and Ufer's longtime model and assistant—as *Two Workers,* a designation that suggests equality between the subjects. It was in Abbott's repair shop on the Taos Plaza that Ufer and his friends would while away many hours drinking and gambling. Such pursuits led to Ufer's deteriorated health and finances by the time of the 1935 painting, which

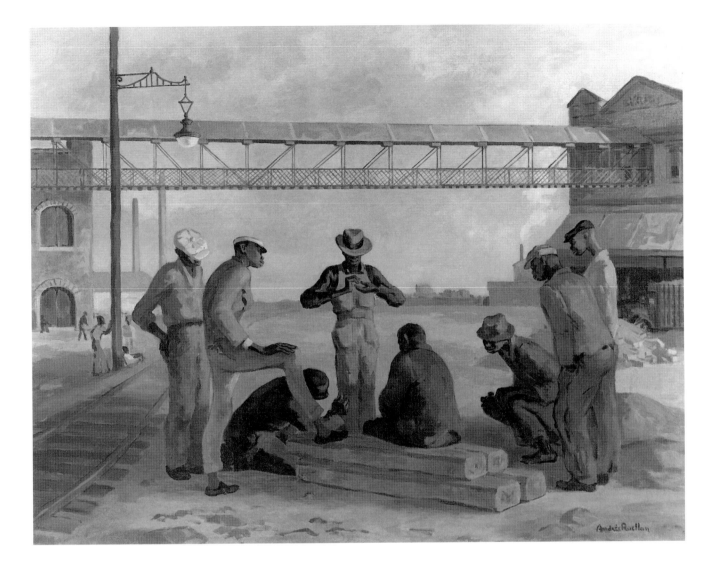

Fig. 25

marked a final determined effort before his death the following year. The painting's original title also implied a celebration of labor, a concern that conforms to Ufer's political sympathies, which ran to Trotsky, socialism, and the International Workers of the World. Jerry Smith speculates that the change in title might have been the artist's effort to soften the political implications of the subject and increase the likelihood of its sale.[84]

Like a machine in the garden—or, rather, the desert—Ufer's deluxe Buick touring car intrudes rudely into the sparkling southwestern landscape, the subject of many Taos school

paintings. But the nineteen-year-old automotive star of this composition—a modern subject rarely tackled by Taos painters—is broken. This might be a reference to the fabled origins of the art colony, when another vehicular problem (a broken wagon wheel) led to the "discovery" of the scenic village by traveling artists Ernest Blumenschein and Bert Phillips; it might also be a metaphor for the state of the American economy of 1935, or an allusion to the state of Ufer's health and reputation of that same date.

Like Hull's Mississippi sharecroppers or Ufer's Taos laborers, the subjects of James Chapin's canvases

stoically awaited the economy's and society's return to working order. The New Jersey painter was hailed by Thomas Craven, champion of the midwestern regionalists, as "conscientious in the extreme, devoid of all that is showy, shocking, or momentary, and averse to publicity,"[85] the last perhaps accounting for his relative unfamiliarity today. Moving away from his early French mannerisms and dismissive of "the usual provincial superiority complex of the European" artist or critic, Chapin sought his inspiration instead among the American working class, as shown for example in *Nine Workmen*, 1942–45 (cat. no. 14). Some writers speculate that his training in Antwerp exposed him to the influence of the Belgian artist and socialist Constantin Meunier, whose subjects and sympathies were akin to Chapin's own.[86] Whatever their source, Chapin's portraits of workers, rendered with a sharply focused realism, won praise from his friend Grant Wood as "among the best things in American art, strong and solid as boulders. They were full of the pain and bleakness of a frugal existence of the land, yet possessed a subtle, melancholy beauty of their own."[87]

Chapin knew something of pain and bleakness. The bonds that unite his workmen suggest the sort of community from which, for much of his life, the artist felt estranged. As a youngster, a severe stammer made him self-conscious and shy, leading to "enforced abstention from the company of his playfellows," according to one of his contemporaries. *Nine Workmen* and his other depictions of groups—which included farmers, musicians, prize-fighters, and gangsters—represent as well a redress for "the wall of loneliness which New York puts up around

sensitive country boys" such as James Chapin of rural New Jersey.[88]

The artist's early works earned him the sobriquet "the American Cézanne" for their mastery of French modernist principles.[89] However, the paintings for which he first achieved wide acclaim were a series of realistic portraits of the Marvin family, simple farmers from Sussex County, New Jersey, sitters whom critics thought typified "the upstanding, independent man with long roots in the soil he owns"[90]—Emmet Marvin, or his brother George, as the Jeffersonian yeoman, the American Adam. Chapin lived on the Marvin farm and worked with the family from 1924 to 1929. Years later he explained this retreat from the artiness of New York, betraying a wariness of metropolitan mores that was a constant in his career: "I have tried to live as much of my life as I could among other kinds of people [than artists], away from the studio . . . not wanting it to encompass a way of life in which to develop and exploit special paint skills to be repeated again and again."[91]

Before Grant Wood painted the plain folk of his native Iowa, before Curry painted Kansas or Benton Missouri, Chapin discovered in the New Jersey farm community of ordinary, hard-working Americans a rich vein to mine. Critics lauded the works of the "Marvin years," praising the artist's "elemental subjects . . . which represent the energy and power of a new country in the making."[92]

Chapin explained his effort to express the unique strength and personality of each of his subjects through "the symbol of human gesture . . . not the gesture of hands and feet so much as the carriage of the human body and the human head."[93] The subjects of *Nine Workmen* are diverse in age

and race or ethnic type; the workers' feet are obscured, as are most of their hands, the concentration being on erect carriage (except the seated eldest) and strongly individuated heads turned in various alignments. "I like solid things," explained the artist, "so my composing inevitably is concerned with the organization of objects in space." These objects, or figures, were "constructed to symbolize their weight" and arranged in highly structured compositions.[94] These subjects of the 1940s, pictorial descendants of the Marvins from twenty years earlier, appear to have realized the promise of work that their predecessors awaited throughout the depression. Together with their antecedents, Chapin's working-class subjects constitute a dignified community of labor, one endowed with exceptional gravitas.

9. Domestic Life

Genre painting has arisen (as numerous scholars have noted) in various times and places that are marked by material prosperity: seventeenth-century Holland, eighteenth-century England, mid-nineteenth-century America. Then and there, it was a burgeoning middle class that provided patronage for genre artists in unprecedented numbers and amounts. Their interest and support inevitably had a bearing on the nature of the storytelling imagery that emerged. "Since the middle-class tends to define itself in terms of private rather than public life," observed Lesley Wright, "the favored art forms also accentuate home, family, and domestic events. Within that smaller world, possessions, poses, descriptive detail, and appearances carry the meaning, rather than action, drama, public display, architecture, or expression." She

noted that American artists frequently invested even their group portraits or conversation pieces with a rudimentary story line, a reflection of the growing power of genre from the second quarter of the nineteenth century onward. "The story adds the dimension of sentiment . . . [which] has the effect of orchestrating feelings, generalizing from the particular, making the painting part of a hegemonic trend."[95] The aim of such artists was, according to another scholar, "to fuse the narrator with the painter."[96]

The painter's "home, family, and domestic events" that Wright found dominant in many genre scenes recall Emerson's interest in the "meaning of household life," a crucial aspect of "the common, . . . the low" to which (as previously mentioned) he directed attention in his "American Scholar" address of 1837. By that date, American painters had already begun to explore the low and common in the national life. Their scenes were variously fraught with moralizing, sentimental, political, comical, or other significance, as Elizabeth Johns has richly detailed.[97]

Many of the antebellum genre paintings focused on the middle-class American family, an interest that persisted among post–Civil War genre painters, albeit often with different emphases. In customary sequence, the family unit has its origins in the rituals of courtship, followed by marriage and then procreation. Like an individual's, a family's life cycle then progresses through various stages: the rearing of children; their passage to adulthood; the rise of a new generation and the role of grandparents; old age, with its wisdom and its pains; and finally the rites of death. Each stage provided material for the observant painter.

In 1840, Francis William Edmonds scored an early triumph at the National Academy of Design's annual exhibition with the display of two canvases on the courtship theme, a motif that must have been especially poignant for the recently bereaved artist. *Sparking*, 1839 (fig. 26), and *The City and the Country Beaux*, circa 1839 (Sterling and Francine Clark Art Institute), earned kudos from the *Knickerbocker*'s critic, who praised them as "*finished* pictures; finished in 'the scope and in the detail.' The whole story is told," he wrote with admiration. "No part is omitted, or slurred over. And it is here that so many of our artists fail."[98]

That Edmonds's paintings told "the whole story" suggests that the artist, like others of his generation, was interested in narrative themes, whether drawn from literature or from daily experience. His first oil painting on an original subject, *Hudibras Catching the Fiddler*, 1829 (unlocated), was inspired by a Samuel Butler poem, and literary texts motivated his imagination in later works as well. Edmonds's sources ranged from *Gil Blas de Santillane* by Alain-René Lesage (1715; U.S. editions, circa 1790–1820) to Tobias Smollett's novel *Peregrine Pickle* (1751) to works by his contemporaries, including Charles Dickens's *Pickwick Papers* and verse by Robert Burns. The last was the likely inspiration for *Barking up the Wrong Tree*, circa 1850–55 (cat. no. 21), a return to the "sparking" theme of his early years, but now recast with a decidedly older swain. The mismatch between the suitor and the object of his pursuit suggests an origin in Burns's poem, "To Daunton Me," in which the speaker, a girl ("me so young"), vows "An auld man shall never daunton me!" with his flattery and false heart.[99] The figures are posed in a boxlike setting, derived from seventeenth-century

Dutch art and favored by Edmonds for his genre scenes, most of which were situated indoors. Details reinforce the contrast in the characters' ages. The young girl is flanked by a cupboard and door that swing open, with access to emblems of domesticity and a light-filled room beyond; the open door can be read as a metaphor for freedom, as traditionally is the open window. By contrast, the man's side is walled in with hard right angles and a looking glass that provides no egress from the confinement. Tartan plaid on the wall behind the girl suggests Burns's Scottish source, as does the caller's Scotch terrier and his ruddy complexion and sideburns, attributes of the Scottish type. The painter's tale is relayed through such telling details, as the gentleman presses his suit to no avail; his gaze is avoided by the knitter, who instead stares out at—and coyly unfurls her ball of yarn toward—the painter and the viewer.

Winslow Homer's *Rab and the Girls* of 1875 (cat. no. 33) might also deal with courtship, or the hope for same. The painting was first shown at the National Academy of Design the year after its creation, with the title *Over the Hills*.[100] In the academy's annual exhibition, it was overshadowed by Homer's now-famous *Breezing Up (A Fair Wind)*, 1873–76 (National Gallery of Art). What little critical attention *Over the Hills* received was devoted more to formal issues than to the picture's subject: "The girls are admirably drawn and painted though the artist has . . . unduly lowered the tone of the coloring," offered the *New York Times*, an example characteristic of the critical ambivalence the painting inspired. Despite the "hasty and imperfect painting" in the fore- and background, the reviewer (probably Charles De Kay)

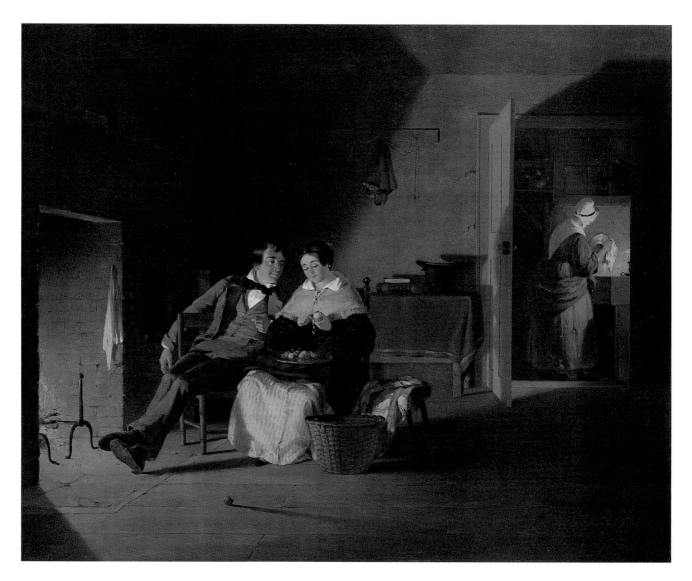

Fig. 26
FRANCIS WILLIAM EDMONDS
Sparking, 1839
Oil on canvas, 19¹⁵⁄₁₆ x 24 inches
Sterling and Francine Clark Art Institute,
Williamstown, Massachusetts
1955.916
Photo © Sterling and Francine Clark
Art Institute

concluded that the two central figures
"reveal such power of handling as no
one dreamed Winslow Homer pos-
sessed."[101] Nowhere in the discussion
did the critic ask what those two "ad-
mirably drawn" women were doing in
a clover field, and neither did any other
reviewer. But in details both subtle and
bold, Homer seems to offer clues to his
pictorial story.

The artist's early practice as an il-
lustrator had given Homer a keen sense
of the telling moment—in literature, in
life—as captured in visual terms. From
his debut in the late 1850s through
the paintings of the 1870s, in scenes
of middle-class or military life, he had

demonstrated his ability to extract
stories of interest from the routines of
life about him. On occasion, he could
add to those pictorial tales secondary
or symbolic levels of meaning, some-
times disguising them beneath the
ordinariness of the subject depicted.
Nicolai Cikovsky cites Homer's *Veteran
in a New Field,* 1865 (Metropolitan
Museum of Art), as a prime exam-
ple—perhaps *the* prime example—of
this tendency toward "a consciously
and deliberately symbolic painting," in
that case a post–Civil War rumination
on death. "Homer possessed both the
intention and the intelligence to create
symbolic meaning," he noted, although

rarely with such a momentous subject as that in the *Veteran.* "But Homer's ability to invent symbols and manipulate symbolic references becomes a potential of his pictorial practice that any interpretation of his later art must take into account."[102]

Earl Shinn perhaps inferred something of the symbolic meaning, the narrative of *Rab and the Girls,* which admittedly is by no means as significant as the *Veteran.* When first shown in 1876, he wrote of the "peculiar moral freshness which characterizes Mr. Homer's girls, and which in some of them becomes a kind of handsome hardness"; but then, instead of exploring their peculiarity, he lapsed into a description of the pair holding a "four-leaved shamrock . . . balanced by the bouquet of red maple leaves," avoiding further exploration of the "perfect maidenhood" the figures embody.[103] Three years later he reacted to the "native and racy" painting in language more suggestive, even feverish, although still circumspect. The "fresh girls" have wandered the "wild, lone hills"; "themselves far enough from life's autumn," they carry home a "scarlet branch of that most American tree, the maple," tinted with "the first blood drawn by aggressive winter." With "breezy frankness" Homer renders these avatars of "hopeful maidenhood" in a "picture [that] seems to include the most delicate and pensive aroma of Coleridge's 'November,' while at the same time it speaks the American accent."[104]

The four-leaf clover that occupies a central position in Homer's composition also plays a central role in the symbolism through which the painting's "racy" tale might be related. The botanical oddity has been accepted as a symbol of good luck since ancient

times. In 1873 the tiny, lucky quatrefoil had provided Homer with the subject and title for an oil painting (Detroit Institute of Art) in which it was held by a young girl and silhouetted against a sunstruck wall. Luck could play a role in affairs of the heart as well as other human affairs, and amorous themes played an unusually prominent role in Homer's work of the 1870s. In *Shall I Tell Your Fortune?,* 1876 (private collection), one of the artist's most exceptional works, love and luck are combined, as a comely fortune-teller displays a hand of cards foretelling the viewer's (and the artist's?) romantic future. Such a romantic theme might be interpreted in *Rab and the Girls* as well. The fresh greenness of the clover contrasts with the autumnal hues of foliage, seasonal associations that beg the question, Are the girls "over the hill," as the original title might imply? Or are they still eligible, still desirable examples of "perfect maidenhood" who, with luck (and clover), might avoid old-maidenhood? Homer, of course, was generally too masterful to resort to such obvious storytelling. Yet in subtle ways, he invests his scene with narrative details that elevate *Rab and the Girls* beyond the "barren canvas" that Clarence Cook faulted as the sort of painting "Mr. Homer [produces] when he has nothing to say and persists in taking a big canvas to say it in."[105] Consideration of its subject, not solely its formal elements, might yield a pictorial narrative of unusual interest.

When gentlemen callers were not "barking up the wrong tree," when maidens weren't alone strolling in clover, courtship might lead to marriage. Wedding rituals, particularly the appearance and actions of the bride, provided the motif for numerous nine-

teenth-century canvases. In addition to the portraits that were the basis for his reputation and income, Kentucky artist William Edward West painted several works on the bridal theme. *The Unwilling Bride* and *Adornment of the Bride* are both mentioned in his papers; in *The Present,* 1833 (fig. 27), a bride examines a wedding gift of a gold-and-amethyst necklace, while around her gathers a sorority (and one young boy) whose mixed expressions suggest varying reactions to the present, or to the impending union.

Marriage was often followed by the arrival of children, who have provided subjects for many artists in many lands for many years. In numerous examples, they are represented with their parents, suggesting the premium placed on family life and the domestic arena, as well as on family lineage and perpetuation. These were concerns that especially motivated American painters in the nineteenth century. The child—or, better, children—often took center stage in their family portraits, figuratively and sometimes, as in the case of Ralph E. W. Earl's Foster family portrait (fig. 28), literally. In James Clonney's painting *Offering Baby a Rose,* 1857 (cat. no. 18), the intent is not a specific likeness, but a general evocation of the joys of babyhood and domestic life. Like Edmonds, Clonney betrays his interest in Dutch traditions; the young mother, elegantly garbed but unusually elongated, might have wandered in from a Terborch canvas, while the new father sits within a boxy stage set before a map of the sort that Vermeer often included in his interiors. Details help to convey the narrative of family life, again as with Edmonds; the map, writing implements, and books in the father's vicinity connote the worldly arena of the male, while on the mother's side a

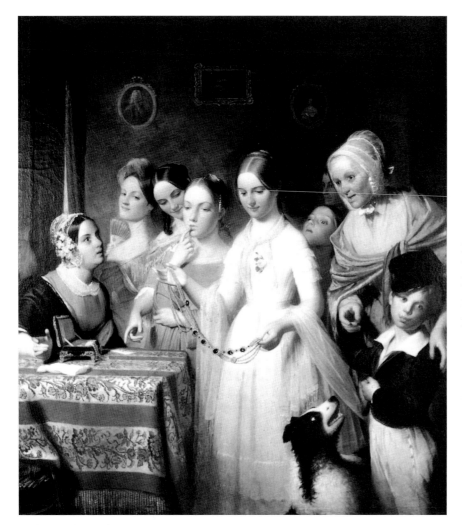

Fig. 27
<small>WILLIAM EDWARD WEST</small>
The Present, 1833
Oil on canvas, 38 x 31¾ inches
Collection of The Speed Art Museum,
Louisville, Kentucky
Bequest of Mrs. Blakemore Wheeler
1964.31.33

birdcage (barely discernible beside the door), whose bars are rhymed in the balustrade beyond, define the more limited domestic sphere of the female. The pink rose—in the period's "language of flowers," symbolic of feminine beauty and innocence—is offered to the baby girl, as if in exchange for the ring with red ribbon that she has dropped at mother's feet. A wicker stroller is parked nearly offstage at the father's side, perhaps a reference to the mobility that might take a baby girl born at midcentury into a wider world in her adulthood. Through the careful delineation and compilation of such details, Clonney's pictorial narrative celebrating domesticity and what David Lubin

calls "the sentimental family" is made legible.[106]

A rather different family dynamic is conveyed in Lilly Martin Spencer's *The Young Husband: First Marketing,* 1854 (cat. no. 55). Spencer was a rarity in nineteenth-century America, a female artist who supported herself, her husband, and their large brood with sales of her artwork, which enjoyed great vogue, particularly in the 1840s and '50s. Most of her domestic genre pictures feature female protagonists—woman in the nursery, woman in the kitchen. But in several scenes from the mid-1850s to the mid-1860s, men figure prominently—husbands and fathers depicted, Lubin claims, in Spencer's "passive-aggressive" manner.[107] First among these were the young husband marketing, Spencer's sly subversion of the period's patriarchal paradigm. The man, ineptly carrying out a domestic task, vainly tries to maintain his balance and his composure.[108] To the amusement of passers-by, his produce and eggs crash to the slick pavement, as he manfully grabs the slick bird (a young cock?) about to slip from his basket. Spencer's husband, Benjamin, the perennially unemployed father of their thirteen children, was the probable inspiration for this comic pratfall. That the subject enjoyed popularity during the artist's heyday is suggested by the several versions of the composition that Spencer painted.[109]

Spencer's young husband's burden apparently was not shared by the Native American, at least not in Alfred Boisseau's *Louisiana Indians Walking along a Bayou,* 1847 (cat. no. 9). There, the proud sire is empty-handed but for his gun as he leads a pair of burden-bearing women and his young son along a southern stream near Lake Ponchartrain. Like the father, the boy

carries only a weapon, in his case a slender spear, leaving the heavy lifting to the women of the party. Boisseau was a French-born and -trained painter who worked in New Orleans for several years, beginning in 1845, before moving to New York. Like many of his compatriots at that time, he was attracted by the exotic, in this case the Choctaw, identified by the style of their basketry and hair. An earlier visitor to the region, describing a similar procession, suggests the accuracy of Boisseau's documentation of native family life: "The squaws went by, walking one behind the other. . . . These squaws carried large Indian baskets on their backs, and shuffled along, barefooted, while their lords paced before them . . . with blue and red clothing and embroidered leggings, with tufts of hair at the knees, while pouches and white fringes dangled about them. They looked like grave merry-andrews; or, more still, like solemn fanatical harvest men going out for largess."[110] Boisseau sent his *Louisiana Indians* to the annual Paris Salon of 1848, where it provided a New World complement to the colorful "Oriental" motifs often depicted by French artists of the period.

The Choctaws that Boisseau painted in 1847 were among the remnant of a tribe that had once inhabited a large area in Louisiana. Events of midcentury discombobulated American family

Fig. 28
RALPH E. W. EARL
Ephraim Hubbard Foster Family,
ca. 1825
Oil on mattress ticking, 53³⁄₁₆ x 70¹⁄₁₆ inches
Collection of Cheekwood Museum of Art,
Nashville, Tennessee
1969.2

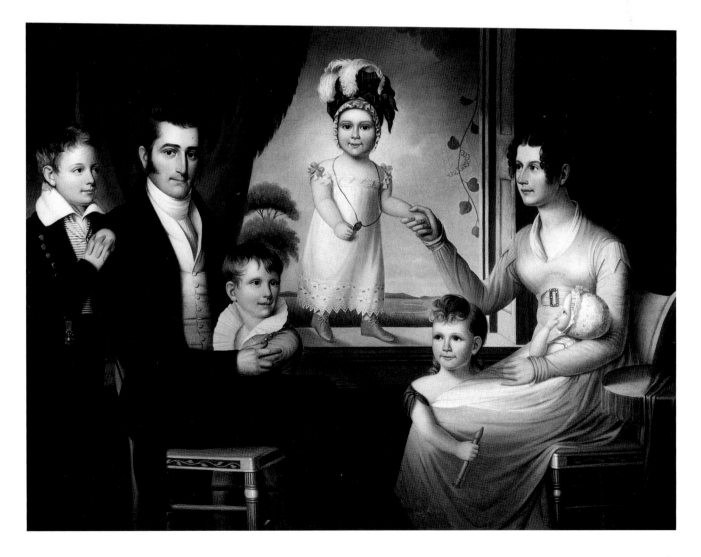

life, and not for European Americans alone. In 1830, the Choctaw, one of the four great Indian nations of the old Southeast, had signed a treaty calling for their removal from ancestral lands within three years. The migration brought hardship, disease, and death to the relocated people, as it did to their southern neighbors, the Creek and the Chickasaw, who were also relocated or placed on reservations during the Jackson administration. The Cherokee, the fourth southern nation, had to be forcibly relocated in 1838, when they joined thousands of other Native Americans who had traveled the "trail of tears" to the Indian Territory in the trans-Mississippi West, which in 1908 became the forty-sixth state, Oklahoma.

Enslaved blacks in the Confederate states, who were proclaimed emancipated by President Lincoln in 1863, were practically freed by eventual Union victory in the Civil War. But for African Americans, the peace of Appomattox in 1865 only began another period of trial. Thomas Hovenden's *Contentment,* 1881 (cat. no. 34), is characteristic of the artist's "highly narrative" subjects from common experience that won him the approbation of his generation.[111] At the 1893 World's Columbian Exposition in Chicago, Hovenden's *Breaking Home Ties,* 1890 (fig. 29), was the single most popular picture at the fair; the young man's soulful expression upon taking leave from mother, home, and hound tugged at the heartstrings of late Victorian audiences. (It also provided the precedent and probable inspiration for Gilbert Gaul's *Leaving Home* [cat. no. 23], where the young man is in his father's grasp rather than his mother's.) The sentimentality of *Breaking Home Ties* is evident as well in a group of African American domestic scenes that

Hovenden had painted in the preceding decade, including *Contentment.* Although emancipation had ended the agony of arbitrary severance of slaves' family ties, poverty, lack of education, and overt discrimination continued to plague African Americans. Such concerns, however, are largely absent from Hovenden's sentimentally viewed subjects, who in title and deportment exude "contentment." In a quiet, end-of-day moment, the husband pushes back from the table in his comfortable rocking chair to enjoy his pipe and listen to his wife as she speaks to him while clearing the dinner from the table. While the setting is simple, it is not without its amenities—note the white tablecloth, the blue-and-white china—and could be replicated in countless white households of the period. Hovenden's mise-en-scène suggests a pronounced sympathy with his subjects, a sympathy some historians have attributed to family connections, specifically to his in-laws' ardent abolitionist sentiments.[112]

Like Hovenden's, many of Edward L. Henry's paintings, both historical subjects and genre scenes, were stamped with a narrative. Their storytelling character earned the artist critical praise as "the Washington Irving of a painted 'Sketch-Book.'"[113] Such a work might be Henry's *The Sitting Room,* 1883 (cat. no. 31). In an interior more lavishly appointed than Hovenden's, two figures flank an ornate mantelpiece (and also the sleeping family pet, who appeared in many Henry paintings); an older woman reads and her younger companion works her needle, both lost in silent concentration. On the upholstered sofa an elderly man naps away the October afternoon. In dark garb, something like a military uniform, and tucked beneath

a multihued cover that enshrouds him like battle colors, the sleeper resembles a Civil War officer; from his insensate hand, a paper with the news of worldly affairs has slipped to the floor, leaving the old man to his reveries, perhaps of past chivalry and battle glory. The room's old-fashioned decor suggests a time past, a backward glance: ancestral portrait, Adamesque fireplace, and antique furniture of the sort inspired by the collecting vogue begun at the Centennial Exposition a few years earlier, an enthusiasm in which Henry eagerly participated. The "certain slant of light" (as Emily Dickinson might call it)[114] and the autumnal foliage outside further imply a time and season of nostalgia and reflection, of winding down, even (in Dickinson's verse) of death. Henry's patrons were eager for such paintings "that tell their own story, so soon as the artist gets them on canvas."[115] He obliged buyers and the art critics alike with images, like *The Sitting Room,* that convey "the very feeling of security and happy contentment which belongs to a well regulated household."[116]

Henry's vision may have been retrospective, but the values that inform his genre scenes, stressing historical continuity and domestic harmony, were topical in his day and well beyond. The ancestral ties suggested in the portrait over the sitting-room mantelpiece found new expression in the modern era. During the depression years, institutional historicism flourished in organizations such as the Mayflower Society or the Daughters of the American Revolution, when genealogy seemed to offer comforting assurance of continuity beyond the difficult circumstances of the moment. In 1932, Grant Wood savaged the potential narrow-mindedness of such an attitude in

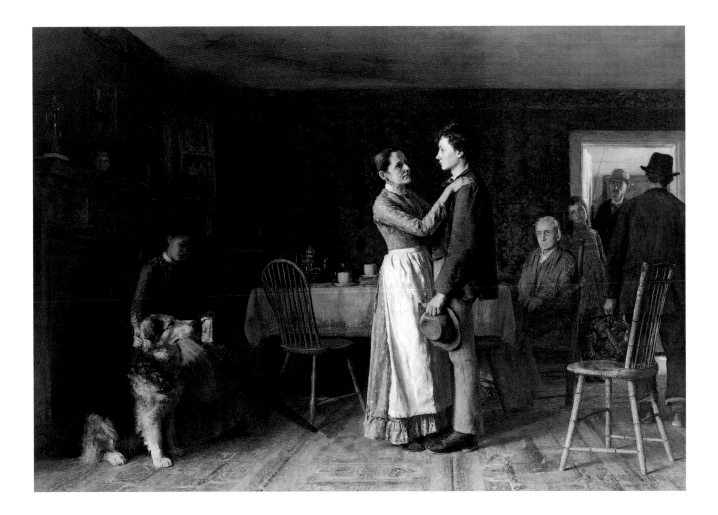

Fig. 29

THOMAS HOVENDEN

Breaking Home Ties, 1890

Oil on canvas, 52⅛ x 72¼

Philadelphia Museum of Art

Gift of Ellen Harrison McMichael in

memory of C. Emory McMichael

1942-60-1

Photo by Will Brown, 1977

his *Daughters of Revolution* (Cincinnati Art Museum); a few years later, Eleanor Roosevelt castigated the D.A.R. for its refusal to allow the distinguished African American contralto Marian Anderson to perform at its Washington headquarters, and famously offered the steps of the Lincoln Memorial in place of that venue.

Bloodlines and family histories might have their positive aspects, which Philip Evergood underscored with his memorable composition *My Forebears Were Pioneers,* 1939 (cat. no. 22). The scene of fortitude amid devastation was inspired by a sight the artist witnessed during a trip through New England following the awful hurricane of September 1938. "I was impressed," he explained, "by the way that old

lady of pioneer stock was unperturbed by anything. Her grandfathers had fought Indians and come over on the Mayflower, and there she was with her Bible, not changed by all that turmoil of nature." While he acknowledged the timeliness of the storm subject for his contemporaries, "I don't like to feel that it will always be topical. I don't paint to put over topical issues. I feel very conscious when I develop a theme that it must have universal connotations before I put it down in paint."[117] Viewers responded to the painting, one of Evergood's most important, and appreciated what one reviewer called his "revival of the literary associative approach, though now with Surrealist overtones."[118] Evergood's friend and dealer explained the picture's narrative

through a comparison, writing that *My Forebears Were Pioneers* "contains as much poignancy and social philosophy as is to be found in Chekov's 'The Cherry Orchard.'"[119]

The family as the focus of portraitists, WPA muralists, or genre artists persists into our own time (for example, painter-printmaker Eric Fischl or photographer Tina Barney). And the family ideal has been periodically invoked by social reformers, politicians, advertisers, and others who use the image of harmony to promote their cause. In the years following World War II, the United States embarked on a new era of domesticity. The repatriation of GIs from foreign theaters of war—and the return of Rosie the Riveter from factory to home—created great changes in American family life: birth rates skyrocketed in an unprecedented baby boom, which in turn led to a greatly expanding suburbia, made possible by home loans to veterans and requiring a host of new services and facilities.

The advertising profession grew with this domestic revolution, using traditional media as well as new technologies (especially television) to reach a newly affluent middle class. Enterprising postwar pitchmen made use of striking designs by visual artists, building on the success of earlier advertising campaigns. Particularly influential were the Container Corporation of America's efforts, begun in the 1930s, which culminated in the famous Great Ideas series of print ads introduced by the company's founder, Walter Paepcke, in 1950. The coal industry, which fueled much of the expanding economy, made similar use of the fine arts. In 1945, to promote its important role in the national life, the Bituminous Coal Institute commissioned Rockwell Kent to produce a projected series of twelve paintings to be used in a national advertising campaign. *The Baker of the Bread of Abundance* (cat. no. 37) is part of that little-known series, each panel of which is dominated by a gigantic Genie who holds a glowing lump of the sponsor's product. (To Kent's complaints about the format, the ad agency representative confided to the artist that the sponsor's conception of "a man two thousand feet high holding a lump of hot coal in his hand is pretty silly to start with.")[120] Among the myriad images of coal's blessings for Americans—in transit, manufacturing, health care, and so on—none was closer to home, literally and figuratively, than the image of family gathered in prayer at the table of postwar prosperity. As Eric Schruers has explained, "arranged in perfect boy-girl order around the table, the figures represent health in youth, maturity and old age as afforded by an abundant food supply."[121] In order to promote the product effectively, Kent (or any artist working in advertising) perforce had to work in a manner that made the corporate patron's pitch, or narrative, comprehensible; indeed, as others have noted, advertising "provides so many analogues for the depth impact of narrative art."[122] In the Coal series, Kent did this by using familiar tropes, such as the image of the American family. It was a favorite theme of narrative painters from early in the nation's history, and a timeless one that appealed as well to Kent's modern audience.

10. Childhood

"Hail to children! . . . Children! They rule the world. The mother and the child are the two sacredest figures in our modern life and literature." This exclamation by literary critic Eugene Benson indicates the revered position that "the dimpled darlings of our household, the little demi-deities of the cradle" held in mid-nineteenth-century American culture. Benson was writing shortly after the Civil War, at a moment when children were newly looked upon as redeemers of a society that their forebears had failed. He addressed the privileged role that children had come to occupy in modern letters, especially citing Wordsworth and Longfellow, Whittier and Hawthorne, "writers deficient in passion, but tender and contemplative, . . . or simply domestic, like Mrs. Stowe." In their writings, children achieved a central position of the sort they had long enjoyed in religion and the visual arts. At least from the Renaissance, he noted, "art had scattered its laughing and smoothly-curved images [of children] over the fronts of palaces, about altars, and in pictures."[123]

In America, palaces and altars were notably lacking in the early years of European settlement, and where children did appear in pictures, they were generally presented as miniature adults. By the early nineteenth century, however, what Henry Tuckerman called "this normal sympathy between the mature and childhood" led to a new appreciation of the early years as a special and distinct phase of a human's life. Tuckerman believed that "there is not a more suggestive chapter in human history . . . than that which records the recollections of childhood by introspective men."[124] During his lifetime (1813–71), depictions and recollections of childhood by painters—introspective or otherwise, male or female—flourished, and changed in character from those by earlier colonials.

The difference was apparent as early as the 1820s, when Thomas Sully painted *Juvenile Ambition* (cat.

no. 57). Sully copied his composition from *Grandfather's Hobby*, circa 1824 (Henry Francis du Pont Winterthur Museum), a work by his friend Charles Bird King, a Washington portraitist and genre painter. Instead of presenting the boy as a miniature adult, both artists depicted him in his childish role-playing: with tricorn and spectacle, walking stick and newspaper, the subject acts the grandfatherly adult but clearly is still a child. The youthful game of make-believe adds a note of gentle humor to Sully's genre scene, which is representative of the "fancy" or fanciful picture that enjoyed an international vogue during the early nineteenth century. An engraving of Sully's copy after King's painting appeared in 1830 in *The Token*, a popular gift book, where it was accompanied by a verse describing the impact that the grandfather's stories of the heroic "olden time" had on the young boy:

> How on the morrow will that boy
> With swelling thought resign his toy,
> Steal the cocked hat, and on his nose,
> The reverend spectacles impose,
> Mount to the vacant chair, and place
> The wise gazette before his face,
> And there half sly, half serious pore
> The last night's legend o'er and o'er,
> And deem himself in boyish glory,
> Like the old man that told the story![125]

The anonymous poet, who apparently was inspired by the painting, like Sully or King looks back from his maturity on that "boyish glory" with bemused ambivalence. The attitude was common in the period, as Tuckerman noted, and led to other poetic laments:

> Ah, those days have passed away,
> Brows are wrinkled, hair grown gray;
> Yet I love their cheer and noise,
> And my heart says, "Bless the boys!"[126]

Youthful imitation of elders often attracted the attention of painters. Chester Harding, for example, about 1833 portrayed a young girl as she rehearsed the hostess's role with her toy tea set (*Harriet Gardner Denny*, Telfair Museum of Art). The protagonist of Eastman Johnson's *Earnest Pupil (The Fifers)*, 1881 (cat. no. 36), pays rapt attention to the musician whose skills he hopes to emulate on his small pipe. The generational transfer of knowledge—from parent to child, from master to apprentice—was the traditional basis of education; only during the later nineteenth century did institutionalized public education become widespread in the United States, and even then the training of the young by elders continued in many fields.

The child's aspiration to adult mien and manners—to grandfather's hobby—did not charm everyone. During the nineteenth century, some British visitors voiced disapproval of the youngest members of American society. "Many of the children in this country," wrote one, "appear to be painfully precocious—small stuck-up caricatures of men and women, with but little of the fresh ingenuousness and playfulness of childhood."[127] Another complained that "Little America is unhappily, generally, only grown-up America, seen through a telescope turned the wrong way." What the United States lacked was "real child-like children."[128]

Such criticism might seem strange, coming as it did from visitors from Dickens's London with its teeming tenements and armies of child laborers. Similar conditions could be found in this country at midcentury as well, and on occasion provided the subject for urban genre painters. George Henry Hall depicted three urban urchins in *Boys Pilfering Molasses*, 1853 (cat.

no. 28). He found his subject in New York, the city to which he returned in 1852 following his studies in Dusseldorf. Although he is best known today for his sparkling still lifes, it was in Germany that Hall learned the meticulous finish and developed the penchant for genre subjects by which he initially came to acclaim. Hall's boys enjoying illicit molasses scarcely look like the suffering waifs who became the cause of later social reformers; their neat clothes and clean faces suggest an urban counterpart to the healthy young fraternity that gamboled in William Baker's or other rural pastures (cat. no. 4). Molasses constituted an important part of the triangular trade between Africa, the Caribbean, and north Atlantic ports, commerce that had early brought enslaved Africans to the New World; but the jaunty African American boy in Hall's painting was, like all of his race in New York by that date, a free black, in "The free city! no slaves! no owners of slaves!"[129] His inclusion in this scene more likely was intended for "local color" rather than any abolitionist statement. The port of New York—Walt Whitman's "mast-hemm'd Manhattan,"[130] to which ships brought molasses and other goods from around the globe—was the major commercial center in the United States, its economic and cultural domination suggested by the "Empire Line" reference in the background. Despite this metropolitan "imperial" status, the docks (the symbol of the city's trade and prosperity) and the teeming life of New York harbor seldom figured in genre pictures; as Hermann Williams noted, "Few indeed are the scenes which record this vanished and picturesque side of nineteenth-century American life."[131]

From the 1860s and later, the

young lads in John G. Brown's hugely popular paintings worked a different part of town, the city sidewalks where bootblacks, street vendors, and other young New Yorkers congregated. Their appearance was familiar: by the 1880s, there were an estimated one million working children in New York City, thousands of them homeless.[132] Their youth and their occupations were not, of course, unique, either to Brown or to New York; newsboys in particular had been a favorite subject of urban genre artists for at least a generation and remained so throughout the century in numerous centers. Like the Louisville newsboy depicted by local artist Aurelius Revenaugh (fig. 30), they often carry a hometown paper, a combined tribute to place and commerce. In Brown's *Three for Five* (cat. no. 11), the young flower seller holds out his bargain carnations in an effort to stop the foot traffic that passes by unseen. Like Hall's molasses pilferers, he is neatly turned out, his simple garb worn but clean; he is dressed in what one curator calls the "iconography of the city"—old boots, drab brown trousers held up with suspenders, and cloth cap.[133] Even the corner on which he stands is tidy, with only a few of the flowers' leaves casually dropped on the pavement. Clearly, he is not one the hapless, grimy urchins that Jacob Riis was beginning to photograph at the same time, whose images he, and later Lewis Hine, used to motivate child labor reform. The boy's expectant expression makes it seem that a sale might be near, the realization of his entrepreneurial hopes. The large format of Brown's canvas—it is of a dimension customarily used for society portraits—appears to ennoble the young capitalist at work, a sentimental celebration of free enterprise that would have

been favored by the merchants whose patronage made Brown wealthy. In his later years, the artist himself apparently came to believe in his painted fictions, claiming often that many of his street-urchin models had gone on to become successful businessmen. "Brown's real genius," Martha Hoppin summarized, "lay in his ability to tell a story and to sense the direction of popular taste."[134] This enabled him to serve long and ably the public's appetite for narrative paintings.

If Brown's stock in trade was New York's working young of the late nineteenth century, Edward Potthast's was the next generation's urban population at leisure. He was particularly acclaimed for his paintings of children playing on the beach of Coney Island or other metropolitan shores. During the last several decades of his career, Potthast repeated this motif many times over, an ongoing celebration of a halcyon moment in American life. Begun around the start of the twentieth century, the beach scenes captured the innocence of that pre–World War I era. Potthast painted with a broad and loose brushwork, often using a high-keyed palette. Rather different from the piles of humanity that Reginald Marsh later described on these same shores during the Great Depression (cat. no. 45), Potthast's interest is more in the atmosphere—the holiday brightness of color, sparkling sunlight on foaming waves, the fresh sea breeze—conveyed through impressionist technique. These felicitous, carefree moments at the shore are suggested as well through his titles, such as *Happy Days*, circa 1910 (cat. no. 51).

The urban scene that motivated artists of Brown's and Potthast's generations continued to inspire painters throughout the twentieth century. The

social realists who flourished in the 1930s, including Reginald Marsh and Jack Levine (cat. no. 41), were succeeded by a postwar generation that reacted in different ways to the city setting. Out of its dense space and dynamic energy, some created a new, nonrepresentational expression, in which personality counted only insofar as it could be expressed through "authentic" but abstract gesture or form. In this new abstract expression, narrative was effaced by formal, pictorial concerns and the process of creation. As Max Kozloff summarized the situation, narration belonged to an older culture and "on no account was the Modernist work of art to be understood as an account, as an allusion to interwoven or sequenced events, or to human cause and effect."[135]

Of course, not all agreed. Other artists, not part of the abstract expressionist camp, responded to the postwar age of anxiety by resorting to traditions of representation, often tinged with expressionist angst. Such was the case with Andrée Ruellan, whose prewar concerns for American scene imagery yielded in the late 1940s to a darker, more personal approach, one that on occasion incorporated surrealistic elements. Her early works were primarily figurative, inspired by observations of the people around Woodstock, New York, where she was a longtime member of the local art colony, or from her travels to Savannah and Charleston; in the latter she discovered the motif for *Crap Game*, 1936 (fig. 25), which is characteristic of her work from that period. "What moves me most," she explained a few years later, "is that in spite of poverty and the constant struggle for existence, so much kindness and sturdy courage remain." While striving for good design and technique, Ruellan

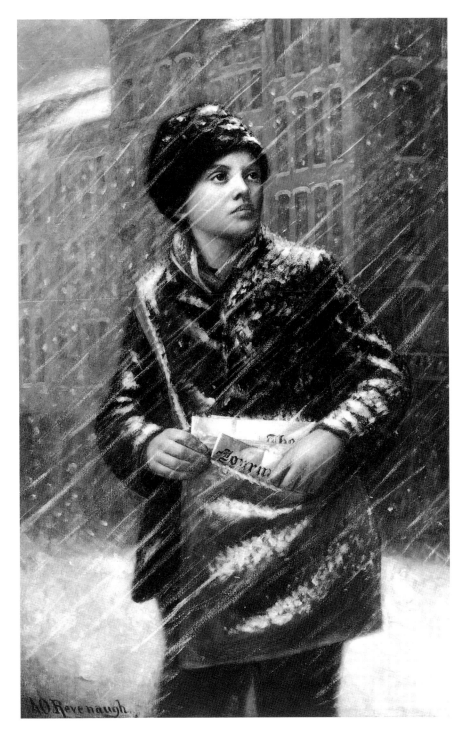

Fig. 30
AURELIUS O. REVENAUGH
Newsboy, late nineteenth century
Oil on canvas, 43 x 27 inches
Collection of The Speed Art Museum,
Louisville, Kentucky
Gift of Mrs. Silas Starr
1939.22.7

also wanted "to convey these warmer human emotions. . . . my deepest interest has been and is for people, at work or at play."[136]

The young people at play in Ruellan's *Children's Mardi Gras,* 1949 (cat. no. 52), however, bear scant resemblance to the figures from her prewar works. Costumed and masked, like the revelers in McCrady's *Parade* (cat. no. 47), Ruellan's subjects leave an unsettling impression, more akin to a madhouse than a Mardi Gras. From the blackness behind a barrier, four children struggle to join their cohort, who are held in (or out?) by a high wall and menacing pales. They have been likened to the grotesques that appear in some of Francisco Goya's more nightmarish scenes; closer to the artist's own time, the dancing couple and noisemakers recall the contorted figures of George Tooker's cruel *Children and Spastics,* 1946 (private collection), or the masked New York gamins photographed by Helen Levitt (fig. 31). The cataclysm of war and the havoc wrought on France, Ruellan's ancestral and sentimental homeland, left the artist in a transformed state; while her subjects remained figurative, they grew increasingly symbolic and reflect a darker mood at midcentury.

Paul Cadmus also had a keen eye for the changing social landscape at midcentury. His art earned him notoriety when one of his paintings, *The Fleet's In!,* 1934 (Naval Historical Center, Washington, D.C.), was ordered removed from an exhibition of government-sponsored works at Washington's Corcoran Gallery of Art. Navy brass objected that it gave an unsavory view of randy sailors on shore leave consorting with a variety of both women and men, many apparently of dubious repute; it was, claimed the Navy

Secretary, the product of a "sordid, depraved, imagination." Years later, the bemused painter commented, "I owe the start of my career really to the Admiral who tried to suppress it."[137] Early on, Cadmus had discovered the potential power of the narrative picture, and for many years he remained faithful to that pursuit, admitting, "I would be pleased to be remembered as a literary painter."[138] He also remained constant in his devotion to a painstaking technique of academic realism, used to render the human form—idealized or grotesque, female or, especially, male, viewed through the eye of an unapologetic homosexual—in various situations, from classical pose to satirical tableaux.

In one of his best-known works, Cadmus presented a cast of various young urban types, gathered in and around the caged confines of a bleak city playground (cat. no. 13). With exquisite draftsmanship and painstaking egg tempera technique, Cadmus created an icon of midcentury angst. With his art, the tale is in details, which reward close scrutiny. At the left, a teenaged pair erotically couples, his ski-jump nose echoing her uplifted breasts. Leaning against the screen and the pair, a swarthy male with bared torso grasps his cigarette with one hand, and with the other, things unseen in his pants. A skinny redhead behind him takes the measure of the phallic bat balanced on his middle finger. Another baseball bat emerges from between the legs of young tough at the right; he is part of a muscular trio that includes a black pressed close behind him and a nose-picking blonde whose physical endowment strains against his unbuckling pants. Their fraternity bears little semblance to "those budding potentates—the boys," the

subjects beloved by nineteenth-century genre painters, storytellers, and their audiences.[139] Behind them, separated from this adolescent community by the wire screen, a meditative figure seems lost in thought beneath a sign with the admonitory word fragment NO. Above them all, another bare-chested youth is suspended from the fence in a rising pose suggestive of Superman or, oddly, the airborne nude in Maltby Sykes's *Ascension* (cat. no. 58). In the caged space beyond the screen, two boys play some sort of handball game, a favorite city pastime that, a decade earlier, Ben Shahn had used in a series of paintings and photographs to symbolize urban anomie. The playground is squeezed by the buildings beyond, including tenements, some of which are ruined by arson, others still inhabited. Several occupants of the latter are seen at the windows; one turns her ample backside to the youths as she struggles, futilely, to clean her environs; above her, another appears with a skull-like face. The church at left is partially eclipsed by the building in front of it; its power to effect change, to offer hope in this bleak precinct, seems canceled by a laundry line before it, from which suspend women's undergarments. In the foreground, garbage and trash reinforce the sense of ruination; cracked pavement suggests the broken dreams of this place. The headlines of discarded newspapers verbally enhance the effect: OFFENSIVE—DENOUNCES PEACE—WAR—POWER—WOULD FORCE ALL TO COMPLY. Amid this wreckage and dominating the foreground is a blond ephebe, through whom we literally and figuratively enter the scene. Pale in complexion, the golden boy seemingly emanates lightness in these drear environs; substantially nude, his physical perfection stands in contrast

to the mannered poses and physiques of his company, as he stares out beseechingly from amidst the social and physical detritus of the modern city.

The painting tells a stirring story for an anxious age. Speaking of the primary figure, Cadmus said that he saw no place for this "sensitive individual in this corrupting environment." He asked, "What is to become of him?"—a plea to which the painting offers little solace and no answer.[140]

The world painted and inhabited by Andrew Wyeth seems a rebuke to the city's "corrupting environment." Yet even in his woods and fields at Chadds Ford, Pennsylvania, or the weathered, Christina's-world landscape of Cushing, Maine, the anxieties of midcentury were apparent. These he conveyed through portrayals of his crippled neighbor, Christina Olson, or his repeated images of dead birds and animals or of various architectural and still-life subjects that bespeak decrepitude. Katherine Kuh attributed the artist's unprecedented popularity to the temper of the times that his paintings so often reflect. "No time or place in history," she wrote in the late 1960s, "could be better adapted to the hero worship of this particular artist than present-day America," a frenetic society with a nostalgia for a simpler life. "The more international our world, the more tormented it is by unrest, the more unstable our social fabric, the more, alas, we turn to oversimplistic solutions." Viewing his *Winter 1946* (cat. no. 70), one might quarrel with Kuh's implication of the artist's "oversimplicity," but surely not with her apt characterization of the "pervasive solitude that underlies Wyeth's work."[141] Like Cadmus's *Playground*, Wyeth's composition centers on a young boy, but now alone in a bare and wintery rural landscape. Wyeth

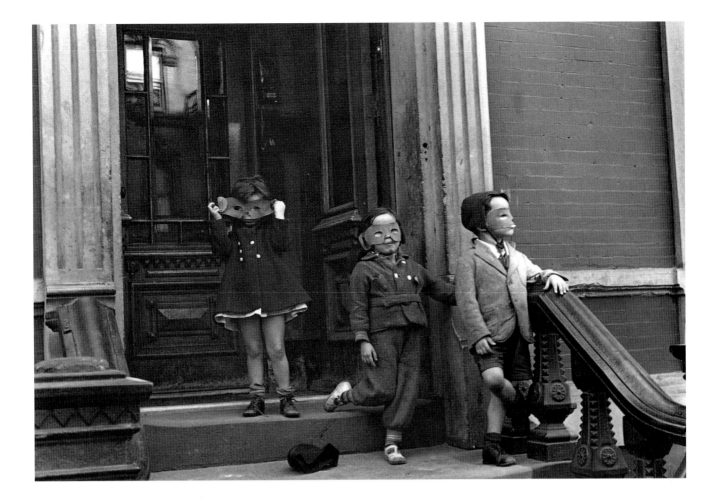

Fig. 31

used egg tempera (again, like Cadmus), a demanding medium he favored for its "feeling of dry lostness."[142] A sense of "lostness" pervades the dark picture, which was painted shortly after the death of N. C. Wyeth, the noted illustrator and Andrew's teacher and father, and captures what the artist remembered as his "vast gloomy feeling."[143] Andrew Wyeth has spoken of *Winter 1946* in personal terms, explaining that the hill became a symbolic portrait of his father; the bulging forms "seem[ed] to be breathing—rising and falling— almost as if my father was underneath them."[144] Patches of rotting snow are pocketed in crevices of the landscape, like "little islands of dying winter. They're very symbolic to me," Wyeth explained. Across this symbolic landscape, a young boy runs, fairly tumbles

down the hillside. He represents the artist's "feeling of being disconnected from everything. It was me, at a loss— that hand drifting in the air was my free soul, groping."[145] And behind the boy, in close pursuit, his dark shadow symbolizes fear and death. With such subtle details, Wyeth compiles this pictorial narrative of loss; but, as the artist warns, "I want more than half the story. There are some people who like my work because they see every blade of grass. They're seeing only one side of it. They don't see the tone." The essential "tone" resides in the combination of subjects faithfully depicted, blade by grassy blade, with formal, even abstract pictorial concerns. "If you can combine realism and abstraction," he adds, "you've got something terrific."[146] In *Winter 1946,* the combi-

nation results in Wyeth's most personal expression of grief, the whole story told in particulars described and abstractions implied.

11. Death

In 1846 John Wood Dodge painted a miniature portrait of Felix Grundy Eakin, the young scion of a middle Tennessee family (fig. 32). The child stands in an architectural setting that suggests his family's prosperity. With painstaking precision of the sort that often characterizes a self-taught artist, Dodge described his subject's costume, face, flowers, and other details of the composition, including hat, toys, and tools on the checkered floor. Their scattered disarray might be the product of a lively three-year-old's play, from which Master Eakin had been distracted to pose for the painter. The circumstances of the portrait were, however, of a different sort altogether.

The image is a posthumous one, memorializing young Eakin, who was among the many victims of the period's awful childhood mortality rates. The details that Dodge so carefully brushed with watercolor onto the small ivory panel were symbolic of the boy's sorry demise. He stands before a fiery sunset, suggesting the end of day, and beside an urn, long a symbol of mourning. The flowers on the ledge are wilted and dropping downward, to join other blossoms already fallen to the floor. The toy cart that Felix Eakin would pull is immobilized by a broken wheel, which is not repaired by the hammer and nails, themselves the instruments of another Son's death on the cross. Dodge's poignant portrait, which conveys its message through such symbols of death, is part of a large

Fig. 32
JOHN WOOD DODGE
Posthumous Likeness of Felix Grundy Eakin, 1846
Watercolor on ivory, 6 x 5 inches
Collection of Cheekwood Museum of Art,
Nashville, Tennessee
1960.2.72

group of funerary subjects to which artists in this country, as elsewhere, turned their attention in the nineteenth century.

Elihu Vedder knew the subject well, both in his art and in his personal life. The dead or dying often figured in his imaginative compositions. These included *The Dead Alchemist*, *The Dead Abel*, *Prayer for Death in the Desert*, and *The Plague in Florence*, all from the 1860s; memorial subjects inspired by family deaths in the 1870s; the multiple versions of *The Cup of Death* (1880s) from the *Rubaiyat of Omar Khayyam*; and *The Last Man* (1891), whose subject is posed atop a pile of human skulls. So pronounced was his

morbid interest that one of his contemporaries referred to this "idealist of idealists" as "an artistic Poe."[147] The narrative quality of many of Vedder's paintings may account for the number of writers who purchased his work, including James Russell Lowell, Herman Melville, Thomas Bailey Aldrich, William Dean Howells, and Mark Twain.[148]

Death stalked Vedder in life as in his art. In 1872, his infant son Alexander died of diphtheria, a death that was foretold in Elihu's dreams. Three years later, after another son, Philip, succumbed to the same disease, Vedder memorialized him in two posthumous portraits, painting his favorite child from memory.[149] Vedder once confessed, "I always try to embody my moods in some picture."[150] Beginning the year after Philip's death and continuing through the balance of the decade, Vedder did just that in a group of at least four memorial paintings inspired by his personal loss, including *Memory (Girl with Poppies)*, 1877 (cat. no. 65).[151] The initial painting in the group, *Woman among Poppies Holding Etruscan Jar*, 1876 (private collection), established the iconography that would run throughout. Each of these canvases featured the woman (for which Vedder's bereaved wife posed) with symbolic attributes, to create allegorical statements of the cycle of death and rebirth. The figure holds an Etruscan vase of the sort routinely excavated in nineteenth-century Italy, where the expatriate Vedder spent much of his career; the vessel was made to contain the ashes of the dead, but it was also a symbol of the womb and thereby of rebirth. The dead poppies amid which the urn bearer stands also have funereal connotations. In the narcotic culture of the fin de siècle, poppies, the source

of opium, were often used to represent sleep or death; conversely, the plant's seedpods also suggest regeneration, and the ancient Romans associated its leaves with Juno, the goddess of childbirth. The moon hovering on a distant horizon lends a lugubrious nocturnal air to the composition; its glow is filtered through the miasmic vapors that were traditionally associated with evening and danger on the Roman Campagna. The memorial paintings culminated in the largest example, *In Memoriam*, 1879 (fig. 33), in which Vedder further enriches the symbolism with the addition of a bleached boar's skull atop a funereal shaft that is decorated with a passion flower and a placque inscribed,

> *Heu flos unus superstes*
> *Inter mortuos iam socios vigens*
> *Sic at in corde desolato*
> *Vivit adhuc nomen illud*

("Also, as one surviving flower lives among his dead companions, Thus in the desolated heart still that name lives").[152] In each of these mourning pictures, Vedder relates this allegorical meaning through symbolic forms and objects, the comprehension of which depends on an informed viewer.

No special learning was necessary, however, to understand other treatments of this universal theme. An anonymous portrait of three children (cat. no. 63) suggests the sorry frequency with which families of an earlier age had to deal with such losses. A young boy and girl pose with their sister, who appears to sleep on a Victorian sofa; but upon closer scrutiny, the "sleeping" child seems to have departed this life and here is subject of a final portrait, a memento of her brief existence and of her loss. The closed-eyed, stiffly laid out corpse rests

on a piece of furniture that also looks disturbingly like a lidded coffin. The striped drape over her body is topped by a bouquet of white blossoms of the sort recommended by Victorian-era arbiters of funerary practices: "the lily, the rose, the azalea; all white save a few violets; [were] all appropriate to scatter over the dead."[153] On the floor lies her fallen doll, an echo of its owner's still repose, and other abandoned toys and papers. A child's hoop is held by the brother, perhaps suggesting the circle of life now completed, perhaps simply emblematic of childish pursuits from which his baby sister is now retired. At her feet is an empty child's rocker. The "vacant chair" was a familiar trope for sentimental writers, used to connote a loss such as that of "Little Mary, bright and blest," who

> *Early sought her heavenly rest.*
> *Oft we see her in our dreams—*
> *Then an angel one she seems!*
> *But we oftener see her, where*
> *Stands, unfilled, the vacant chair.*[154]

In an era when childhood losses were many—for instance, of Lilly Martin Spencer's thirteen children, only seven survived to maturity—images of domestic life, and death, were of special appeal to the grieving survivors who patronized artists for such mementos.

Three Children documents a family tragedy of the sort that also motivated George Lambdin. In the mid–nineteenth century, he won acclaim for his paintings of poverty and illness, even death, "because of the skill in pathetic expression."[155] *The Last Sleep*, circa 1858 (cat. no. 39), deals with a subject similar to the *Three Children*, but in more generalized and even more sentimentalized terms. Lambdin's is not a specific demise, but rather a general evocation of nineteenth-century death

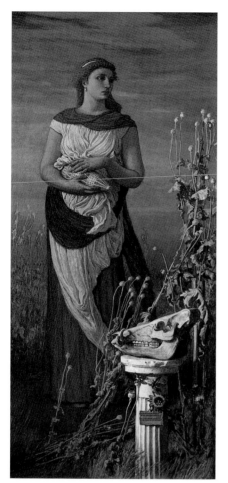

Fig. 33

ELIHU VEDDER

In Memoriam, 1879

Oil on canvas, 44⅛ x 20 inches

In the collection of The Corcoran Gallery
of Art, Washington, D.C.

Museum purchase, Anna E. Clark Fund

59.23

and the rituals of grieving, focusing on a young wife mourned by her prostrate husband. Again, white blossoms bedeck the dead, whose silvery bed curtains provide a shroud. Family piety is marked by the angelic sculpture mounted on the bedroom wall; in the far room, two chairs—his and hers—suggest the domestic tranquillity now lost. The picture relates its tale of loss with an intent more bathetic than documentary, an emphasis appreciated by Victorian critics and audiences. To underscore the sentimental point, Lambdin titled the work when first exhibited with lines taken from Tennyson's "The Deserted House":

> . . . *Life and thought*
> *Here no longer dwell*
> *But in a city glorious*
> *A great and distant city they have bought*
> *A mansion incorruptible.*[156]

The painting, which was shown without poetry at the Paris Exposition Universelle in 1867, stirred viewers to emotional narration, which, in Henry Tuckerman's case, was even accompanied by sound effects: "the husband, utterly crushed with grief, has flung himself across the bed. His face is not seen, but we can imagine its pallor, even as in fancy we can hear the choking sobs with which his bosom heaves."[157] The subject had an enduring appeal, sufficient to lead Lambdin to paint another deathbed scene in *Woman on Her Deathbed* about thirty years later.[158]

Funeral rites and their sentiments were also an interest of certain artists in Vedder's and Lambdin's day. Pathos could be prompted even when the lamented was not human; J. Alden Weir, for instance, could pluck the heartstrings of his viewers with a painting such as *Children Burying a Dead*

Bird, 1878 (fig. 34). When the victim was human, sentiment could flow even more freely. And the more exotic the ritual, the more unfamiliar the activities depicted were to the largely Christian audiences in the United States, the more enticing the paintings were. Frederick Bridgman knew this and, like many midcentury romantic artists, based a successful career on "Oriental" subjects, in his case drawn from his travels in North Africa and Egypt (1872–73). Though he was to return to Algiers often in the ensuing years, this was his only visit to Egypt; nevertheless, it gave him an exposure that critics subsequently thought endowed his works with "archaeological value."[159] *The Funeral of a Mummy,* 1876–77 (cat. no. 10), is a notable example of such a painting.

Bridgman's traveling companion in Egypt, Charles Sprague Pearce, was also moved by the experience. In *Lamentations over the Death of the First-Born of Egypt* (fig. 35) Pearce plays to the Egyptomania of the period, as did his friend; however, unlike Bridgman, he conflates that exoticism with familiar biblical references. More strikingly, his subject is steeped with sentimentality that is lacking from Bridgman's. Parents mourn their dead and embalmed child, whose recumbent form is echoed in the diminutive figures in the foreground; these broken *ushabtis* add a sorrowful, symbolic note, just as do the broken toys at young Eakin's feet or the empty chair and fallen doll in *Three Children.*

Although the setting for Bridgman's obsequies was remote in time and space, thereby enhancing the romantic allure of the subject, the viewer is not struck by the same mournful sentiment. Instead, the artist presents the scene as if it was his own firsthand impression,

Fig. 34

J. ALDEN WEIR

Children Burying a Dead Bird, 1878
Oil on canvas mounted on fiberglass,
22¼ x 18⅛ inches
Smithsonian American Art Museum
Museum purchase
1986.1

an "archaeologically valuable" document more than a Victorian tearjerker. The funeral barge crossing the Nile to the land of the dead looks like a motif straight from the easel of French Salon painters of the period, most notably Bridgman's Parisian teacher, Jean-Léon Gérôme (fig. 36); one reviewer of the 1877 Salon even remarked that it might have been signed by the French master himself.[160] Bridgman's painting appealed to jurors at the 1877 Paris Salon, who awarded the painting a third-class medal. His art also appealed to the critics, who provided readers with detailed descriptions of figures and settings,

along with information on the relevant cultural practices being depicted. As Lois Fink has noted, the method of the critics was akin to that of Bridgman and his Orientalist cohort: "Like the artists, they aimed at instruction and documentation—so that Bridgman's paintings, with commentary provided by reviewers, served on one level much like the illustrations in the *National Geographic* magazine."[161]

Like Bridgman, Carl Gutherz was a product of European academic training, although his mature works bear no resemblance to the former's Orientalizing motifs. Gutherz came to the United States as a young boy with his immigrant family and was raised near Cincinnati and later in Memphis. He returned to Europe in 1868 for training in Paris and subsequently Munich. Thereafter, his career was divided between periods of European residence and protracted stays in the United States, but wherever he worked, his manner was shaped by his academic training and his proclivity for storytelling subjects. In the 1870s, newly returned from European training, Gutherz produced a series of drawings illustrating Henry Wadsworth Longfellow's poem "The Golden Legend" (1851), which, being based on the German "Der Arme Heinrich," had an appeal to the Swiss-born painter.

Gutherz's interest in narrative motifs continued in later life, but he came to draw more often from Scripture than from writings by his contemporaries. His most productive period came during the twelve years he spent in Paris, to which he returned in 1884 and where he exhibited regularly in the annual Salons. His contribution in 1888, *Light of the Incarnation (Lux Incarnationis)* (fig. 37), won critical praise for its spiritual sentiment. It also surprised

Fig. 35

CHARLES SPRAGUE PEARCE
*Lamentations over the Death of the
First-Born of Egypt,* 1877
Oil on canvas, 38½ x 51½ inches
Smithsonian American Art Museum
Museum purchase
1985.28

by virtue of its composition, viewing the miraculous events from an angel's-eye perspective: artist and viewer—and the heavenly host—look down on the spiritual light emanating from a Bethlehem manger far below, symbolic of the divine incarnate in the human. The gathering of emblematic flowers, birds and butterflies, and angels and putti suggests the redemptive theme, while the darkened group of figures foreshadows Christ's ultimate fate. Writers of Gutherz's day were quick to recognize and applaud the affinities of his work with idealist compositions by the era's symbolist artists. For critic Lilian Whiting, *Light of the Incarnation* "suggest[ed] the same sublime lesson as that taught in the lines of Tennyson:

'Knowledge by suffering entereth / And life is perfected by death.'"[162]

Gutherz's 1888 Salon success was followed by more large canvases in a similar religious vein, including *Arcessita ab Angelis,* 1889 (cat. no. 26). Gutherz confided in his notebook that "death is the one sure phenomenon, and it is not necessarily less beautiful than any other creation of the Divine Intelligence."[163] In *Arcessita ab Angelis,* two angels bear a young woman's body tenderly heavenward, assisted by a trio of putti, one of whom weeps and strews blossoms upon the clouds. The ethereal ascension, the transition from the mundane to the heavenly, is rendered in subtle tonalities that reinforce the spirituality of the moment, one that

Fig. 36
JEAN-LÉON GÉRÔME
Excursion of the Harem, 1869
Oil on canvas, 31 x 53 inches
Chrysler Museum of Art, Norfolk, Virginia
Gift of Walter P. Chrysler Jr.
71.511

is dramatically different from Maltby Sykes's later *Ascension* (cat. no. 58).

The guardian angels painted by Dorothea Tanning (cat. no. 60) are of a different species from those who wafted Gutherz's dead maiden heavenward more than fifty years earlier. Her painting is devoid of his religious sentiment; neither does Tanning's subject pretend to document an exotic terrain and culture, as Bridgman did. The guardian angels are instead purely the product of the artist's rich imagination. Tanning spoke of her technique as not based on empirical observation, but as coming from "my hand, its secret path to my brain and how it found ways to paint the visions it found in there."[164] Those visions were often populated with women or young girls, a subject the artist finds endlessly fascinating. "What is more wonderful than the female body? That's the most important and the most wonderful and the most mysterious and extraordinary thing that I

know."[165] In her works of the 1940s and early '50s, Tanning's female protagonists often found themselves in strange, dreamlike—certainly mysterious and extraordinary, even nightmarish—situations: tearing wallpaper from walls to reveal human forms beneath; standing before charred ruins in a desert landscape; floating in file to the ceiling of a menacing interior; or being ravished by winged furies, as in *Guardian Angels.*

These visions' surreal quality gave them an affinity with the works in the landmark exhibition of 1936, *Fantastic Art, Dada, Surrealism,* at the Museum of Modern Art, which Tanning recalled as a "real explosion [that] rock[ed] me on my run-over heels. Here is the infinitely faceted world I must have been waiting for. Here is the limitless expanse of POSSIBILITY, a perspective having only incidentally to do with painting on surfaces. Here . . . are signposts so imperious, so laden, so seductive and, yes, so perverse that . . .

Fig. 37

CARL GUTHERZ

Light of the Incarnation

(Lux Incarnationis), 1888

Oil on canvas, 82¼ x 122 inches

Memphis Brooks Museum of Art,

Memphis, Tennessee

Gift of Mr. and Mrs. Marshall F. Goodheart

68.11.1

they would possess me utterly."[166] That possession led to her enlistment in the surrealist camp, both artistically, from her first solo exhibition at Julian Levy's gallery in 1944, and personally, with her long association with Max Ernst, whom she married. When, in 2002, she looked back on her life and art, Tanning saw this involvement with surrealism as central: "There's enough of greatness in there that there will always be something rewarding for someone who likes to look at beautiful things and wonderful paintings." Today, she admits, "Surrealism is a piece of history," and yet its allure persists, "and it has stained the consciousness of everyone."[167]

In *Guardian Angels,* as often in her work, the subject—the tale from the easel—is not the visual documentation of a clear narrative. Instead, its sensual significance is intuited, perhaps by

painter as much as by viewer; it is the product of suggestion, not exposition. Clues may exist to its genesis, both visual and verbal. The silvery white forms shot through with linear folds recall the abstract patterns in paintings by Roberto Matta, the surrealist master whom Tanning admires extravagantly, the "irrepressible exotic and seminal artist" she thought "worth a hundred pages of fantasies to match his own imagination."[168] The birdlike creatures suggest affinities less with any conventional angelic tribe than with the winged monsters—"Loplop" and other bizarreries—that inhabited the mind and paintings of her husband. They transport young girls, known only by their lower limbs, to . . . what? Safety, or ruin? Tanning recalls the circumstances of the painting's creation, in the desert home she and Ernst shared

in Sedona, Arizona. "Day after day, surrounded as by an enemy who dares not deal the final blow, we doggedly painted our pictures, each of us in our own shimmering four walls, as if we were warriors wielding arms, to survive and triumph." In such "a place of ambivalent elements . . . you gave yourself up to that incredibly seductive wafture that, try as you might, you could never name."[169] The painting's subject, likewise so powerful yet elusive, so unnameable, suggests the domestic arena, "the spaces around our table and our bed [that] were hung with the web of his [Ernst's] stories, a long strand of shimmering beads strung with knots and areas of time and place in between each one," stories now vaguely recalled, "like dried mummy linen [clinging] to an indistinct silhouette."[170]

In the end, we can trust only the sense, not the story, for there is no clear meaning, neither in word nor in image. It was D. H. Lawrence's advice that we trust the tale, not the teller. Here, as with so many narrative images, we must trust the painting, not the painter.

NOTES

1. Nancy Willard, *Simple Pictures Are Best* (New York: Harcourt Brace Jovanovich, 1977).

2. Walter Benjamin, *The Origin of German Tragic Drama;* as quoted in Craig Owens, "The Allegorical Impulse: Toward a Theory of Postmodernism," in *Beyond Recognition: Representation, Power, and Culture,* ed. Scott Bryson et al. (Berkeley: University of California Press, 1992), 56.

3. Robert Scholes and Robert Kellogg, *The Nature of Narrative* (New York: Oxford University Press, 1966), 4.

4. Rufus Jarman, "Profiles: U.S. Artists—II," *New Yorker,* March 24, 1945: 36.

5. H. L. Mencken, "The Sahara of the Bozart," in *The American Scene: A Reader,* ed. Huntington Cairns (New York: Alfred A. Knopf, 1977), 117. Originally printed in shorter form in the *New York Evening Mail,* Nov. 13, 1917.

6. Although the "Lansdowne" portrait is sometimes described as a depiction of Washington addressing Congress, the subject stands inert and closemouthed, "as still as a statue" (in Richard McLanathan's happy phrase) with no suggestion of oratorical flourish. Richard McLanathan, *Gilbert Stuart* (New York: Harry N. Abrams, 1986), 88.

7. Meyer Schapiro, *Words and Pictures: On the Literal and Symbolic in the Illustration of a Text* (The Hague: Mouton, 1973), 39.

8. See Dorinda Evans, *The Genius of Gilbert Stuart* (Princeton, N.J.: Princeton University Press, 1999), for a discussion of the variants on this composition.

9. For a discussion of Stearns's Washington paintings, see Mark Edward Thistlethwaite, *The Image of George Washington: Studies in Mid-Nineteenth-Century American History Painting* (New York: Garland, 1979).

10. Mark Thistlethwaite notes that when Stearns exhibited the painting at the Pennsylvania Academy of the Fine Arts and at the National Academy of Design, both in 1854, it was with the title *Washington, the Farmer.* Mark Thistlethwaite, "Picturing the Past: Junius Brutus Stearns's Paintings of George Washington," *Arts in Virginia* 25 (1985): 19, n. 28. From the more generic "Farmer" title, John Vlach concludes that Stearns aimed "to make Washington more approachable. Perhaps he intended the term to insulate Washington from any of the stigma that nonsoutherners might have associated with the word 'planter.'" John Vlach, *The Planter's Prospect: Privilege and Slavery in Plantation Paintings* (Chapel Hill: University of North Carolina Press, 2002), 194, n. 49.

11. Horatio Hastings Weld, *The Life of George Washington* (Philadelphia: Lindsay and Blakiston, 1845), 146; quoted in Barbara J. Mitnick, "Paintings for the People: American Popular History Painting, 1875–1930," in *Picturing History: American Painting, 1770–1930,* ed. William Ayres (New York: Rizzoli, 1993), 161–64.

12. Just as genre or history painting is often discussed in literary terms of its narrative, so too has literature been described in pictorial terms. Mark Twain's *Life on the Mississippi,* for instance, with its classic description of the folklife of raftsmen, has been called "a genre painting, both realistic and idealized." Hennig Cohen, "Folklore in Literature," *Encyclopedia of Southern Culture,* ed. Charles Reagan

Wilson and William Ferris (Chapel Hill: University of North Carolina Press, 1989), 855.

13. A. Saule, "Genre Pictures," *The Aldine* 9 (1878–79): 22. Henry Tuckerman anticipated this reaction when he noted that "the greater part of the literature of the country has sprung from New England, and is therefore, as a general rule, too unimpassioned and coldly elegant for popular effect." Henry T. Tuckerman, "A Sketch of American Literature," in Thomas B. Shaw, *Outlines of English Literature* (Philadelphia: Blanchard and Lea, 1856), 434.

14. Sanford Schwartz, "Back to the Future" (review of Elizabeth Prettejohn, *The Art of the Pre-Raphaelites*), *New York Review of Books,* Feb. 8, 2001: 12.

15. Lesley Carol Wright, "Men Making Meaning in Nineteenth-Century American Genre Painting, 1860–1900" (Ph.D. dissertation, Stanford University, 1993), 44.

16. Frederick Wedmore, *The Masters of Genre Painting* (London: Kegan Paul, 1880), 2.

17. Susan Danly, *Telling Tales: Nineteenth-Century Narrative Painting from the Collection of the Pennsylvania Academy of the Fine Arts* (New York: American Federation of Arts, 1991), 10.

18. David Thorburn, "Television as an Aesthetic Medium," *Critical Studies in Mass Communication* 4 (1987): 167–68, 170.

19. Thorburn, "Television as an Aesthetic Medium," 171.

20. Roland Barthes, "Introduction to the Structural Analysis of Narratives," in *Image—Music—Text,* trans. Stephen Heath (New York: Hill and Wang, 1977), 79.

21. Introduction to *Storytellers: Folktales and Legends from the South,* ed. John A. Burrison (Athens: University of Georgia Press, 1989), 1.

22. Tuckerman, "A Sketch of American Literature," 433–34.

23. Horace Bradley, *Atlanta Constitution,* May 7, 1882; quoted in Carlyn Gaye Crannell, "In Pursuit of Culture: A History of Art Activity in Atlanta, 1847–1926" (Ph.D. dissertation, Emory University, 1981), 21.

24. Barbara Novak, *Nature and Culture: American Landscape and Painting, 1825–1875* (New York: Oxford University Press, 1980), 3.

25. Edward Hicks, *Memoirs of the Life and Religious Labors of Edward Hicks, Late of Newtown, Bucks County, Pennsylvania. Writ-*

ten by *Himself*; quoted in Carolyn J. Weekley, *The Kingdoms of Edward Hicks* (New York: Harry N. Abrams, 1999), 236, n. 13.

26. Charles C. Eldredge and Barbara B. Millhouse, *American Originals: Selections from Reynolda House, Museum of American Art* (New York: Abbeville, 1990), 34.

27. Weekley, *The Kingdoms of Edward Hicks*, 53.

28. Andrew Wilton and Tim Barringer, *American Sublime: Landscape Painting in the United States, 1820–1880* (London: Tate, 2002), 88.

29. W. E. B. Du Bois, "The Looking Glass: Tanner," *Crisis* 31 (Jan. 1926): 146. Du Bois was speaking of an earlier version of the same subject (unlocated) that was exhibited at New York's Metropolitan Museum of Art in 1926.

30. Albert Boime, *Thomas Couture and the Eclectic Vision* (New Haven: Yale University Press, 1980), 604.

31. Sykes quoted in James Saxon Childers, "Meet Maltby Sykes, Talented Local Young Artist," *Birmingham News,* June 23, 1940. I am grateful to Alice Carter, librarian at the Montgomery Museum of Fine Arts, for bringing this article to my attention.

32. "There is no Frigate like a Book," no. 1286 in *The Poems of Emily Dickinson,* ed. R. W. Franklin (Cambridge, Mass.: Belknap, 1999), 501.

33. James Fenimore Cooper, *The Pioneers* (1823; Oxford: Oxford University Press, 1991), 197 (chap. 17). For a discussion of Deas's painting and its relation to Cooper's text, see Elwood Parry, *The Image of the Indian and the Black Man in American Art, 1590–1900* (New York: George Braziller, 1974), 77–81. Deas appears to be the first painter, and among the few, to depict Cooper's turkey shoot incident. William Walcutt followed with an oil painting, circa 1845–50 (Smithsonian American Art Museum), as did Tompkins H. Matteson in 1857 (New York State Historical Association, Cooperstown).

34. "The Second Voyage of Sindbad the Sailor," in *Arabian Night's Entertainments,* ed. Robert L. Mack (Oxford: Oxford University Press, 1995), 147–151.

35. Joshua C. Taylor et al., *Perceptions and Evocations: The Art of Elihu Vedder* (Washington: Smithsonian Institution Press, 1979), 62–63. Vedder's interest in Sinbad's adventures with the Roc was unusual but not unique among American artists. Thomas

Moran, who was better known for his depictions of western landscape, in 1897 painted a watercolor of the subject, *Sinbad and the Roc* (unlocated). In 1906–7, Maxfield Parrish, on a commission from *Collier's,* produced a series of twelve illustrations for *The Arabian Nights,* which appeared in a special volume in 1909.

36. Elizabeth Broun, *Albert Pinkham Ryder* (Washington: Smithsonian Institution Press, 1989), 66.

37. Rick Stewart, "Carroll Cloar," in *Encyclopedia of Southern Culture,* ed. Charles Reagan Wilson and William Ferris (Chapel Hill: University of North Carolina Press, 1989), 121.

38. Henry McBride, "The Art of Burroughs," *Fine Arts Journal* 36 (1918): 63. In the purposeful merger of modern and ancient references, Burroughs coincidentally paralleled the practice of Henry O. Tanner. W. E. B. Du Bois proposed that the pall in Tanner's *Sodom and Gomorrah* (cat. no. 59) was inspired by explosions during World War I, a "characteristic interpretation of old-world stories and legends into which enters some aspect of our own day." Du Bois, "The Looking Glass: Tanner," 146.

39. "Tribute Is Paid to Classical and Whimsical Art of Burroughs," *Art Digest,* April 1, 1935: 10.

40. Elliott Daingerfield, "Sketch of his life—written by Elliott Daingerfield—in response to a request" (unpublished and undated typescript, Elliott Daingerfield estate files, Center for the Study of Southern Painting, Morris Museum of Art, Augusta, Ga.), 2. I am grateful to J. Richard Gruber for calling this document to my attention.

41. Elliott Daingerfield, "The Sleepers," in *Victorian Visionary: The Art of Elliott Daingerfield,* by Estill Curtis Pennington and J. Richard Gruber (Augusta, Ga.: Morris Museum of Art, 1994), 43.

42. Patricia M. Burnham and Lucretia Hoover Giese, "Introduction: History Painting: How It Works," in *Redefining American History Painting,* ed. Burnham and Giese (Cambridge: Cambridge University Press, 1995), 1.

43. Craig Owens, "The Allegorical Impulse: Toward a Theory of Postmodernism," in Owens, *Beyond Recognition: Representation, Power, and Culture* (Berkeley: University of California Press, 1992), 53–54, 57. Emphasis in original.

44. Moser's painting (sadly, unlocated), as described at length in the local press, included a rich combination of regional references. It featured "a beautiful brunette girl draped in the American flag which falls in graceful folds about a still more graceful figure. Her left hand rests upon a bale of cotton while her right is extended in a welcome to all visitors. Above the 'New South' stands uncle Sam, his face beaming with satisfaction as he joins in the welcome and points with pride to achievements of the 'New South.' Columbia, on a seat of state behind a bale of cotton, which is surmounted with a crown and wreaths, has relaxed her features into a smile of approval. An Indian chief quietly smokes his pipe in the foreground and presents a picture of the most supreme satisfaction. 'Clio,' with pen and tablet in hand, sits eager to catch and record each word of praise of the grand and glorious event in the history of the south. The familiar faces of 'Uncle Remus' and 'Old Si' peep from opposite sides of the tableau, which, with its marble columns, brocaded curtains, plush carpets, etc., etc., rises from the very midst of a cotton field, from which negroes are picking the great staple. . . . The left side of the picture represents the agricultural features of the south; a scene of Mississippi cotton country stretches away toward a dim horizon, showing the 'big house' of the planter, the negro quarters, the modern cotton presses, that the old screw will soon be numbered among the things that were, and a brief view of the Mississippi river with boats plying in the distance. With the blue waters of the gulf of Mexico for a background, the city of New Orleans is seen with her crowded levee. Mississippi steamboats are discharging their cargoes of cotton, while a forest of tall masted ocean vessels await patiently their load of compressed bales for manufactures beyond the sea. Following up the river from the city is seen high brick cotton factories, a reminder that cotton is manufactured with success in Mississippi, where so much of it is grown." *Atlanta Constitution,* Nov. 11, 1881; quoted in Crannell, "In Pursuit of Culture," 151–52.

45. Douglas Southall Freeman, foreword to *A Treasury of Southern Folklore,* ed. B. A. Botkin (New York: Crown, 1949), vii.

46. *The Confederate Veteran,* May 1907; quoted in James A. Hoobler, *Gilbert Gaul, American Realist* (Nashville: Tennessee State Museum, 1992), 5. The Southern Art

Publishing Company's venture failed and the portfolio was never realized in full, although five editions of selected works were subsequently issued and sold.

47. While in Libya in 1943, Wilt painted a "portrait" of a B-25 (oil on canvas, 20 x 24 inches), which is illustrated in *Richard Wilt*, exh. cat. (Pontiac, Mich.: Creative Center for Art, 1998), 17.

48. The expansive scene, painstakingly detailed in the documentation of figures and armaments, was intended for a print; the painting's strong contrasts of light and dark would have aided the printmaker in making that translation. An engraving of the subject was published in Paris in 1817. Estill Curtis Pennington, *Downriver: Currents of Style in Louisiana Painting, 1800–1950* (Gretna, La.: Pelican, 1990), 96–97.

49. "Review of the Exhibition," *Portfolio Magazine* 8:1 (July 1812): 22–23.

50. Kevin Sack, "In Its Heart, It's a Southern Town," *New York Times*, March 4, 2001, Sophisticated Traveler section, p. 16

51. Ralph Waldo Emerson, "The American Scholar" (1837), in *Selections from Ralph Waldo Emerson*, ed. Stephen E. Whicher (Boston: Houghton Mifflin, 1957), 78.

52. For the Doyle cartoon, see Bruce W. Chambers, *The World of David Gilmour Blythe (1815–1865)* (Washington: National Collection of Fine Arts, 1980), 61, fig. 37.

53. As Estill Pennington has pointed out, the parable from the Old Testament offers another parallel to the painting's subject; like the slave-owner father, Abraham also abandoned another son, Ishmael, who was born of a miscegenational relationship with the faithful servant Hagar. After Sarah gave birth to Isaac, Abraham expelled both Hagar and Ishmael into the desert. Estill Curtis Pennington, *Look Away: Reality and Sentiment in Southern Art* (Spartanburg, S.C.: Saraland, 1989), 18.

54. Unidentified critic, quoted in Harold Holzer and Mark E. Neely Jr., *Mine Eyes Have Seen the Glory: The Civil War in Art* (New York: Orion Books, 1993), 254.

55. *The Art Journal* (1876), quoted in William Lipke, *Thomas Waterman Wood, P.N.A (1823–1903)* (Montpelier, Vt.: Wood Art Gallery, 1972), 41–44.

56. "I did not do one on *Swing Low Sweet Chariot* because it had been well handled by John McCrady, a Mississippi artist working in New Orleans, and was reproduced in *Life* magazine." Lamar Baker, *Recollections of an Art Student* (New York: Vantage, 1990), 143–44.

57. Thomas Jefferson, *Notes on the State of Virginia* (1784); quoted in Vernon Louis Parrington, *Main Currents in American Thought: The Colonial Mind, 1520–1800* (1927; New York: Harcourt, Brace & World, 1954), 353.

58. Hector St. John de Crèvecoeur, *Letters from an American Farmer* (1782); quoted in Alfred Kazin, *A Writer's America: Landscape in Literature* (New York: Knopf, 1988), 28.

59. William U. Eiland, "Picturing the Unvictorious: The Southern Scene in Alabama, 1930–1946," in *The American Scene and the South*, ed. Patricia Phagan (Athens: Georgia Museum of Art, 1996), 39.

60. Quoted in Louis D. Rubin Jr., introduction to *I'll Take My Stand*, by Twelve Southerners (New York: Harper & Brothers, 1962), viii–ix.

61. Donald Davidson, "A Mirror for Artists," in *I'll Take My Stand*, 29.

62. Andrew Nelson Lytle, "The Hind Tit," in *I'll Take My Stand*, 205.

63. Roxana Barry, *Land of Plenty: Nineteenth Century American Picnic and Harvest Scenes* (Katonah, N.Y.: Katonah Gallery, 1981), 4.

64. Barry, *Land of Plenty*, 13.

65. "One Day in My Life," *Harper's Weekly* 2, no. 53 (Jan. 2, 1858): 11.

66. Michael Kimmelman, "An Invigorating Homecoming," *New York Times*, April 12, 1996.

67. Go Peep, "The Promenader," *Montgomery Advertiser-Journal*, Jan. 9, 1949. I am grateful to Dr. Paul Richelson, Mobile Museum of Art, for providing a copy of this article.

68. Elizabeth McCausland, "Robert Gwathmey," *Magazine of Art*, April 1946: 149.

69. H. G. Wells, *Tono-Bungay* (New York: Duffield, 1909), 286–87.

70. David Park Curry, "Shopping, Collecting, Remembering: Some Turn-of-the-Century American Paintings," *New York International Art Fair* (spring 1996): 17.

71. Albert Eugene Gallatin, *Art and the Great War* (New York: E. P. Dutton, 1919), 45.

72. Franklin Delano Roosevelt, "Second Inaugural Address," in *The Inaugural Addresses of the American Presidents from Washington to Kennedy*, annotated by David Newton Lott (New York: 1961), 239.

73. David Riesman, *The Lonely Crowd* (New Haven: Yale University Press, 1950).

74. Michael Harrington, *The Other America* (New York: Macmillan, 1963), 136. The poor are at variance with America's "self-image as a nation of joiners . . . [which is] a phenomenon of the middle class" (133).

75. *Choruses from "The Rock"* (1934), in T. S. Eliot, *The Complete Poems and Plays* (New York: Harcourt, Brace, 1952), 101. In Eliot's case, the ideal was a community "in praise of God."

76. D. H. Lawrence, *Studies in Classic American Literature* (1923; New York: Viking, 1964), 6. Emphasis in original.

77. "Song of Myself," stanzas 15, 20; Walt Whitman, *Leaves of Grass*, ed. Harold W. Blodgett and Sculley Bradley (New York: New York University Press, 1965), 44, 47.

78. Excerpt from Jacksonville newspaper, date unknown; quoted in typescript regarding painting, p. 2 (curatorial files, Birmingham Museum of Art).

79. For a surreal example, see Morris Kantor's *Captain's House*, 1929 (Smithsonian American Art Museum), or his *Haunted House*, 1930 (Art Institute of Chicago); for a social realist example, see Mitchell Siporin's *The Homeless*, 1939 (coll. Sandra and Bram Dijkstra).

80. Regina Soria, *Elihu Vedder: American Visionary Artist in Rome (1836–1923)* (Rutherford, N.J.: Fairleigh Dickinson University Press, 1970), 152.

81. James Weldon Johnson, *The Autobiography of an Ex-Coloured Man* (1912; New York: Knopf, 1927), 90–97, 110–14.

82. Randolph Delehanty, *Art in the American South: Works from the Ogden Collection* (Baton Rouge: Louisiana State University Press, 1996), 207.

83. For the most famous examples, see James Agee and Walker Evans, *Let Us Now Praise Famous Men* (Boston: Houghton Mifflin, 1941).

84. Soon after its completion, the painting was exhibited at the Art Institute of Chicago, the National Academy of Design, and the Dallas Museum of Fine Arts, but it found no buyer, and Ufer's career never recovered. Shortly before her death in 1946, his widow gave the painting to the Speed Museum in Louisville, which had been Ufer's childhood home. (For his fine Ufer research generally, and for specific details on the subject and

history of *Bob Abbott and His Assistant,* I am indebted to my University of Kansas graduate student Jerry N. Smith and his seminar paper on this painting.)

85. Thomas Craven, *Modern Art: The Men, the Movements, the Meaning* (New York: Simon and Schuster, 1940), 336.

86. "A Painter of Labor"; unidentified magazine clipping in vertical file (Chapin), American Art/Portrait Gallery Library, Smithsonian Institution, Washington, D.C.

87. Guy C. McElroy, *Facing History: The Black Image in American Art, 1710–1940* (San Francisco: Bedford Arts, 1990), 117. Chapin and Wood were among the nine American artists commissioned by the motion picture industry to produce paintings based on the filming of *The Long Voyage Home.* See "The Long Voyage Home as Seen and Painted by Nine American Artists," *American Artist* 4 (September 1940): 4–14.

88. Harry Salpeter, "Chapin: Little Man in Art," *Esquire,* Aug. 1940: 107.

89. C. J. Bulliet, "Our American Cézanne Looks at Nature," *Chicago Evening Post: Magazine of the Art World,* Dec. 29, 1925: 1.

90. F.L.K., "Paintings of Farm Life by James Chapin," *Survey Graphic,* Aug. 1928: 464.

91. Maureen C. O'Brien, "James Chapin: The Marvin Years," *Montclair Art Museum Exhibition Notes* (Montclair, N.J.: Montclair Art Museum, 1974), n.p.; copy in vertical files, American Art/Portrait Gallery Library, Smithsonian Institution, Washington, D.C.

92. "James Chapin, American Painter," *Christian Science Monitor,* May 29, 1926.

93. Alexander Eliot, *Three Hundred Years of American Painting* (New York: Time, 1957), 206.

94. "An Evening in the Studio of James Chapin," *American Artist,* May 1941: 6–8.

95. Wright, "Men Making Meaning," 150–51. As in the late nineteenth century, so too in the late twentieth did emotional cues aid the pictorial narrative: "The narrative artist cannot assume that the viewer will believe in or feel compelled to even read his work. For this reason it is common for a narrative artist to seek a relatively accessible theme, often one which touches on emotional or action-packed issues as would a more vernacular form of narrative. Most frequently such themes are enriched by a narrative artist with a heightened sense of poignancy, mystery, or ambiguity."

96. Boime, *Thomas Couture,* 590.

97. Elizabeth Johns, *American Genre Painting: The Politics of Everyday Life* (New Haven, Conn.: Yale University Press, 1991).

98. "Editor's Table: The Fine Arts," *Knickerbocker* 16 (July 1840): 82.

99. Robert Burns, "To Daunton Me," in *Poems and Songs of Robert Burns,* ed. James Burke (London and Glasgow: Collins, 1955), 440.

100. The mastiff Rab was not part of the original composition but was added sometime between 1876 and 1879. Presumably this modification was made at the suggestion of, or with the consent of, the painting's owner, Charles Stewart Smith, and occasioned the change in title. For details on the painting's history, see Margaret C. Conrads, *Winslow Homer and the Critics: Forging a National Art in the 1870s* (Princeton, N.J.: Princeton University Press, 2001), 227, n. 64.

101. "The Fine Arts: Exhibition of the National Academy," *New York Times,* April 8, 1867, 6–7. I am grateful to Margaret Conrads for providing copies of this and other reviews of Homer's 1875 work. For a thorough discussion of the critical response to Homer's contributions to the 1876 exhibition, see Conrads, *Winslow Homer and the Critics,* chap. 5.

102. Nicolai Cikovsky Jr., "A Harvest of Death: *The Veteran in a New Field,*" in *Winslow Homer: Paintings of the Civil War,* by Marc Simpson et al. (San Francisco: Fine Arts Museums of San Francisco, 1988), 93.

103. Edward Strahan [Earl Shinn], "Fine Arts: The National Academy Exhibition, II," *The Nation* 22 (April 20, 1876): 268.

104. Edward Strahan, ed., *The Art Treasures of America,* vol. 2 (1879; New York: Garland, 1977), 91–92.

105. Clarence Cook, Review of National Academy of Design exhibition, *New York Daily Tribune,* April 18, 1876, 2.

106. David M. Lubin, *Picturing a Nation: Art and Social Change in Nineteenth-Century America* (New Haven: Yale University Press, 1994), chap. 4.

107. Lubin, *Picturing a Nation,* 193.

108. Though the kitchen and its provisions were customarily a feminine domain in the nineteenth century, in Cincinnati, where the

Spencers once resided, Mrs. Trollope discovered that "It is the custom for the gentlemen to go to the market. . . . The smartest men in the place, and those of the 'highest standing' do not scruple to leave their beds with the sun, six days in the week, and, prepared with a mighty basket, to sally forth in search of meat, butter, eggs and vegetables." Frances Trollope, *Domestic Manners of the Americans* (1849); quoted in Robin Bolton-Smith, *Lilly Martin Spencer, 1822–1902: The Joys of Sentiment* (Washington, D.C.: National Collection of Fine Arts, 1973), 172–73.

109. The Hunter Museum's painting is likely Spencer's second version of the subject. Ellen Simak, *A Catalogue of the American Collection,* vol. 2 (Chattanooga: Hunter Museum of American Art, 2001), 13.

110. Harriet Martineau, *Society in America* (1837); quoted in Ella-Prince Knox et al., *Painting in the South: 1564–1980* (Richmond: Virginia Museum, 1983), 234.

111. Carolyn Kinder Carr, "Prejudice and Pride: Presenting American Art at the 1893 World's Columbian Exposition," in *Revisiting the White City: American Art at the 1893 World's Fair,* by Carolyn Kinder Carr et al. (Washington: National Museum of American Art and National Portrait Gallery, 1993), 98.

112. This connection was first proposed by Linda Bantel in *American Paintings in the Metropolitan Museum of Art,* vol. 2, by Natalie Spassky et al. (New York: The Museum in association with Princeton University Press, 1985), 540.

113. Unidentified newspaper clipping, quoted in Elizabeth McCausland, *The Life and Work of Edward Lamson Henry, N.A., 1841–1919* (1945; New York: Kennedy Graphics and DaCapo, 1970), 64.

114. "There's a certain Slant of light," no. 320 in *The Poems of Emily Dickinson,* ed. R. W. Franklin (Cambridge, Mass.: Belknap, 1999), 142.

115. W. J. Lampton to E. L. Henry; quoted in McCausland, *Edward Lamson Henry,* 104.

116. Unidentified newspaper clipping, April 3, 1879; quoted in McCausland, *Edward Lamson Henry,* 105.

117. John I. H. Baur, *Philip Evergood* (New York: Harry N. Abrams, 1975), 47, 50. More recently, the painter-critic Sidney Tillim similarly explained, "'currency' is only part of the motivation behind history painting . . . topicality destroys either the temporal

or geographical remoteness that, indeed, insulates the event from reality and permits the imagination to simplify and 'idealize' it." Sidney Tillim, "Notes on Narrative and History Painting," *Artforum* 15 (May 1977): 43.

118. Ruth Berenson, "The Romantic Agony in America," *Art News* 42, no. 14 (Dec. 1, 1943): 49.

119. Herman Baron, Statement for Philip Evergood exhibition catalogue, ACA Galleries, New York, March 24–April 13, 1940, n.p. (copy in curatorial files, Georgia Museum of Art).

120. Sanford Gerard to Rockwell Kent, Feb. 21, 1946; in Rockwell Kent Papers, Archives of American Art, Smithsonian Institution, Washington, D.C.

121. Eric J. Schruers, "Interpreting the Real and the Ideal: Rockwell Kent's Lost Bituminous Coal Series Rediscovered," *Kent Collector*, summer 1999: 28. I am grateful to Professor Schruers, Mesa State College, for his helpful response to my questions regarding the series.

122. George MacBeth, "Subliminal Dreams," in *Narrative Art, Art News Annual*, ed. Thomas B. Hess and John Ashbery, 36 (1970): 29. Max Kozloff reiterated the ties between narration and advertising: "The narrative way . . . was the route taken in . . . the middlebrow arts, and the media—in the movies, popular fiction, songs, mainstream theater, soaps, and the comics. And it was the implied structure of a great deal of advertising." Max Kozloff, "Through the Narrative Portal," *Artforum* 24:8 (April 1986): 86.

123. Eugene Benson, "Childhood in Modern Literature," *Appleton's Journal of Popular Literature, Science, and Art* 1 (April 24, 1869): 118–19.

124. Henry T. Tuckerman, "Children," *The Galaxy* 4 (July 1867): 316.

125. *The Token; A Christmas and New Year's Present* (Boston, 1830); quoted in Andrew J. Cosentino, *The Paintings of Charles Bird King (1785–1862)* (Washington, D.C.: Smithsonian Institution Press, 1977), 93.

126. "When We Were Boys," in *Sunshine at Home: Sparkling Pages for the Child, the Youth, the Parent* (Battle Creek, Mich.: Review and Herald, 1883), 23.

127. Greville Chester, *Transatlantic Sketches* (London, 1869); quoted in Richard L. Rapson, "The American Child as Seen by British Travelers, 1845–1935," *American Quarterly* 17:3 (fall 1965): 521.

128. Lady Emmeline Stuart-Wortley, *Travels in the United States* (Paris, 1851), 67; quoted in Rapson, "The American Child," 521.

129. Walt Whitman, "Mannahatta," in *Walt Whitman's Blue Book: The 1860–61 Leaves of Grass Containing His Manuscript Additions and Revisions* (New York: New York Public Library, 1968), 405.

130. Walt Whitman, "Crossing Brooklyn Ferry," stanza 8, in *Walt Whitman: Complete Poetry and Collected Prose* (New York: Library of America, 1982), 312.

131. Williams cited only John Carlin's *After a Long Cruise (Salts Ashore)*, 1857 (Metropolitan Museum of Art). Hermann Warner Williams, *Mirror to the American Past: A Survey of American Genre Painting: 1750–1900* (Greenwich, Conn.: New York Graphic Society, 1973), 103.

132. Walter Rawls, *The Great Book of Currier and Ives' America* (New York, 1979), 527; cited in Lee M. Edwards, *Domestic Bliss: Family Life in American Painting, 1840–1910* (Yonkers, N.Y.: Hudson River Museum, 1986), 26.

133. Martha Hoppin, *Country Paths and City Sidewalks: The Art of J. G. Brown* (Springfield, Mass.: George Walter Vincent Smith Art Museum, 1989), 23.

134. Hoppin, *Country Paths and City Sidewalks*, 28.

135. Kozloff, "Through the Narrative Portal," 86.

136. Ernest W. Watson, "An Interview with Andrée Ruellan," *American Artist*, October 1943: 8. Ruellan's interest in subjects at work or play appeared very early; *April*, a drawing of a person raking, with flowers and flying forms, was published in *The Masses* in April 1914, when the precocious artist was only eight years old.

137. Lincoln Kirstein, *Paul Cadmus* (San Francisco: Pomegranate Artbooks, 1992), 25.

138. William Grimes, "The Charge? Depraved. The Verdict? Out of the Show," *New York Times*, March 8, 1992.

139. Joseph O. Goodwin, "In a Country Store," *Harper's New Monthly Magazine* 40 (July 1870): 827.

140. Philip Eliasoph, *Paul Cadmus: Yesterday and Today* (Oxford, Ohio: Miami University Art Museum, 1981), 73.

141. Katherine Kuh, "Why Wyeth?" *Saturday Review*, Oct. 26, 1968, 26–27.

142. John W. Coffey, Entry for Wyeth's *Winter 1946*, in *North Carolina Museum of Art Handbook of the Collections* (Raleigh: North Carolina Museum of Art, 1998), 225.

143. Richard Meryman, "Andrew Wyeth: An Interview," in *The Art of Andrew Wyeth*, by Wanda M. Corn (Greenwich, Conn.: New York Graphic Society, 1973), 58.

144. "American Realists," *Time*, July 16, 1951: 72. "Over on the other side of that hill was where my father was killed [when a train hit his car at a crossing], and I was sick I'd never painted him. The hill finally became a portrait of him." Richard Meryman, "Andrew Wyeth: An Interview," in Corn, *Art of Andrew Wyeth*, 58.

145. Richard Meryman, *Andrew Wyeth: A Secret Life* (New York: Harper Collins, 1996), 231.

146. "Andy's World," *Time*, Dec. 27, 1963: 51.

147. "Studio Notes," *Art Interchange* 4 (March 17, 1880): 47. In 1883, Vedder sold a drawing to Harper and Brothers to serve as title page illustration for Poe's "The Raven." Elihu Vedder, *The Digressions of V.* (Boston and New York: Houghton Mifflin, 1910), 483.

148. For an account of one literary patron, see Regina Soria, "Mark Twain and Vedder's Medusa," *American Quarterly* 16 (winter 1964): 603–7. It is worth noting that in addition to his narrative paintings, Vedder also produced illustrations for others' texts, most notably a remarkable series of drawings (Smithsonian American Art Museum) illustrating Edward Fitzgerald's *Rubaiyat of Omar Khayyam*, published in 1884. Moreover, Vedder was a writer as well as a painter; his published works include poetry and fanciful short stories in addition to his autobiography, *The Digressions of V.*

149. Vedder suffered the loss of a third son, Nico, who died in 1916, leaving the artist's daughter Anita as his sole heir.

150. Vedder, *Digressions*, 236.

151. The other known examples of this type are catalogued in *Elihu Vedder: American Visionary Artist in Rome (1836–1923)*, by Regina Soria (Rutherford, N.J.: Fairleigh Dickinson Press, 1970), nos. 300, 309, and 337. The High Museum's painting is not included in Soria's inventory.

152. Soria, *Elihu Vedder*, 321.

153. *Illustrated London News*, 1864; quoted in Phyllis Cunnington and Catherine Lucas, *Costume for Births, Marriages, and Deaths* (London, 1972), 142.

154. Richard Coe Jr., "The Vacant Chair," *Godey's Lady's Book* 40 (Jan. 1850): 69. I am grateful to Matthew Bailey for calling this verse to my attention. The image and the sentiment were frequently encountered at midcentury, as in the lament:

We shall meet but we shall miss him,
There will be one vacant chair;
We shall linger to caress him
While we breathe our evening prayer.

Henry S. Washburn and George F. Root, Chorus to "The Vacant Chair (We Shall Meet But We Shall Miss Him)" (Chicago, 1861).

155. Henry T. Tuckerman, *Book of the Artists: American Artist Life* (1867; New York: James F. Carr, 1966), 450.

156. Tennyson, as misquoted by Lambdin when he exhibited the painting at the Pennsylvania Academy of the Fine Arts in 1858. Ruth Irwin Weidner, *George Cochran Lambdin, 1830–1896* (Chadds Ford, Pa.: Brandywine River Museum, 1986), 21.

157. Tuckerman, *Book of the Artists,* 451.

158. The later painting pairs the deceased with a mourning woman and a child. Sotheby Parke-Bernet, New York: Sale catalogue, Nov. 17–19, 1977, lot 494; cited in Weidner, *George Cochran Lambdin,* 51, n. 24.

159. Editor's note, *Art Interchange* 6 (March 3, 1881): 56; quoted in Lois Fink, *American Art at the Nineteenth-Century Paris Salons* (Cambridge: Cambridge University Press, 1990), 166.

160. Parisian critic Albert Wolff, in *Le Figaro*; cited in H. Barbara Weinberg, *The American Pupils of Jean-Léon Gérôme* (Fort Worth, Tex.: Amon Carter Museum, 1984), 49, n. 42.

161. Fink, *American Art at the Nineteenth-Century Paris Salons,* 166.

162. Lilian Whiting, "The Art of Carl Gutherz," *International Studio* 24 (Feb. 1905): lxxxiii.

163. Carl Gutherz, "The Blue Book," 1892–93 (Memphis Brooks Musuem of Art); quoted in Douglas Hyland, "Carl Gutherz and His Utopian Vision," *Interpretations* 13 (spring 1982): 64.

164. Dorothea Tanning, *Between Lives: An Artist and Her World* (New York: W. W. Norton, 2001), 146.

165. Linda Yablonsky, "Surrealist Views from a Real Live One," *New York Times,* March 24, 2002.

166. Dorothea Tanning, *Birthday* (San Francisco: Lapis, 1986), 73–74.

167. Yablonsky, "Surrealist Views."

168. Tanning, *Between Lives,* 177.

169. Tanning, *Between Lives,* 144–45.

170. Tanning, *Birthday,* 32.

Catalogue OF THE Exhibition

By
Reed Anderson
and
Stephanie J. Fox

Gertrude Abercrombie

Born in Austin, Texas, 1909

Died in Chicago, Illinois, 1977

Gertrude Abercrombie was steeped in alternative methods of storytelling from a very early age. The only child of opera singers, Abercrombie maintained throughout her life a love of music (jazz in particular), an interest in contemporary literature, and a penchant for eloquence.

When she was four years old, Abercrombie's family moved to Berlin, Germany, to facilitate her mother's study of opera. On Christmas Eve, 1914, the family arrived back in the United States. By the next year, Abercrombie was in Illinois, first in Aledo, and soon thereafter in the Hyde Park neighborhood of Chicago, which she would call "home" for the rest of her life. In 1929 Abercrombie was awarded a degree in Romance languages from the University of Illinois. The following year she attended the School of the Art Institute of Chicago and the American Academy of Art, where she learned figure drawing as well as commercial drawing techniques.

By the early 1930s, Abercrombie's artistic star was in its ascendancy. Her paintings were shown in several Chicago galleries, and by 1935 her work was exhibited regularly at the Art Institute. Like many other artists of her generation, Abercrombie found employment with the Public Works of Art Project that was part of President Roosevelt's Works Progress Administration.

In the 1940s, Abercrombie's renown spread as an artist and as an affable hostess to many jazz greats such as Dizzy Gillespie, Sarah Vaughn, and Charlie Parker, whose concert tours brought them to Chicago. Surrounded by musicians, writers, and thinkers, Abercrombie, the self-pronounced "Queen of Chicago," painted prolifically and exhibited widely until she fell ill in 1959. During the 1960s her health and her art production declined. Gradually, she became housebound. In the final decade of her life, Abercrombie commenced work on her "joke book," a compilation of anecdotes and remembrances as autobiographical as her paintings. SJF

FOR FURTHER READING

Gertrude Abercrombie: A Retrospective Exhibition. Chicago: Hyde Park Art Center, 1977.

Gertrude Abercrombie and Friends. Springfield: Illinois State Museum, 1983.

Weininger, Susan, and Kent Smith. *Gertrude Abercrombie.* Springfield: Illinois State Museum, 1991.

1

GERTRUDE ABERCROMBIE
Charlie Parker's Favorite Painting, 1946
Oil on masonite, $17^{15}/_{16}$ x $21^{15}/_{16}$ inches
Ackland Art Museum, The University of North Carolina at Chapel Hill
Gift of the Gertrude Abercrombie Trust
80.20.1

Mary Hoover Aiken

Born in Cuba, New York, 1907

Died in Savannah, Georgia, 1992

Mary Hoover Aiken was raised in Pennsylvania and Washington, D.C. Her father, a civil engineer, recognized her artistic abilities at an early age and guided her toward the arts. While in high school, Aiken honed her drawing skills copying plaster casts in night classes at the Corcoran Gallery. She soon moved on to life drawing classes, which she described as liberating.

After graduation in 1924 Aiken enrolled in painting classes at the Cape Cod School of Art in Provincetown, Massachusetts. The school was established in 1899 by Charles W. Hawthorne, one of the most distinguished teachers of art in the United States. Under Hawthorne's tutelage Aiken discovered plein-air painting and developed what was to become a lifelong appreciation for clarity of color. In 1925 Aiken moved to New York City and studied with George Luks (q.v.); she spent approximately three months mastering his technique of blending colors with a wide square brush.

Seeking to expand her education, Aiken traveled to Europe and studied briefly in Fontainebleau and at the Kunstgewerbeschule in Munich. She then traveled to Madrid and secured an apprenticeship with Luis Quintanilla, who instructed her in the art of fresco. While in Madrid Aiken also devoted time to mastering the art of mosaics.

Having fully absorbed these experiences, Aiken retired to the Balearic Islands in the Mediterranean. She spent approximately the next two years there developing her own style, which she described as a mélange of influences, including the lessons she had learned from her three principal teachers and those she had gleaned from Japanese woodblock prints and Chinese painting. In 1938 she married the highly introspective poet Conrad Aiken, and in the years that followed she continued to paint and occasionally to exhibit portraits, architectural subjects, and city views. RA

2

MARY HOOVER AIKEN
Café Fortune Teller, 1933
Oil on canvas, 33⅝ x 28⅞ inches
Telfair Museum of Art, Savannah, Georgia
Gift of friends of Mary Hoover Aiken, 1975
Photo © Paul Nurnberg Photography

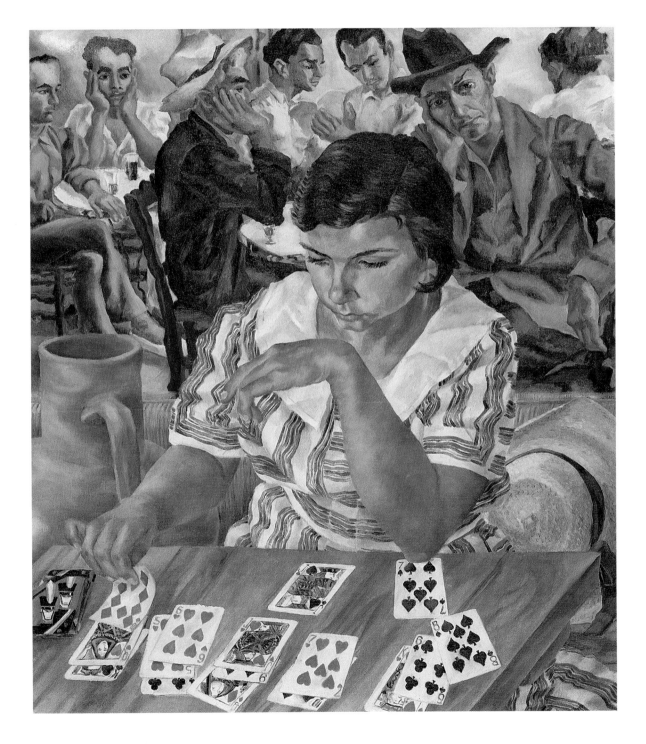

Lamar Baker

Born in Atlanta, Georgia, 1908

Died in Columbus, Georgia, 1994

*P*rint connoisseur Carl Zigrosser deemed Lamar Baker "one of the first native artists to reckon with the problems of the Deep South."[1] Those problems were familiar to the artist through the lyrics of Negro spirituals, which inspired a dramatic series of paintings. More important, as one who spent the majority of his life in the South, sensitive issues such as labor conditions, politics, and race relations were immediate to Baker.

Baker lived in Georgia until he left for New York City shortly after his graduation from the University of Georgia in 1935. Building on the training he received at the Studio Club and through night classes at the High Museum Art School, Baker enrolled at the Art Students League. While there he produced his Cotton Series, twelve lithographs that detailed aspects of the southern textile industry.

Baker's training under printmaker Harry Sternberg and painter Kenneth Hayes Miller at the Art Students League paved the way for several exhibitions during the late 1930s and early 1940s. In April 1942 he won a Julius Rosenwald Fund fellowship, which he used for a tour of Mississippi and Louisiana. He chose these destinations in order that he might depict, in his own words, "life in the South and the Negro" upon his return to New York.[2]

Nobody Knows the Trouble I've Seen but Jesus (1943) arose from sketches made during these travels. In the five paintings of the Negro Spiritual series, Baker juxtaposed themes of black life with graphic incidents of racial violence rendered in a manner influenced by social realism and left-wing socialist currents.

Baker participated in several more group exhibitions and one-person shows during the mid-1940s. At this time, he was also a draftsman for the RKO and Republic Pictures theater chains. In August 1951 Baker returned to Georgia, where he married, taught art classes, and was employed as a designer by the Litho-Krome Company in Columbus until 1977. After his return, the content of his art changed. The regional issues he explored in the 1940s changed to themes of mortality. Baker published his autobiography in 1990. SJF

NOTES

1. Quoted in Lawson, "From Cotton Fields to Cotton Mills," 502.

2. Ibid.

FOR FURTHER READING

Baker, Lamar. *Recollections of an Art Student.* New York: Vantage, 1990.

Lawson, Karol. "From Cotton Fields to Cotton Mills: Lamar Baker's Lithographs on Labor, 1938–1941." *Georgia Historical Quarterly* 81: 2 (summer 1997): 498–503.

3

LAMAR BAKER

Nobody Knows the Trouble I've Seen but Jesus, 1943

Oil and tempera on canvas, 36 x 42 inches

Collection of the Columbus Museum, Columbus, Georgia

Museum purchase

87.4

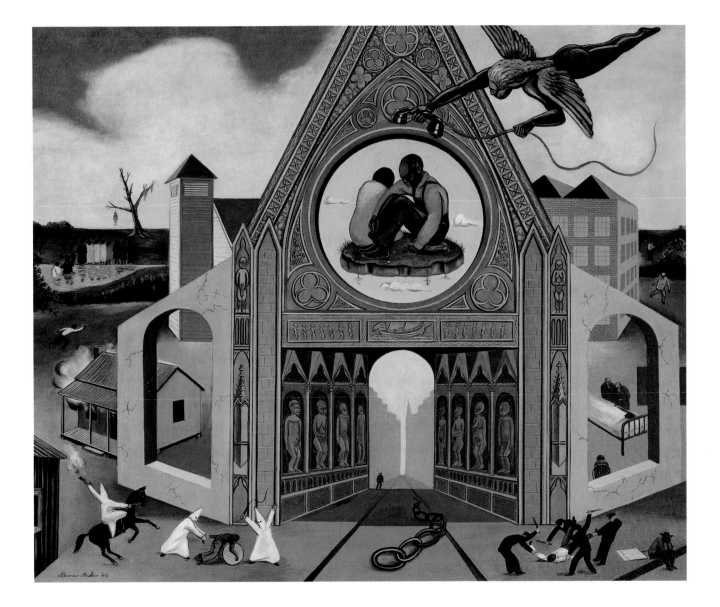

William Bliss Baker

Born in New York, New York, 1860

Died in Hoosick Falls, New York, 1886

Even though his promising career was tragically cut short by injuries suffered in a skating accident in 1886, William Bliss Baker achieved considerable success during his lifetime. A native New Yorker, he began his art education at the age of seventeen, attending classes at the National Academy of Design. There he studied with Albert Bierstadt and M. F. H. de Haas. His drawing skills attracted considerable notice and earned him the academy's Elliott Prize in 1879. Hailed by contemporary critics as one of the country's most up-and-coming landscape painters, Baker went on to win the Hallgarten Prize in 1885 for his painting *The Woodland Brook*. Writers praised him for his nativist sensibility and were especially taken with his ability to capture the objective truth of a particular scene. Although some of his paintings contain an anecdotal element, the majority of his landscapes, with their depictions of a vast and transcendent nature, unspoiled and unpopulated, reveal the influence of the Hudson River school. Possessing an innate talent for drawing, Baker also created a number of engravings during his brief career. RA

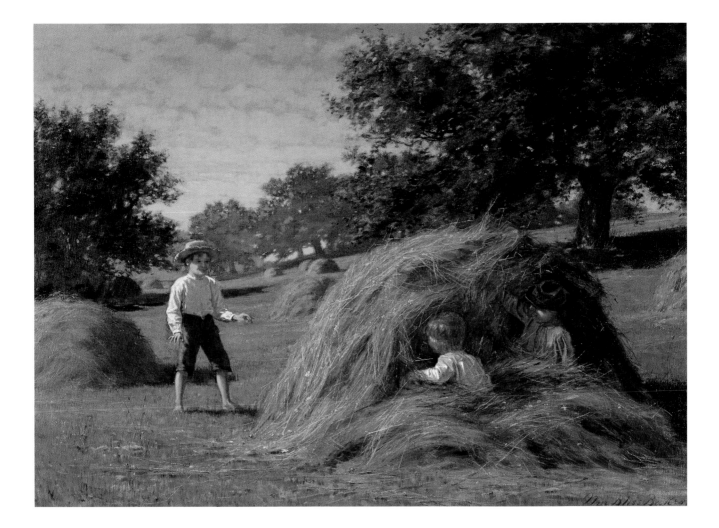

4

WILLIAM BLISS BAKER
Hiding in the Haycocks, 1881
Oil on canvas, 22⅛ x 30¼ inches
Memphis Brooks Museum of Art,
Memphis, Tennessee
Gift of Mr. and Mrs. Ben K. Baer
94.12

Thomas Hart Benton

Born in Neosho, Missouri, 1889

Died in Kansas City, Missouri, 1975

One of the regionalist triumvirate along with Grant Wood and John Steuart Curry, Thomas Hart Benton was a midwesterner by birth and was especially proud of that fact. A great-uncle who bore the same name had been a U.S. senator from Missouri. His father, Colonel Maecenas Benton, was a five-term congressman and attorney general under President Cleveland. Both Benton ancestors were populists whose sympathy for the common man and distrust of big business left a lasting impression on the artist.

Benton's formal art instruction began in 1903 at the Corcoran Gallery of Art in Washington, D.C., while his father was serving in the House of Representatives. He moved on to the Art Institute of Chicago in 1907, intent on becoming a newspaper illustrator. In 1908 Benton enrolled at the Académie Julian in Paris, and for the next three years he absorbed all the leading art movements of the period, including neo-impressionism, cubism, fauvism, and synchronism. After he returned to the United States in 1912, Benton's populist upbringing eventually collided with east-coast elitist art circles; he eventually rejected European modernism's emphasis on formalist concerns as being too esoteric for the American viewing public. He returned to his native Midwest and, heavily influenced by Hippolyte Taine's *Philosophie de l'art*, committed himself to creating a purely American art, one that would resonate with his fellow midwesterners. In time he developed a realistic style informed by European modernism, which he used to illustrate narrative subjects drawn from contemporary events, social history, and folklore.

In 1930 he created *America Today* for the New School of Social Research in New York City. Painted in his dynamic signature style composed of vibrant colors and sensuous outlines, this vast panorama of contemporary society established Benton as the nation's leading muralist. Despite some adverse criticism, the work sparked renewed interest in the mural as the preeminent public art form and contributed to the development of the Public Works Administration's mural program of the 1930s. RA

FOR FURTHER READING

Adams, Henry. *Thomas Hart Benton, an American Original*. New York: Knopf, 1989.

Benton, Thomas Hart. *An Artist in America*. Columbia: University of Missouri Press, 1937.

Gruber, J. Richard, et al. *Thomas Hart Benton and the American South*. Augusta: Morris Museum of Art, 1998.

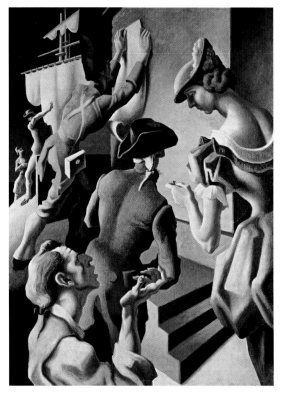

5

THOMAS HART BENTON
Brideship (Colonial Brides), ca. 1927–28
Oil and egg tempera on canvas mounted on
composite board, 60³⁄₁₆ x 42⅛ inches
Virginia Museum of Fine Arts, Richmond
The J. Harwood and Louise B. Cochrane
Fund for American Art and Gift of
Crosby Kemper
98.28
Photo: Katherine Wetzel, © Virginia
Museum of Fine Arts

6

THOMAS HART BENTON
Engineer's Dream, 1931
Oil on panel, 29⅞ x 41¾ inches
Memphis Brooks Museum of Art,
Memphis, Tennessee
Eugenia Buxton Whitnel Funds
75.1

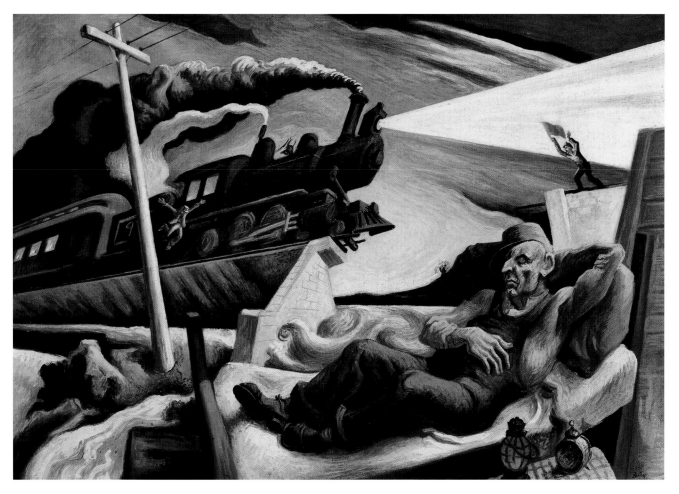

George Caleb Bingham

Born in Augusta County, Virginia, 1811

Died in Kansas City, Missouri, 1879

Although George Caleb Bingham began and ended his career as a successful portraitist, he is best known for his outstanding contributions to American genre painting: visual narratives of fur traders, jovial boatmen, and the corrupt election process in Missouri. When Bingham moved to Missouri from Virginia in 1819, most Americans would have considered the territory an unfamiliar frontier. Bingham's idealized representations of life on the Missouri and Mississippi Rivers helped to discredit the negative descriptions of the frontier frequently encountered in literature of the time.

Not long after his arrival in Franklin County, Missouri, Bingham met the itinerant painter Chester Harding, an introduction that left Bingham with the desire to become an artist. Primarily self-taught, Bingham supported himself initially as a portrait painter. Due to his ability to capture the essential character of a subject, his facile execution, and his skills at self-promotion, Bingham was rarely at a loss for sitters. In 1838 he traveled to Philadelphia, where he is believed to have first encountered genre paintings. The paintings he saw may have been by Henry Inman, who was working in the city at that time. Bingham settled in the nation's capital during the early 1840s and painted portraits of such luminaries as Daniel Webster.

Upon his return to Missouri in 1845, Bingham opened a studio in St. Louis and became privy to the lives of those who made their living on two of the nation's great rivers. Attracted to itinerant workers much like himself, he produced his first genre painting, *Fur Traders Descending the Missouri,* in 1845. He followed this work with several paintings depicting the convivial life of boatmen on the Mississippi River. A lifelong and politically active Whig, Bingham was also interested in political issues, which he recorded in a series of works that take a satirical view of the election process on the frontier. In 1856 he traveled to Düsseldorf and worked on private commissions, including full-length portraits of George Washington and Thomas Jefferson. When he returned to the United States the following year, he adopted a more relaxed pace of life while remaining active in both politics and portraiture. RA

FOR FURTHER READING

Bloch, Maurice E. *The Paintings of George Caleb Bingham: A Catalogue Raisonné.* Columbia: University of Missouri Press, 1986.

Rash, Nancy. *The Painting and Politics of George Caleb Bingham.* New Haven, Conn.: Yale University Press, 1991.

Shapiro, Michael Edward, et al. *George Caleb Bingham.* St. Louis: St. Louis Art Museum in association with Harry N. Abrams, New York, 1990.

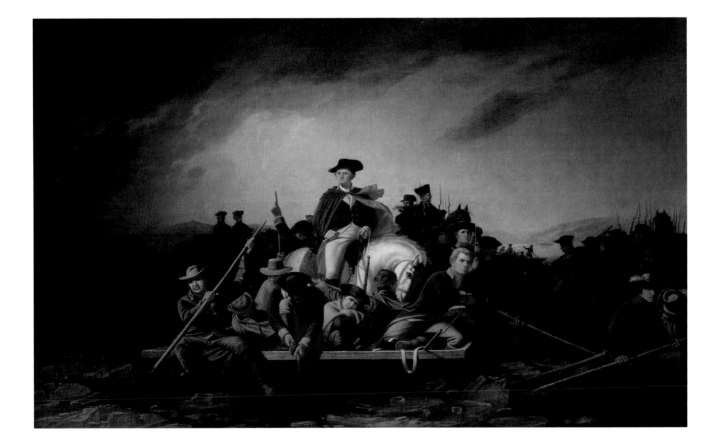

7

GEORGE CALEB BINGHAM

Washington Crossing the Delaware, 1856–57

Oil on canvas 36¼ x 57¼ inches

Chrysler Museum of Art, Norfolk, Virginia

Gift of Walter P. Chrysler Jr. in honor of

Walter P. Chrysler Sr.

83.589

Photo © Chrysler Museum of Art

David Gilmour Blythe

Born in Wellsville, Ohio, 1815

Died in Pittsburgh, Pennsylvania, 1865

David Gilmour Blythe, the son of Scottish immigrants, was a bookish child who exhibited a proclivity for drawing. These early interests contributed to his eventual status as one of the country's foremost satirical painters. The reputation of his biting brush was gradually developed, however. When he was twenty years old, Blythe worked as a carpenter and house painter. In 1837 he traveled to New York to enlist in the navy. Sailing aboard the *Ontario,* Blythe reached ports of call in the Gulf of Mexico and the Caribbean. Following the end of his tour of service, he divided his time and his talents as an itinerant painter between East Liverpool, Ohio, and Uniontown, Pennsylvania, where he eventually settled in 1846. A permanent studio allowed the essentially self-taught Blythe to take on more ambitious projects. In 1850 he carved a heroic statue of General Lafayette to crown the dome of the Fayette County courthouse; one year later he executed a three-hundred-foot panorama depicting the Allegheny Mountains.

While the mammoth mural garnered popular acclaim when Blythe displayed it in Pennsylvania, Ohio, and Maryland, it was not the commercial success for which the artist had hoped. This failure, coupled with the death of his wife from typhoid after only two years of marriage, instigated a period of rootless wandering that culminated in 1856 with Blythe's move to Pittsburgh. There, he developed his signature genre scenes painted in a muddied palette, laden with narrative detail, and featuring figures with disturbingly distorted anatomy. Inspired by the caricatures of British artists William Hogarth and George Cruikshank, as well as by the pointed lithographs of French artist Honoré Daumier, Blythe grew more open in his attack of human foibles and his works became increasingly politically charged. SJF

FOR FURTHER READING
Chambers, Bruce W. *The World of David Gilmour Blythe (1815–1865).* Washington, D.C.: Published for the National Collection of Fine Arts by the Smithsonian Institution Press, 1980.
Miller, Dorothy. *The Life and Work of David G. Blythe.* Pittsburgh: University of Pittsburgh Press, 1950.

8

DAVID GILMOUR BLYTHE
Land of Liberty, ca. 1858–60
Oil on canvas, 24 x 20 inches
Collection of the Columbus Museum, Columbus, Georgia
Museum purchase made possible by the Endowment Fund in honor of D. A. Turner
96.25

Alfred Boisseau

Born in Paris, France, 1823

Died in Buffalo, New York, 1901

*M*any mid-nineteenth-century painters journeyed to locales far from home in search of subjects tinged with a thrilling exoticism. Rather than touring the Near East as artists caught in the currents of Orientalism often did, Alfred Boisseau left Paris in 1845 for the mysteries of New Orleans, where his brother was posted as secretary to the French consul.

Prior to his trip to North America—the place he would spend most of the rest of his life—Boisseau studied art with Paul Delaroche and in classes at the Ecole des Beaux-Arts from 1838 to 1842. Beginning in 1842, Boisseau exhibited his paintings at the Paris Salon where *Louisiana Indians Walking along a Bayou* was shown in 1848.

How long Boisseau remained in Louisiana is unknown. It is possible that he spent anywhere from one to three years painting engaging genre scenes of Native American, Creole, and black people and the distinctive landscape they inhabited. By 1849 Boisseau was in New York City, exhibiting his work at the National Academy of Design and later with the American Art Union. In 1852 the painter, art dealer, teacher, and occasional photographer moved to Cleveland. He painted portraits and instructed students in drawing and painting until 1859. Less is known about Boisseau's later years. There is evidence, however, that he resided as far north as Montreal during the last quarter of the century. SJF

9

ALFRED BOISSEAU

Louisiana Indians Walking along a Bayou,

1847

Oil on canvas, 24 x 40 inches

New Orleans Museum of Art

Gift of William E. Groves

56.34

Frederick Arthur Bridgman

Born in Tuskegee, Alabama, 1847

Died near Rouen, France, 1928

Frederick Arthur Bridgman's engagement with narrative was not limited to telling exotic tales on canvas, although it is for his painted Orientalist fantasies that the expatriate artist is best known. In addition to creating visual narratives, Bridgman was also a poet and an author whose work was published in *Harper's*. Throughout his life, he also entertained an aural fascination as an accomplished violinist and a composer of numerous orchestral works.

Bridgman's artistic interests were fostered at the Brooklyn Art Studio and the National Academy of Design in the early 1860s. By the time he was nineteen years old, the artist had expatriated to France. Once there, he quickly made a name for himself as one of the leading members of the artist colony at Pont-Aven in Brittany. By 1867 Bridgman was in Paris, where he studied art in the studio of the premier Orientalist painter Jean-Léon Gérôme, at the Ecole des Beaux-Arts, and at the Académie Julian under Jules-Joseph Lefebvre.

In search of tantalizingly exotic subjects like those favored by his mentor Gérôme, Bridgman made the first of several trips to North Africa and Spain in 1872. Paintings born of these travels earned praise for the artist when they were exhibited at the Paris Salon, New York's National Academy of Design, and the Pennsylvania Academy of the Fine Arts in Philadelphia. SJF

FOR FURTHER READING

An American Artist on the Nile: Watercolours and Drawings by Frederick Arthur Bridgman, 1847–1928. London: Agnew's, 2000.

Fort, Ilene Susan. *Frederick Arthur Bridgman and the American Fascination with the Exotic Near East*. Ann Arbor, Mich.: University Microfilms International, 1990.

———. *The Drawings of Frederick A. Bridgman*. New York: Jill Newhouse, 1983.

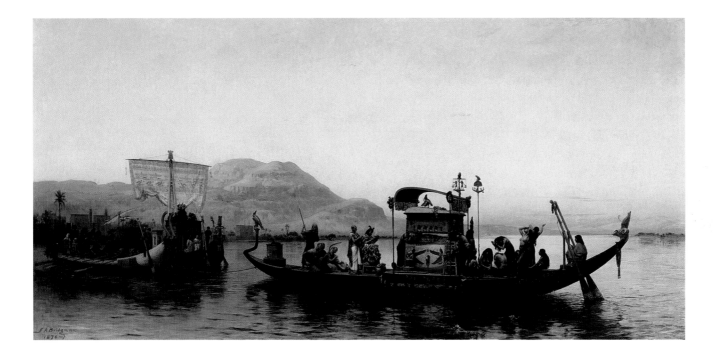

10

FREDERICK ARTHUR BRIDGMAN
Funeral of a Mummy, 1876–77
Oil on canvas, 44⅝ x 91¼ inches
Collection of the Speed Art Museum,
Louisville, Kentucky
Gift of Mr. Wendell Cherry
1990.8

John George Brown

Born near Durham, England, 1831

Died in New York, New York, 1913

*J*ohn George Brown was a painter of both rural and urban genre scenes populated by fresh-faced children at work and at play. His paintings were so avidly sought after during his lifetime that he was forced to have his images copyrighted. An account of a visit to Brown's studio suggests the artist's industry and his popularity: "Today it [the studio] contains not a single finished canvas. Hard times, dull times, bad times, he knows nothing of except by heresay [*sic*]."[1]

While still a youth in England, Brown worked by day as an apprentice glass cutter in Newcastle-on-Tyne and studied drawing at the Government School of Design at night. When he was twenty-one years old, he took his talents to the Holyrood Glass Works in Edinburgh. Once again, he spent his evenings honing his skills as a drafts-man, this time at the Trustees Academy under the tutelage of its director, Robert Scott Lauder.

Brown arrived in Brooklyn, New York, on his twenty-second birthday. He was hired by the Brooklyn Flint Glass Company and attended night classes at the Graham Art School, Brooklyn's first free school of art. Eventually, he enrolled in classes at the National Academy of Design; by 1858 he was exhibiting paintings in the academy's annual exhibition. In 1863 he was named an associate member of the NAD, and he served as its vice president from 1899 to 1903.

In addition to being an active presence within the NAD, Brown was also an important fixture in the Brooklyn art scene. He was a founding member of the Brooklyn Art Society, which was inaugurated in 1859, and was influential in instigating the formation of the Brooklyn Art Association two years later. SJF

NOTE
1. "John G. Brown," *Harper's Weekly* 24 (June 12, 1880): 374.

FOR FURTHER READING
Hoppin, Martha J. *Country Paths and City Sidewalks: The Art of J. G. Brown.* Springfield, Mass.: George Walter Vincent Smith Art Museum, 1989.

11
JOHN GEORGE BROWN
Three for Five, 1890
Oil on canvas, 60 x 35½ inches
Birmingham Museum of Art
Gift of Mr. and Mrs. C. W. Ireland through the Art Fund, Inc.
AFI 1.1980

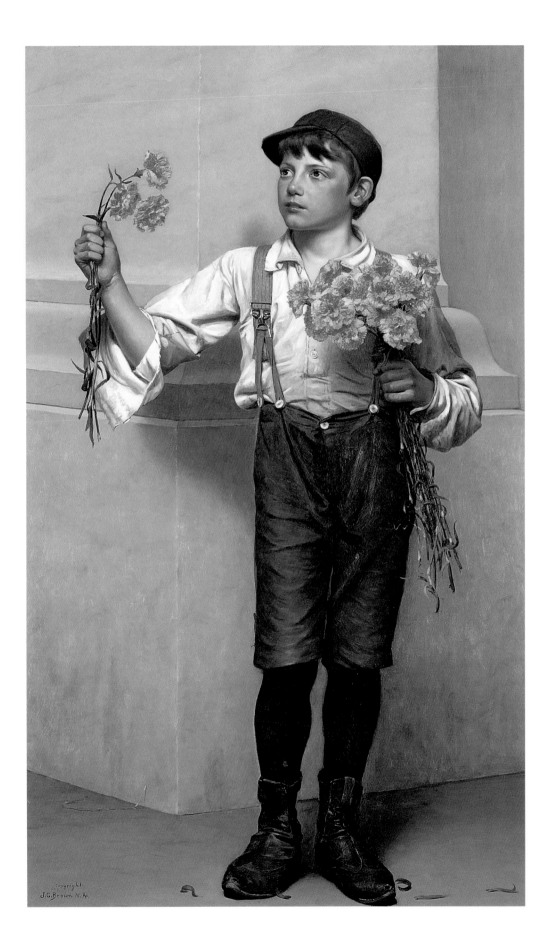

Bryson Burroughs

Born in Hyde Park, Massachusetts, 1869

Died in New York, New York, 1934

Bryson Burroughs is remembered today as a painter of works marked by the influence of classical myth, medieval legends, and by aesthetics akin to those of the French painter Pierre Puvis de Chavannes; he is also recalled as an early curator of paintings at the Metropolitan Museum of Art. His initiation into the art world began when he enrolled in the art school of the Cincinnati Museum of Art as a teenager. He was employed as a cartoonist for one of the daily Cincinnati newspapers before heading to New York City in 1889 to continue his training at the Art Students League.

After a year of study under Kenyon Cox and Siddons Mowbray, Burroughs was awarded the league's Chanler Scholarship, which allowed the artist to relocate to Paris for five years. He took classes at the Ecole des Beaux-Arts and at the Académie Julian and worked with such academicians as Luc-Olivier Merson, Gabriel Ferrer, and William Bouguereau. It was also during this sojourn abroad that Burroughs met Puvis and was captivated by the artist's work.

Early in the twentieth century, Burroughs began to garner recognition. At the Pan-American Exposition in Buffalo, his work earned a silver medal; at the 1904 World's Fair in St. Louis, the artist received two bronze medals. The following year Burroughs set up a studio in New York City and taught at Cooper Union and his alma mater, the Art Students League. In 1906 he accepted a position as assistant curator under Roger Fry at the Metropolitan Museum of Art. By 1909 Burroughs had assumed Fry's title as Curator of Paintings, a position he held until failing health forced him to retire in 1934. SJF

FOR FURTHER READING

Ivins, William Mills, and Harry Brandeis Wehle. *Bryson Burroughs: Catalogue of a Memorial Exhibition of His Work*. New York: Plantin, 1935.

Owens, Gwendolyn. "Pioneers in American Museums: Bryson Burroughs." *Museum News* 57:5 (May/June 1979): 46–53, 84.

The Paintings of Bryson Burroughs (1869–1934). New York: Hirschl & Adler Galleries, 1984.

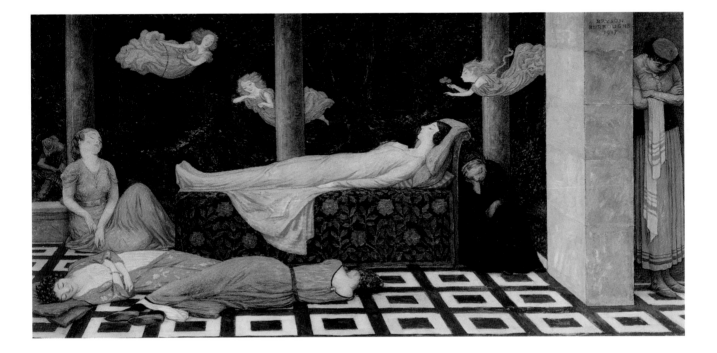

12

BRYSON BURROUGHS

The Sleeping Beauty in the Wood, 1917

Oil on canvas, 18 x 36 inches

Collection of the Lauren Rogers Museum

of Art, Laurel, Mississippi

84.10

Paul Cadmus

Born in New York, New York, 1904

Died in Weston, Connecticut, 1999

A keen observer of life, Paul Cadmus created paintings that often took the form of caustic social satire. Some of them sparked much controversy, yet Cadmus remained indifferent to critical and public opinion throughout his career. Describing himself as a "literary painter," he discovered the subject matter for many of his paintings in the flux of life that animated the streets and neighborhoods of his native New York, which he presented in a realist style that merged contemporary illustration with the language of the Italian Renaissance.

Born to parents who were commercial artists, Cadmus followed their lead; he enrolled in classes at the National Academy of Design, where he completed his course work in 1926. He worked in advertising until 1931, when he began studying lithography at the Art Students League. There he met Jared French. The two later traveled to Europe for two years of independent study. Cadmus was hired by the Public Works of Art Project soon after his return to the United States in 1934. His first work for the federal government was *The Fleet's In!* (1934). The painting depicted a group of debauched uniformed sailors cavorting with prostitutes and, even more controversial at the time, a homosexual pickup.

The painting offended the sensibilities of navy officials, who successfully demanded its withdrawal from a public exhibition at the Corcoran Gallery of Art in Washington, D.C. Cadmus would experience similar controversies in the years that followed.

A slow, meticulous artist whose medium of choice after 1940 was egg tempera, Cadmus produced a small number of paintings, completing on average only two a year. Yet he was highly prolific in drawing and printmaking, in both of which he created many remarkable studies of the male nude. Despite his indifference to critical opinion, Cadmus achieved considerable professional success. He became a member of the American Academy of Arts and Letters in 1974 and an academician of the National Academy of Design in 1979. RA

FOR FURTHER READING

Eliasoph, Philip. *Paul Cadmus, Yesterday and Today.* Oxford, Ohio: Miami University Art Museum, 1981.

Kirstein, Lincoln. *Paul Cadmus.* San Francisco: Pomegranate Artbooks, 1992.

Leddick, David. *Intimate Companions: A Triography of George Platt Lynes, Paul Cadmus, Lincoln Kirstein, and Their Circle.* New York: St. Martin's, 2000.

13

PAUL CADMUS

Playground, 1948

Egg yolk tempera on hardboard panel, 23½ x 17½ inches

Georgia Museum of Art, University of Georgia

University purchase

GMOA 1970.2619

Photo by Michael McKelvey

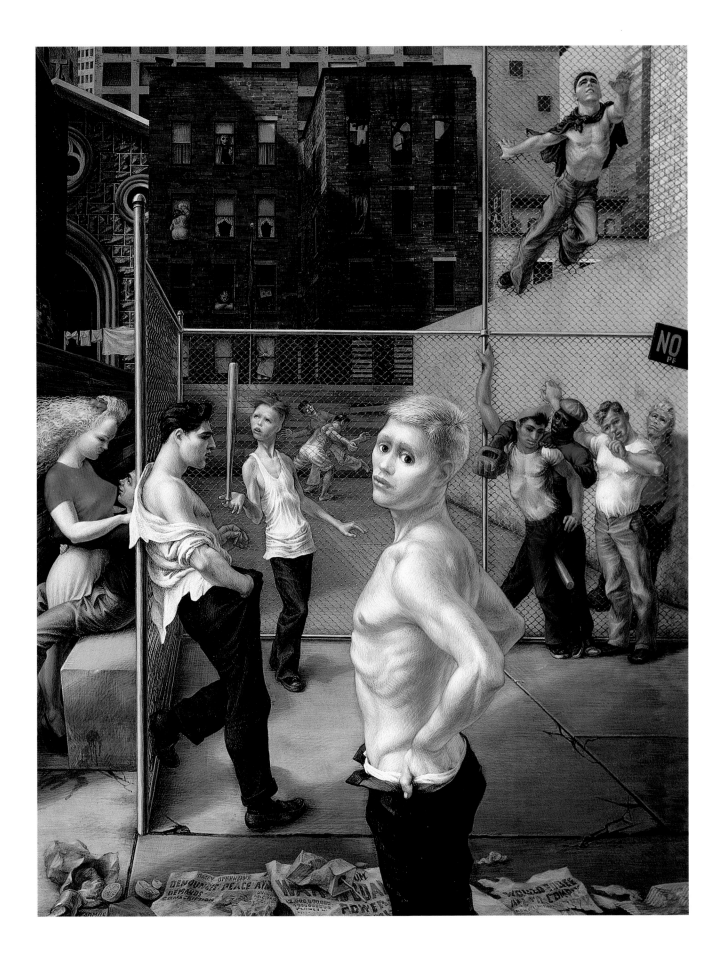

James Ormsbee Chapin

Born in West Orange, New Jersey, 1887

Died in Toronto, Ontario, Canada, 1975

A slow analytical painter with a predilection for storytelling, James Chapin received his artistic education at Cooper Union and the Art Students League in New York and the Royal Academy in Antwerp, Belgium. In his early works he demonstrated his familiarity with European modernism, especially the works of Cézanne and other post-impressionist painters. At the same time he supported himself as an illustrator, mostly for textbooks. He was eventually commissioned to illustrate an edition of Robert Frost's *North of Boston*. This commission led to a friendship with the poet who inspired Chapin's love of country life.

Chapin's artistic style underwent a radical change in 1924 when he moved to a remote location in northwest New Jersey. There he rented a two-room log cabin on a small piece of land belonging to the Marvin family, who were at the time struggling to make ends meet on their unprofitable farm. Chapin spent the next five years working side by side with the family, and in his free time he captured the tenacious personalities of his hosts in remarkable portraits and genre scenes that depict them working the land. In creating these works Chapin discarded the European modes of representation with which he had been working and developed his own style; for this he is credited with having developed a regionalist imagery well before Grant Wood, John Steuart Curry, and Thomas Hart Benton appeared on the American scene. These paintings later drew enthusiastic praise from Wood, who claimed that they were among the best things in American art. After he returned to New York City in the 1930s, Chapin's subject matter broadened significantly to include many of the city's inhabitants, including boxers, gangsters, industrial workers, and blues singers. Chapin is also known for his many sympathetic portrayals of African Americans, in which he eschewed stereotypes in favor of a new pictorial image that focused on their physical and spiritual beauty. Chapin, who was noted for his social concerns, was so opposed to U.S. involvement in southeast Asia that he moved with his family to Canada in 1969 and remained there until his death in the year the war ended. RA

FOR FURTHER READING

O'Brien, Maureen. *James Chapin: The Marvin Years*. Montclair, N.J.: Montclair Art Museum, 1974.

Prescott, Kenneth W. *James Chapin*. Toronto: Yaneff Gallery, 1980.

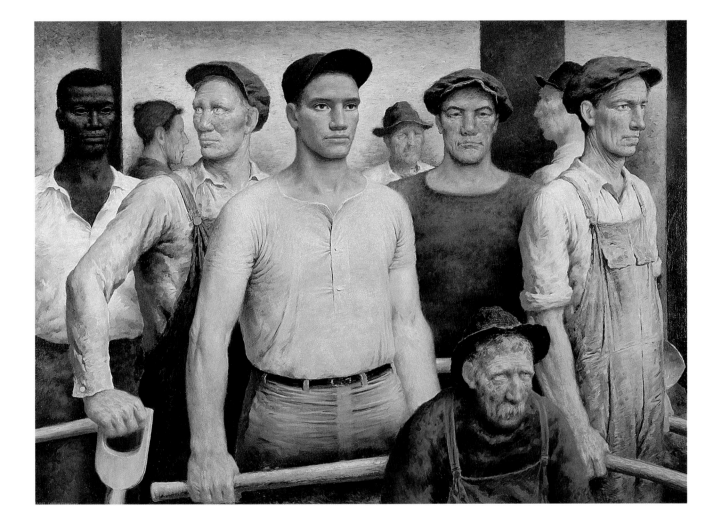

14

JAMES ORMSBEE CHAPIN
Nine Workmen, 1942–45
Oil on canvas, 42¾ x 57¾ inches
Collection of the Asheville Art Museum,
Asheville, North Carolina
Photo by Paul Jeremias

John Gadsby Chapman

Born in Alexandria, Virginia, 1808

Died in Staten Island, New York, 1889

A young man in search of a profession, John Gadsby Chapman was directed away from a career in law when a member of his extended family, the artist George Cooke, persuaded him to take up the brush. Cooke and another of Chapman's acquaintances, Charles Bird King, offered him early encouragement and instruction, which he supplemented with training at the Pennsylvania Academy of the Fine Arts.

Intent on becoming a history painter, Chapman traveled to Italy in 1830 and there met up with Samuel F. B. Morse. The two men studied the old masters as they traveled the countryside together. Chapman returned to his hometown in 1831 and supported himself with portrait commissions and an occasional history painting. He was made an honorary member of the Na-

tional Academy of Design in 1832 and for a time served as its secretary. In 1835 he opened a studio in New York and quickly succeeded as a painter of portraits, seascapes, landscapes, genre, and historical subjects. In 1837 Chapman was given the most prestigious commission of his career, a painting for the rotunda of the United States Capitol depicting the baptism of Pocahontas. He returned to Europe in 1848, where his eventual studio in Rome became a point of destination for many American artists studying abroad. Chapman remained in Europe until 1884.

Chapman was a skilled artist in several media. He made sculpture and, more importantly, was the first notable figure in American illustration. He is credited with being the first to design and execute his own wood engravings. His most famous work in the medium

are the fourteen hundred illustrations he created for the *Harper's Family Bible* (1846). Chapman also wrote three volumes of art instruction, including *The American Drawing Book: A Manual for the Amateur, and Basis of Study for the Professional Artist* (1847), which went into numerous editions and became the primary text for a generation or more of aspiring artists. RA

FOR FURTHER READING

Campbell, William P. *John Gadsby Chapman, Painter and Illustrator.* Washington, D.C.: National Gallery of Art, 1963.

Chamberlain, Georgia Stamm. *Studies on John Gadsby Chapman.* Annandale, Va.: Turnpike, 1963.

———. "John Gadsby Chapman, Painter of Virginia." *Art Quarterly* 24:4 (winter 1961): 378–90.

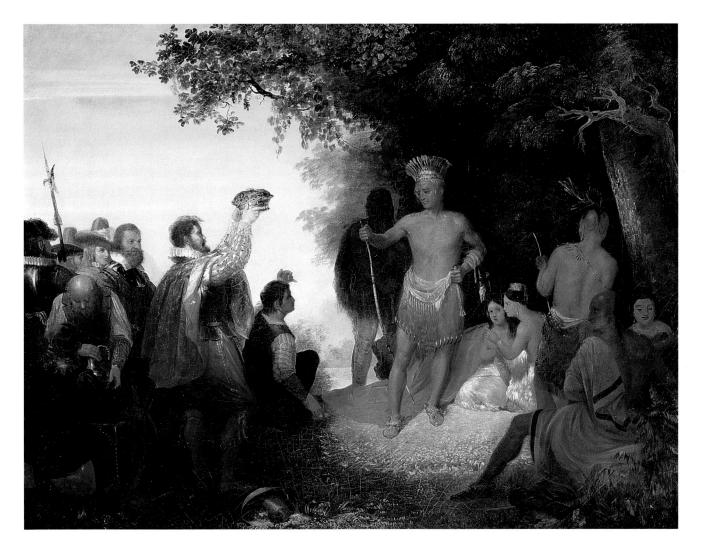

15

JOHN GADSBY CHAPMAN
The Coronation of Powhatan, ca. 1835
Oil on canvas, 22¼ x 29⅛ inches
Collection of the Greenville County
Museum of Art, Greenville, South Carolina
Museum purchase with funds donated by
the Arthur and Holly Magill Foundation
GCMA 90.21.6 (2025)

Christopher Clark

Born in Quincy, Florida, 1903

Death date and place unknown

A resident of Florida for much of his life, Christopher Clark studied at the University of Florida and subsequently with Kenneth Hayes Miller at the Art Students League in New York. For a time he worked as an illustrator for *Forbes* magazine. In the early 1930s he was hired by Donald Deskey to create several decorative murals for Radio City Music Hall in Rockefeller Center. During his New York years, he received several portrait commissions, "put[ting] many of the socially famous and intelligentsia on canvas" in oils and pastels.[1] He also represented Florida in the first national exhibition of American art at Rockefeller Center.

Returning to Tampa later in the decade, Clark worked for the Works Progress Administration's Federal Arts Program. He made his contribution to regionalist art with subjects drawn from local, Gulf Coast experience. Clark enjoyed a long teaching career, giving classes at the Ringling School of Art in Sarasota, the Tampa Art Institute and Contemporary Arts Gallery, and the Island City School of Art in Key West, among others. In the 1950s he lived and painted aboard a homemade houseboat, the *Li-Po* (named for the Chinese lyric poet), which became a temporary landmark at various Gulf ports. In addition to his painting, Clark was known as a talented pianist and chef. RA

NOTE
1. Gloria Paul, "Clark, Artist, Ties Up Boat at Johns Pass," *St. Petersburg Independent*, March 18, 1955.

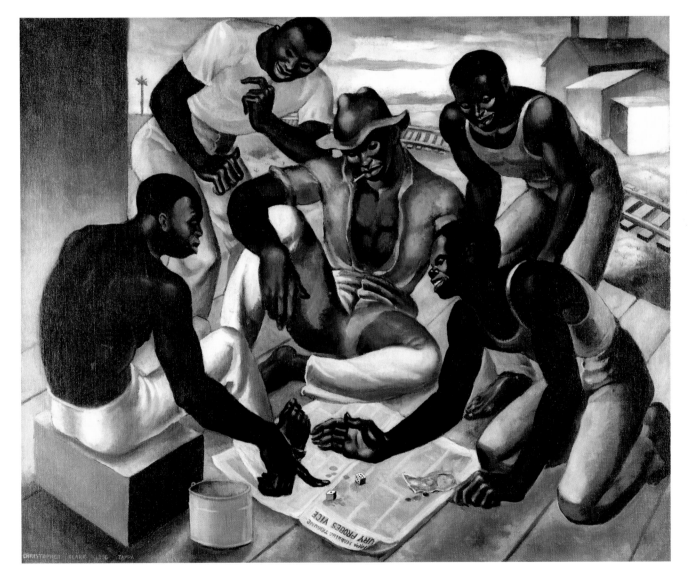

16

CHRISTOPHER CLARK

Crapshooters, 1936

Oil on canvas, 30 x 36 inches

The Ogden Museum of Southern Art,

University of New Orleans

Gift of the Roger H. Ogden Collection

Carroll Cloar

Born in Earle, Arkansas, 1913

Died in Memphis, Tennessee, 1993

*I*n 1934, after graduating with a degree in English from Southwestern Presbyterian College (now Rhodes College) in Memphis, Carroll Cloar toured Europe, visiting many of its renowned museums. When he returned to the United States, he briefly studied at the Memphis Academy of Art (now Memphis College of Art) before entering the Art Students League in New York in 1936, where he studied under Harry Sternberg and Ernest Fiene. In his spare time, he invented a comic strip character he christened "Junius," who possessed the qualities of "an unlikely hero, a fat boy character with glasses, erudite but strong as an ox," according to his creator.[1]

In 1940 Cloar was awarded a Mac-Dowell Traveling Fellowship from the Art Students League, which he used for travel throughout the United States and Mexico. After service in the Army Air Corps during World War II, he returned to Mexico on a Guggenheim Fellowship awarded in 1946. By the late 1940s he was back in New York, where he was "discovered" by Downtown Gallery owner Edith Halpert. In 1952 *Life* published the work of a group of six artists it dubbed Halpert's "New Crop of Painting Protégés," including Cloar.

In the early 1950s Cloar moved to Memphis and began to paint the recollections from his boyhood that have become his best-known works. Many of these were included in the artist's first solo exhibition at the Alan Gallery in New York in 1956. With titles such as *Grandparents, Nostalgia, My Father Was Big as a Tree,* and the enigmatic *Story Told by My Mother,* Cloar's paintings weave together the artist's personal recollections with local legends and lore of the South. SJF

NOTE

1. Northrop, *Hostile Butterflies,* 27.

FOR FURTHER READING

Carroll Cloar: Painter of the Mid-South. Memphis, Tenn.: Brooks Memorial Art Gallery, 1966.

Northrop, Guy. *Hostile Butterflies and Other Paintings by Carroll Cloar.* Memphis: Memphis State University Press, 1977.

Stuart, Dabney. *Second Sight: Poems for Paintings by Carroll Cloar.* Columbia: University of Missouri Press, 1996.

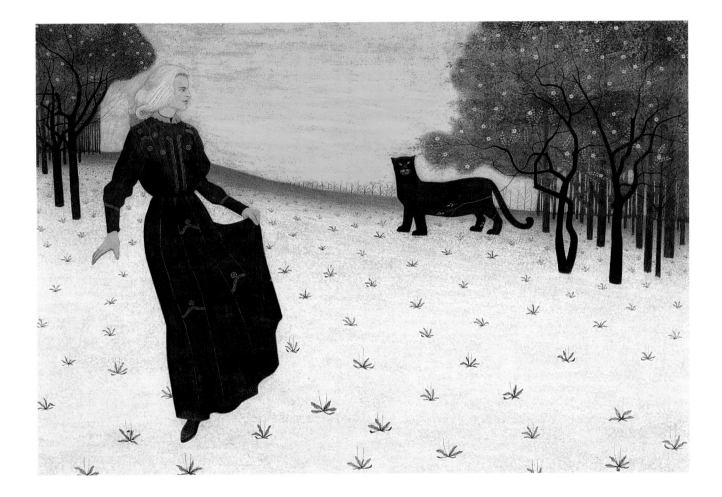

17

CARROLL CLOAR

Story Told by My Mother, 1955

Casein tempera on masonite,

21⅞ x 30⅛ inches

Memphis Brooks Museum of Art,

Memphis, Tennessee

Bequest of Mrs. C. M. Gooch

80.3.16

James Goodwyn Clonney

Born (probably) in Liverpool, England, 1812

Died in Binghamton, New York, 1867

*J*ames Goodwyn Clonney is a relatively obscure painter. Nearly a century and a half after the artist's death, as more of his rural genre scenes come to light, the artist himself is emerging from the long shadows cast by his contemporary and fellow genre painter William Sidney Mount. Very little is known about the early years of Clonney's life. Even his place of birth is uncertain, as is the date of his immigration to the United States. It is known, however, that he was naturalized in 1840.

The earliest notice of Clonney's work is linked to his skills as a draftsman. Between 1830 and 1833, several of Clonney's lithographic illustrations were published by firms in New York and Philadelphia; these included a series of ten images depicting birds and other wildlife in *Cabinet of Natural History* and *American Rural Sports,* and two precise renderings of a New York City residence.

At the National Academy of Design in 1833, Clonney was awarded second prize for a drawing after the antique. He exhibited his works at the NAD a year later and often thereafter; he included his genre paintings in exhibitions at the Pennsylvania Academy of the Fine Arts, the Apollo Association, and the American Art Union, among other venues. In 1852 Clonney settled in Cooperstown, New York, and later took up farming in Binghamton in order to supplement the income he earned from his paintings. SJF

FOR FURTHER READING
Giese, Lucretia. "James Goodwyn Clonney (1812–1887): American Genre Painter." *American Art Journal* 11:4 (Oct. 1979): 5–31.

18

JAMES GOODWYN CLONNEY
Offering Baby a Rose, 1857
Oil on canvas, 25 x 19 inches
The Mint Museums, Charlotte, North Carolina
Museum purchase: Exchange Funds from the Gift of Harry and Mary Dalton 1998.20

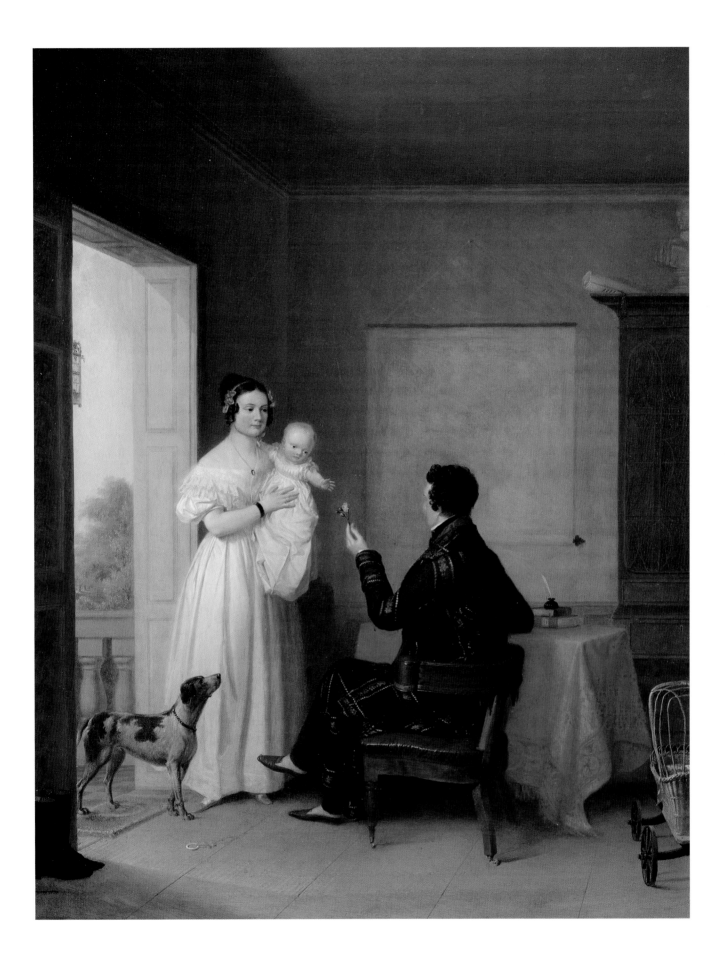

Elliott Daingerfield

Born in Harpers Ferry, (West) Virginia, 1859

Died in New York, New York, 1932

Elliott Daingerfield, the son of a Confederate army captain, grew up in Fayetteville, North Carolina, where his family relocated in 1861 when his father assumed command of the Confederate arsenal there. Despite his upbringing, Daingerfield chose not to retell the tales of the War Between the States in his art. Instead, "the American Millet" (as he has been called) exhibited more interest in a subjective, symbolist style. This tendency also appears in the artist's poetry that often accompanied his paintings.

George Inness, whom Daingerfield met in 1884 in New York City while studying at the Art Students League, inspired his visionary style, as did Kenyon Cox and Albert Pinkham Ryder (q.v.). In 1886, while escaping the city to recuperate from diphtheria, Daingerfield discovered Blowing Rock, North Carolina. Enchanted by the landscape, the artist eventually built three homes/studios there.

Following the death of his first wife in 1891 and his subsequent remarriage in 1895, Daingerfield's increased recognition for his religious paintings led to a commission for a mural in the Church of Saint Mary the Virgin in New York City. The year 1911 marked a high point in Daingerfield's career: he published an influential essay, "Nature versus Art," in *Scribner's*; he wrote the biography of his mentor, Inness; and he traveled for the first time to the American West, as the guest of the Santa Fe Railway Company. Daingerfield and other artists traveled free of charge in exchange for capturing spectacles such as the Grand Canyon on their canvases, images that could be used by the company as advertisements in the burgeoning tourist trade. In 1913 the artist returned to the Grand Canyon and executed seven major works. SJF

FOR FURTHER READING

Daingerfield, Elliott. "Nature versus Art." *Scribner's Magazine* 49 (Feb. 1911): 253–56.

Hobbs, Robert Carleton. *Elliott Daingerfield Retrospective Exhibition.* Charlotte, N.C.: Mint Museum of Art, 1971.

Pennington, Estill Curtis, and J. Richard Gruber. *Victorian Visionary: The Art of Elliott Daingerfield.* Augusta, Ga.: Morris Museum of Art, 1994.

19

ELLIOTT DAINGERFIELD

The Sleepers, 1914

Oil on canvas mounted on board,

36 x 48⅛ inches

Morris Museum of Art, Augusta, Georgia

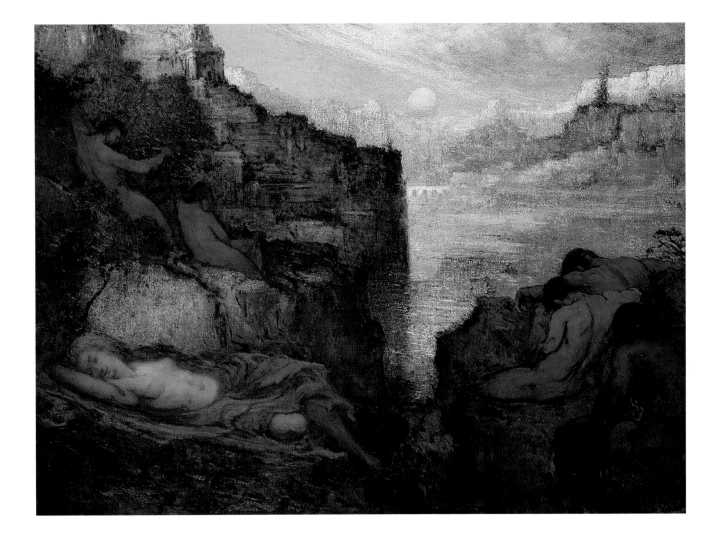

Charles Deas

Born in Philadelphia, Pennsylvania, 1818

Died in New York, New York, 1867

Although his career lasted only slightly longer than a decade, Charles Deas has nevertheless earned recognition for his dramatic renderings of the American West. He was also the painter of less-known works that took as their subject episodes penned by classic American authors such as Washington Irving and James Fenimore Cooper.

Deas came from a family with a long history of military service. He was not destined to follow that family tradition, however, as he was unsuccessful in his attempt to secure an appointment to the U.S. Military Academy at West Point. Instead, Deas turned to a career in art. In the mid-1830s he studied at the National Academy of Design in New York City. In 1838 he exhibited *Turkey Shooting* at the NAD, and one year later he was elected an associate member.

In 1840, reportedly after viewing some of George Catlin's paintings depicting Native Americans, Deas ventured west to the Wisconsin Territory. He traveled to Fort Snelling, near present-day St. Paul, and visited his brother, a military officer, at Fort Crawford near Prairie du Chien, Wisconsin. At the forts and while traveling throughout the Upper Mississippi, Missouri, and Platte River regions, he painted Native Americans, trappers, and other frontier types.

Late in 1841 Deas settled in St. Louis, which he used as a base for continued exploration of the West. For instance, he joined Major Clifton Wharton's expedition to meet the Pawnee in 1844. He frequently shipped his paintings from this period back east and exhibited them to great acclaim at venues such as the NAD, the Pennsylvania Academy of the Fine Arts, and the Boston Athenaeum. Unfortunately, in 1848 Deas was hospitalized in New York City because of his mental state. He lived the last sixteen years of his life in a mental institution. SJF

FOR FURTHER READING
McDermott, John Francis. *Charles Deas: Painter of the Frontier.* New York: Metropolitan Museum of Art, 1950.

20

CHARLES DEAS

Turkey Shooting, before 1838

Oil on canvas, 24¼ x 29½ inches

Virginia Museum of Fine Arts, Richmond

The Paul Mellon Collection

85.632

Photo © Virginia Museum of Fine Arts

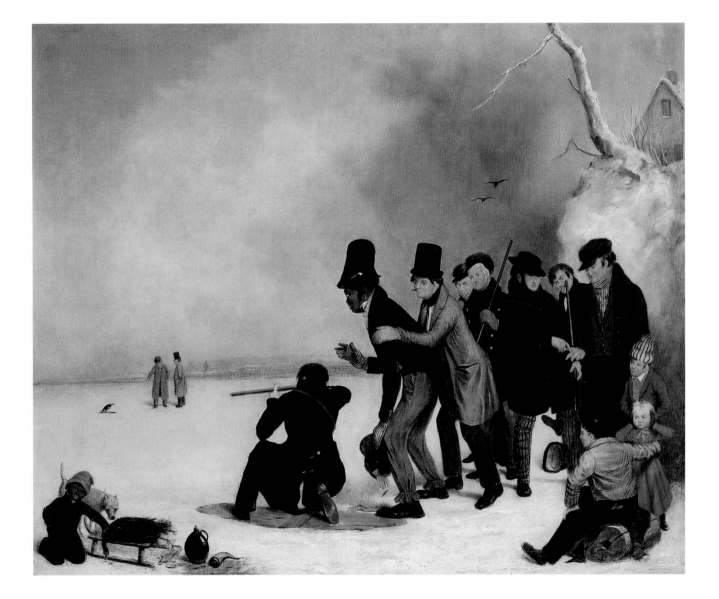

Francis William Edmonds

Born in Hudson, New York, 1806

Died in Bronxville, New York, 1863

The unusual career of Francis William Edmonds comprises two seemingly divergent paths. Edmonds combined pursuits as a banker and as a painter of genre scenes possessing a distinctly American flavor. It would have been difficult to predict either of these careers as the future for Edmonds while he was still a boy. Although he exhibited an aptitude for drawing at an early age, his family could not afford the logical means to foster his talents, for instance, as an apprentice to an engraver. Instead, the future banker and painter was sent to work as a farmhand.

By the mid-1820s, however, Edmonds made inroads into the worlds of finance and the fine arts. In 1823 he accepted a position, secured with the assistance of an uncle, as an underclerk at the Trademen's Bank in New York City. Three years later, he enrolled in night classes at the newly established National Academy of Design. By the late 1830s Edmonds was employed by the Leather Manufacturers' Bank; he engraved designs for bank notes, served as treasurer of the Apollo Association, and exhibited his genre paintings under the pseudonym E. F. Williams, a disguise he abandoned as soon as his work garnered praise.

In 1840 Edmonds, a new member of the NAD, traveled to England, France, and Italy with his friend and fellow painter Asher B. Durand to study the works of the old masters. During the decades that followed, Edmonds continued to assert his presence in both the financial world and the art world. In 1854 he was appointed New York City Chamberlain, which allowed his bank to make loans using the city's funds without having to pay interest on the deposits. Concurrently, he published articles in periodicals and newspapers, served as the director of the American Art Union, was a progenitor of the Artists' Sketch Club, and in 1857 acted as a cofounder of the Bank Note Engraving Company with Alfred Jones and James Smillie. SJF

FOR FURTHER READING

Clark, Henry Nichols Blake. *Francis W. Edmonds: American Master in the Dutch Tradition*. Washington, D.C.: Smithsonian Institution Press, 1988.

Mann, Maybelle. *Francis William Edmonds, Mammon and Art*. New York: Garland, 1977.

21

FRANCIS WILLIAM EDMONDS

Barking up the Wrong Tree, ca. 1850–55

Oil on canvas, 16 x 20¼ inches

Birmingham Museum of Art

Museum purchase with funds provided by Mrs. Allen A. Johnson; Coleman Cooper; Jeanne Adler Scharff; Norine S. Bodlker; and Dr. and Mrs. M. Bruce Sullivan, by exchange

1989.124

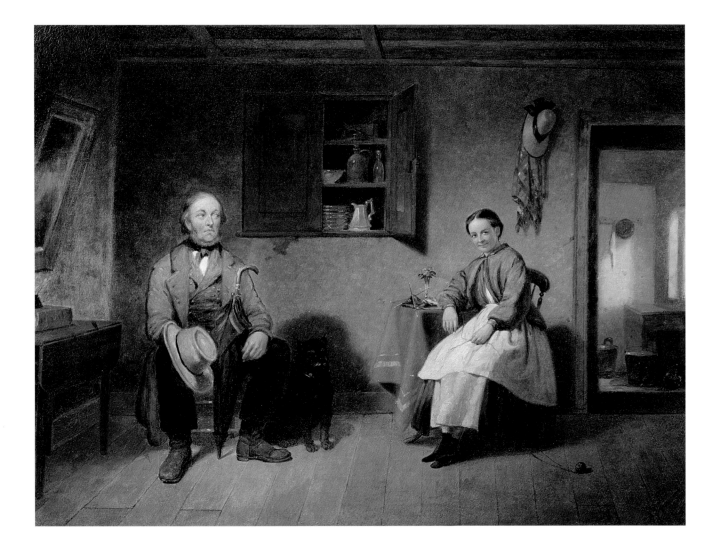

Philip Evergood

Born in New York, New York, 1901

Died in Bridgewater, Connecticut, 1973

Philip Evergood hoped his paintings would, like good stories, affect his audience and entertain them as well. When he was only eight years old, Evergood's mother took him to England. Following his graduation from Stubbington House School in 1914, he spent a brief period at the Royal Naval Training College. Between 1915 and 1919 he was a student at Eton; four years later, Evergood enrolled at London's Slade School of Art. Later that same year, in New York, he continued his training at the Art Students League under the Ashcan school painter George Luks (q.v.), and in sketching classes at the Education Alliance School.

A year later, Evergood was abroad again, furthering his training in Paris with André Lhote. All of this instruction prepared Evergood for his first one-person exhibition in 1927. In 1930 the peripatetic artist spent six months in Spain, where he absorbed the painterly influences of masters such as Goya and El Greco. In 1931 Evergood brought these influences back to the United States at a time when the country was suffering in the grips of the Great Depression. The artist felt sympathy for out-of-work laborers and was arrested on numerous occasions for militant participation in strikes. From 1934 to 1937 Evergood employed his art to express his views on a grand scale in public murals for the Public Works of Art Project and the Federal Art Project of the Works Progress Administration. The most successful of these projects was *The Story of Richmond Hill,* painted between 1936 and 1937 for the district library of Richmond, New York.

Between 1936 and 1937 Evergood also taught at the American Artists School. He continued teaching during the 1940s as an artist in residence at Kalamazoo College in Michigan and as an instructor at Muhlenberg College in Allentown, Pennsylvania. Even those beyond Evergood's classroom could experience his teaching and principles vicariously, through the artist's statements and publications. SJF

FOR FURTHER READING
Baur, John I. H. *Philip Evergood.* New York: Harry N. Abrams, 1975.
———. *Philip Evergood.* New York: Whitney Museum of American Art and Frederick A. Praeger, 1960.
Evergood, Philip. "Sure, I'm a Social Painter." *Magazine of Art* 36 (Nov. 1943): 254–59.

22
PHILIP EVERGOOD
My Forebears Were Pioneers, 1939
Oil on canvas, 50 x 36 inches
Georgia Museum of Art,
University of Georgia
University purchase
GMOA 1974.3190
Photo by Michael McKelvey

112

Gilbert Gaul

Born in Jersey City, New Jersey, 1855

Died in New York, New York, 1919

As a student at Claverack Military Academy, young Gilbert Gaul set his sights on a naval career, but ill health prevented him from reaching this goal. Instead, Gaul, at seventeen, headed for New York City and the National Academy of Design, where he studied with John George Brown (q.v.). Gaul later exhibited his work at the NAD and achieved the honor of being elected its youngest academician at the age of twenty-seven. When the Art Students League was founded in 1875, Gaul was one of its inaugural members.

In 1876 Gaul began a series of trips to the West. He traveled to the Dakota Territory, camped at army posts, lived with a tribe of Sioux only three weeks prior to the Battle of Little Big Horn, and recorded his experiences in sketches as well as photographs. Following this initial excursion, Gaul divided his time between his New York studio and Van Buren, Tennessee, the birthplace of his mother. It was there that he painted rural genre subjects and scenes from the Civil War and produced illustrations for magazines such as *Harper's Monthly*. In 1887 three of Gaul's paintings served as frontispieces for the four-volume text *Battles and Leaders of the Civil War*. Seven of his Civil War–themed canvases were also reproduced in 1907 in *With the Confederate Colors*, a print portfolio published by the Southern Art Publishing Company.

The artist's experience in the West and with Native Americans later allowed him to serve his country, although not in the manner he had originally anticipated as a boy in military school. In 1890 the federal government appointed Gaul to illustrate and assist with the writing of what eventually became the 683 pages of the Eleventh Census, initiated to document various Native American reservations and agencies.

After the Eleventh Census was completed, Gaul traveled to South America. The scenes he sketched there graced the pages of *Century Magazine* in 1892 and earned the artist a bronze medal when they were displayed at the World's Columbian Exposition in Chicago the following year. SJF

FOR FURTHER READING
Hoobler, James A. *Gilbert Gaul, American Realist*. Nashville: Tennessee State Museum Foundation, 1992.
Reeves, James F. *Gilbert Gaul*. Huntsville, Ala.: Huntsville Museum of Art, 1975.

23
GILBERT GAUL
Leaving Home, ca. 1907
Oil on canvas, 33¾ x 43¾ inches
Birmingham Museum of Art
Gift of John Meyer
1972.463

William Glackens

Born in Philadelphia, Pennsylvania, 1870

Died in Westport, Connecticut, 1938

As a member of the Ashcan school, William Glackens captured aspects of everyday life on canvas and in illustrations. Even prior to meeting Robert Henri, the eventual leader of this group of urban realists, Glackens was effectively documenting the mundane as a reporter and illustrator for the *Philadelphia Record.* After making the acquaintance of Henri, Glackens enrolled at the Pennsylvania Academy of the Fine Arts under the realist painter Thomas Anshutz. In 1894, he shared a studio with Henri, who persuaded Glackens to try his hand at oil painting; the next year they traveled to Paris, where they were inspired by the work of the impressionists. Upon their return to the United States, Henri and Glackens relocated to New York City. Once there, Glackens moved into a studio with George Luks (q.v.), another future member of the Ashcan school. Luks helped him secure work with the *World Sunday Supplement.* Gradually Glackens's illustrations were requested by the *New York Sunday World,* the *New York Herald,* by authors such as Alfred Lewis, and by periodicals like *McClure's,* which in 1898 employed the artist to cover the Spanish-American War.

Early in the twentieth century came watershed exhibitions in which Glackens played an integral role. In 1908 his work was featured in "The Eight," an exhibition held at the Macbeth Galleries in New York City that directly challenged the traditions of the venerable National Academy of Design. Five years later, Glackens helped assemble the works in the American section of the famous Armory Show that introduced much of the American public to European modernism. He also was the first president of the Society of Independent Artists, organized in 1917, and the author of several influential essays on modern art. SJF

FOR FURTHER READING

Buckley, Charles E., and Leslie George Katz. *William Glackens in Retrospect.* Saint Louis, Mo.: City Art Museum, 1966.

Gerdts, William H. *William Glackens.* Fort Lauderdale: Museum of Art, 1996.

Glackens, Ira. *William Glackens and the Ashcan Group: The Emergence of Realism in American Art.* New York: Crown, 1957.

24

WILLIAM GLACKENS

The Shoppers, 1907–8

Oil on canvas, 60 x 60 inches

Chrysler Museum of Art, Norfolk, Virginia

Gift of Walter P. Chrysler Jr.

71.651

Photo © Chrysler Museum of Art

Osvaldo Louis Guglielmi

Born in Cairo, Egypt, 1906

Died in New York, New York, 1956

Osvaldo Louis Guglielmi is best known for the vividly rendered, enigmatic works he painted in response to the nation's social, political, and economic conditions. Between 1906 and 1914, while his Italian father, an accomplished violist and violinist, toured Europe, Asia, and North and South America, Guglielmi and his mother resided in Milan and Geneva. In 1914 the family was reunited in Italian Harlem on Manhattan's Upper East Side.

After three years of assimilation, the precocious, eleven-year-old Guglielmi was intent on becoming a sculptor and found work in a bronze-casting factory. By 1920 he was attending the National Academy of Design five nights a week and going to high school during the day. His academic schooling only lasted until 1923, when the budding artist committed himself to his courses at the NAD full time. The completion of his studies coincided with his naturalization in 1927. The following year, he was a guest artist at the Yaddo Colony in Saratoga Springs, New York.

Like many other artists, Guglielmi weathered the Great Depression with the aid of a position in the easel painting division of the Public Works of Art Project of the WPA. Concurrently, he began spending summers as a Fellow at the MacDowell Colony near Peterborough, New Hampshire. In the fall of 1938, the Downtown Art Gallery offered Guglielmi his first one-person show. In 1943 he participated in the noteworthy "American Realists and Magic Realists" exhibition held at the Museum of Modern Art. That same year, Guglielmi began a two-year hiatus from painting to serve in the U.S. armed forces during World War II.

Following the war, Guglielmi was a visiting artist at Louisiana State University and an associate professor in LSU's Department of Fine Arts between 1952 and 1953. In 1956 the artist planned an extended stay in Italy that was cut short after just four days due to a heart attack that proved fatal. SJF

25
OSVALDO LOUIS GUGLIELMI
Tenements, 1939
Oil on canvas, 35½ x 25½ inches
Georgia Museum of Art,
University of Georgia
University purchase
GMOA 1948.197
Photo by Michael McKelvey

FOR FURTHER READING

Baker, John. *O. Louis Guglielmi, a Retrospective Exhibition.* New Brunswick, N.J.: Rutgers University Art Gallery, 1980.
Guglielmi, O. Louis. "I Hope to Sing Again." *Magazine of Art* 37: 1 (Jan. 1944): 173–77.
Harnsberger, R. Scott. *Ten Precisionist Artists: Annotated Bibliographies.* Westport, Conn.: Greenwood, 1992.

Carl Gutherz

Born in Schoeftland, Switzerland, 1844

Died in Washington, D.C., 1907

Swiss-born Carl Gutherz immigrated to the United States with his family in 1851, eventually settling in Memphis, Tennessee. He went to work as a mechanical draftsman after the death of his father. Dissatisfied with this type of work, Gutherz journeyed to Paris in 1868 seeking art instruction. He enrolled in the Ecole des Beaux-Arts and studied with Isidore Alexandre-Augustin Pils, who instilled in his young student a preference for the romantic tradition in painting.

When the Franco-Prussian War erupted in 1870 Gutherz fled Paris, traveling north to Brussels and Antwerp, where he copied works by the great Flemish masters. The paintings inspired him to seek training at the Royal Academy in Munich. There, he studied with the German romantic-symbolist Wilhelm von Kaulbach, who persuaded him to travel to Rome for further instruction. In Italy, Gutherz became familiar with the works of Botticelli and Raphael, whose emphasis on the ideal left a long-lasting impression. He returned to Memphis in 1872, only to depart later for St. Louis, having accepted a short-term teaching position at Washington University. Along with Halsey C. Ives he founded the St. Louis School of Fine Arts in 1879.

Gutherz returned to Paris in 1884 and stayed twelve years, the most productive period of his career. He moved in respectable art circles, becoming a close associate of such French romantic-symbolists as Jules Breton and Pierre Puvis de Chavannes. Many of his allegorical works, with subjects drawn primarily from mythology and religion, found critical success at the Salon. He was a significant influence on many American artists studying abroad at the time, including Childe Hassam (q.v.), Cecilia Beaux, Frank Benson, John Twachtman, and Thomas Dewing. Gutherz is perhaps best known for a seven-panel fresco cycle, *The Spectrum of Light,* which he created for the House Reading Room in the Library of Congress in 1895. RA

FOR FURTHER READING

Czestochowski, Joseph S. *Carl Gutherz*. Memphis, Tenn.: Brooks Memorial Art Gallery, 1975.

Hyland, Douglas. "Carl Gutherz and His Utopian Vision." *Interpretations* 13:2 (spring 1982): 45–71.

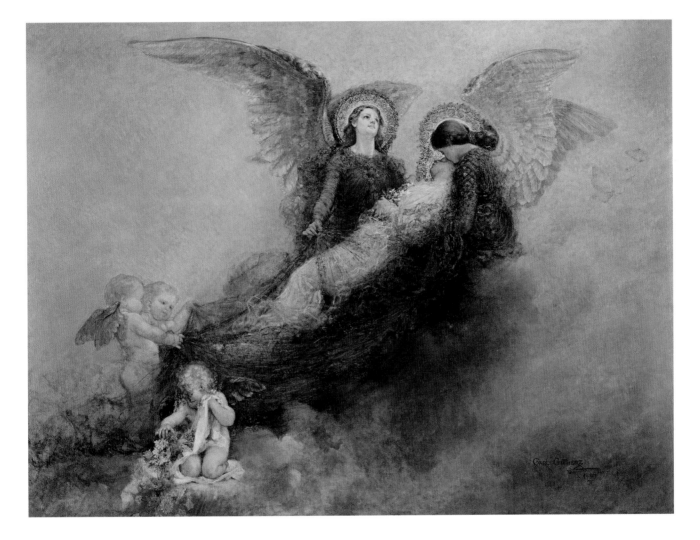

26

CARL GUTHERZ

Arcessita ab Angelis, 1889

Oil on canvas, 59¼ x 79¼ inches

Memphis Brooks Museum of Art,

Memphis, Tennessee

Gift of Mr. and Mrs. Marshall F. Goodheart

68.11.2

Robert Gwathmey

Born in Richmond, Virginia, 1903

Died in Southampton, New York, 1988

One of the most significant artists to come out of the South in the twentieth century, Robert Gwathmey painted what he saw and, perhaps more importantly, how he felt about what he saw. Social criticism, social documentary, and scenes of everyday life were his preferred subject matter, and many of Gwathmey's best works testify to his astute observations and commitment to social change.

An eighth-generation Virginian of middle-class origins, Gwathmey abandoned a planned career in business in order to study art, enrolling at the Maryland Institute of Design in Baltimore in 1925. After returning to his birthplace of Richmond, he became acutely aware of the racial and social inequalities endured by blacks and poor whites living in the South; he addressed those inequalities in some of his later paintings. Gwathmey received a scholarship to the Pennsylvania Academy of the Fine Arts in 1926, where he studied with Franklin Watkins, Daniel Garber, and George Harding. Summer fellowships in 1929 and 1930 provided him with the opportunity to travel abroad for further instruction.

At the close of the 1930s Gwathmey discovered his own style, which has been described as a curious blend of cubism and American folk painting, with an emphasis on the two-dimensionality of the picture plane and a preference for flat planes of color. After the advent of abstract expressionism, his figural style appeared anachronistic. During this period of critical eclipse Gwathmey held a number of teaching positions, the most successful and long-lasting being at Cooper Union School of Art in New York from 1942 to 1968. In the politically charged environment of the 1960s, interest in social issues resurfaced and brought Gwathmey renewed attention. RA

FOR FURTHER READING

Kammen, Michael. *Robert Gwathmey: The Life and Art of a Passionate Observer.* Chapel Hill: University of North Carolina Press, 1999.

Piehl, Charles K. "Robert Gwathmey: The Social and Historical Context of a Southerner's Art in the Mid Twentieth Century." *Arts in Virginia* 29 (1989): 2–15.

———. "Southern Artist at Home in the North: Robert Gwathmey's Acceptance of His Identity." *Southern Quarterly* 26 (fall 1987): 1–17.

27

ROBERT GWATHMEY

Marketing, ca. 1943–44

Oil on canvas, 21¼ x 27¼ inches

Telfair Museum of Art, Savannah, Georgia

Museum purchase, 1944

Photo by Peter Harholdt

George Henry Hall

Born in Manchester, New Hampshire, 1825

Died in New York, New York, 1913

George Henry Hall began his artistic career in Boston at the age of sixteen and lived long enough to witness monumental changes in the art world. Already a successful artist, Hall did not receive formal training until 1849, when, at the urging of his patron, Andrew Warner, he made his way to Düsseldorf. Although he held serious doubts about pursuing the rigorous academic routine and philosophy of the German school, Hall eventually acquiesced and traveled to Germany accompanied by his close friend Eastman Johnson (q.v.). They arrived in the art capital of Düsseldorf via Antwerp during the last gasp of the 1848 revolution, when street fights remained a common occurrence. Hall studied at the Königliche Akademie for approximately a year, adopting the highly detailed and naturalistic style then in favor, and for which he would become well known. He then traveled to Paris and stayed for a year before moving on to Rome. Hall returned to the United States in 1852 and opened a studio in New York.

Most often remembered today as one of the preeminent U.S. still-life painters of the nineteenth century, Hall's subjects were in fact wide-ranging. An inveterate traveler, he was one of the earliest U.S. artists to work in Spain, which he first visited in 1861. He returned five years later and produced several genre paintings depicting Spanish life and customs. He revisited Italy in 1872 and again in 1883, staying primarily in Rome and Capri. There he made the acquaintance of expatriate artists Elihu Vedder (q.v.) and Charles Caryl Coleman. In the years between these visits he undertook an extensive journey throughout the Middle East, and these travels provided additional source material for his art. Hall's decorative and opulent still-lifes of fruits and flowers, whether arranged traditionally on a tabletop or presented in their natural surroundings, were among his most popular paintings. They convey the sense of prosperity and well-being that characterizes the period of his greatest success. RA

28

GEORGE HENRY HALL
Boys Pilfering Molasses, 1853
Oil on canvas, 26½ x 21⁵⁄₁₆ inches
Georgia Museum of Art,
University of Georgia
Gift of Mr. and Mrs. Harry Fox
GMOA 1960.724
Photo by Michael McKelvey

Childe Hassam

Born in Dorchester, Massachusetts, 1859

Died in East Hampton, New York, 1935

Although Childe Hassam is now recognized as a leading American impressionist, his initial foray into art was as an apprentice wood engraver. By the 1870s his talents had drawn the attention of the Boston publishing house Daniel Lathrop and Company, who hired him to illustrate children's books. While in their employ, Hassam enrolled in classes at the Boston Art Club. In 1882 he exhibited watercolors at his first one-person show at the Williams and Everett Galleries. The following year, he sailed to Europe. He returned to Boston one year later with an abundance of watercolors documenting his travels.

In 1886 he went to Paris for three years, where he absorbed the lessons of Jules Lefebvre and Gustave Boulanger at the Académie Julian. Hassam returned to Europe several more times in his career, with stays lasting as long as eighteen months, and gradually developed an impressionist technique. Never satisfied to remain in one place for long, Hassam made numerous domestic journeys in addition to his travels abroad. In 1884 he made the first of many trips to Appledore in the Isles of Shoals, just off the New Hampshire/Maine coast, where he painted sparkling views of the local gardens and the sea. In 1889 the artist settled in New York City.

Hassam enjoyed exploring the New England coast and made frequent painting trips to Cos Cob and Old Lyme, Connecticut. The lure of the West attracted the painter as well. In 1904 he made his first visit to the Pacific Coast. He returned four years later at the invitation of Colonel Charles Erskine Scott Wood of Portland, Oregon, who commissioned Hassam to paint a mural for his library; and in 1914 he painted in northern California and produced a mural for San Francisco's Panama-Pacific Exposition.

Upon Hassam's death in 1935, his estate was granted to the American Academy of Arts and Letters, with the proviso that profits from the sale of his works be utilized to purchase the work of young American and Canadian artists for museum collections in the United States. SJF

FOR FURTHER READING

Adelson, Warren. *Childe Hassam, Impressionist*. New York: Abbeville, 1999.

Fort, Ilene Susan. *The Flag Paintings of Childe Hassam*. Los Angeles: Los Angeles County Museum of Art, 1988.

Hiesinger, Ulrich W. *Childe Hassam: American Impressionist*. New York: Prestel, 1999.

29

CHILDE HASSAM

Avenue of the Allies (Flags on the Waldorf), 1917

Oil on canvas, 18 x 15 inches

Telfair Museum of Art, Savannah, Georgia

Bequest of Elizabeth Miller (Mrs. Bernice Frost) Bullard, 1942

1942.11

W. S. Hedges

The origin and life dates of the artist are unknown. Although the subject is identifiably American, the artist may have been British, a supposition that is supported by the painting's British provenance. At the very least, the painter was clearly familiar with British sporting pictures of the early nineteenth century, which provided the model for this race scene.

30

W. S. HEDGES

A Race Meeting at Jacksonville, Alabama,
1841

Oil on canvas, 19¾ x 33¾ inches

Birmingham Museum of Art

Museum purchase with funds provided by

Mr. Coleman Cooper; EBSCO Industries,

Inc.; Mr. Henry S. Lynn Jr.; Mr. and Mrs.

Jack McSpadden; the Regina and Harold

E. Simon Fund; and Mary Arminda Mays

in the memory of John Edward Mays, by

exchange

1985.278

Edward Lamson Henry

Born in Charleston, South Carolina, 1841

Died in Ellenville, New York, 1919

*G*enre paintings from the easel of Edward Lamson Henry were highly sought after by his contemporaries. Henry copyrighted his nostalgic scenes and sated the public's hunger for his images by allowing his compositions to be reproduced on calendars and in photogravures, etchings, and platinotypes that he himself often hand-colored.

Pinning down the specifics of Henry's youth is difficult. By some reports, he grew up an orphan in his cousins' New York home; other sources claim that he was raised as his mother's nephew, rather than her son, because it was necessary to keep his parents' clandestine marriage a secret. The artist's life from the late 1850s forward is easier to track. When Henry was seventeen years old, he enrolled in the Pennsylvania Academy of the Fine Arts. In 1860, he embarked on the Grand Tour of Europe. During his two-year sojourn there, he dedicated himself to the study of art and the perfection of his techniques, working with notable Parisian painters Charles Gleyre and Gustave Courbet.

Shortly after he returned from Europe, Henry put aside his palette and served as a captain's desk clerk for the Union army. At the end of the Civil War, the artist settled into the famed Tenth Street Studio Building in New York City. It was not long until his painterly talents were recognized and rewarded by the National Academy of Design. In 1867 he was elected an associate; two years later he earned the title of academician.

Henry returned to Europe on at least three other occasions during the 1870s and 1880s. During these decades the artist also traveled a great deal domestically, spending numerous summers in East Hampton and Sag Harbor, Long Island, and participating in the development of the artists' colony at Cragsmoor, New York. sjf

FOR FURTHER READING
McCausland, Elizabeth. *The Life and Work of Edward Lamson Henry, N.A., 1841–1919.* Albany: University of the State of New York, 1945.
The Works of E. L. Henry: Recollections of a Time Gone By. Shreveport, La.: R. W. Norton Art Gallery, 1987.

31

EDWARD LAMSON HENRY

The Sitting Room, 1883

Oil on canvas, 10½ x 13 inches

Collection of The Speed Art Museum,

Louisville, Kentucky

Gift of the Museum Collectors

1982.30

Edward Hicks

Born in Attleborough (now Langhorne), Pennsylvania, 1780

Died in Newtown, Pennsylvania, 1849

*I*n 1846, three years before his death, the Reverend Edward Hicks described his artistic contributions as those of "a poor old worthless insignificant painter."[1] This self-deprecating comment is evidence of Hicks's struggle to reconcile his two seemingly opposed vocations as Quaker minister and painter.

Although Hicks is best known as the author of more than sixty extant paintings on the biblical theme of the Peaceable Kingdom (Isaiah 11:6–9), the beginning of his life was anything but peaceful. When he was only an infant, the Revolutionary War forced his father and his grandfather, the chief justice of Bucks County, Pennsylvania, under the British Crown, to abandon their Anglican family and go into hiding. When the young Hicks was only eighteen months old, his mother died. In essence an orphan, Hicks was taken in by a devout Quaker family with whom his mother had been friends.

When he was just thirteen, Hicks was apprenticed to a coach maker from whom he learned the skills of painting and decorative lettering. By 1801 he ran his own business as a painter and decorator of everything from houses to milk buckets. In 1821 he heeded the call to become a Quaker minister. Given the propensity of the Society of Friends for simplicity, the embellishment of coaches and clock faces seemed to Hicks at odds with his new religious responsibilities and caused him to give up painting. However, the fact that Quaker ministers received no monetary dispensation resulted in Hicks's rapid return to what a fellow minister called "the forbidden tree" of easel painting in order that he might support his wife and five children. Hicks was able to resolve both his financial difficulties and his moral dilemmas by painting works that were the embodiment of his religious conviction, such as his well-known, and widely reproduced, Peaceable Kingdom series. SJF

NOTE

1. Quoted in Weekley, *The Kingdoms of Edward Hicks*, 2.

FOR FURTHER READING

Mather, Eleanor Price. *Edward Hicks: His Peaceable Kingdoms and Other Paintings.* East Brunswick, N.J.: Associated University Presses, 1983.

Weekley, Carolyn J. *The Kingdoms of Edward Hicks.* Williamsburg, Va.: Colonial Williamsburg Foundation in association with Harry N. Abrams, 1999.

32

EDWARD HICKS

Peaceable Kingdom of the Branch, 1826–30

Oil on canvas, 23½ x 30¾ inches

Reynolda House, Museum of American Art, Winston-Salem, North Carolina

Gift of Barbara Millhouse

1969.2.3

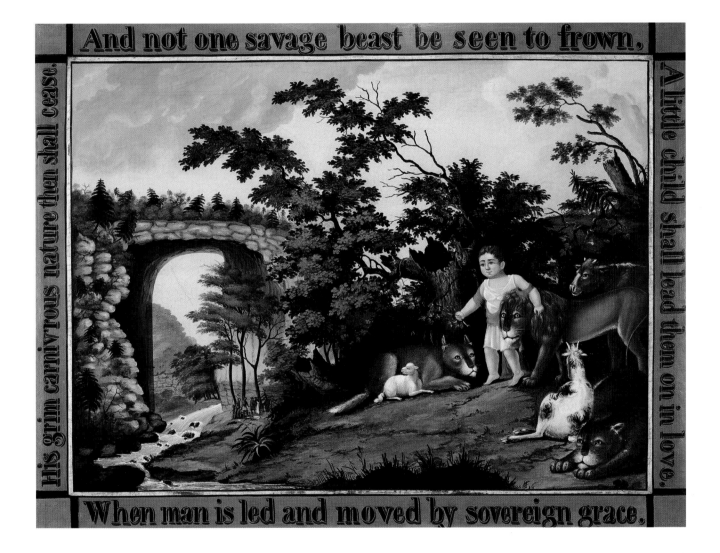

And not one savage beast be seen to frown,

A little child shall lead them on in love.

His grim carniv'rous nature then shall cease.

When man is led and moved by sovereign grace,

Winslow Homer

Born in Boston, Massachusetts, 1836

Died in Prout's Neck, Maine, 1910

Winslow Homer's wonderfully nuanced paintings, enriched by his use of meaningful symbolic content, have contributed to making him one of the most popular and original storytellers in nineteenth-century American art. Primarily a self-taught artist, Homer was apprenticed to a lithographer at an early age in his hometown of Boston. He made a name for himself as a freelance illustrator when, at the age of twenty-five, he was sent to cover the Civil War for *Harper's Weekly*. Rather than record scenes of the fighting, Homer broke with tradition by focusing his attentions on capturing the quotidian aspects of camp life among the Union armies. These informative vignettes, along with his many remarkable paintings of similar subjects, form one of the most truthful visual documents of the Civil War outside of photography.

Homer traveled abroad on several occasions following the war, visiting Paris for ten months in 1866–67 and visiting England in 1881–82, where he lived among the fisher folk of Cullercoats, near Newcastle, observing and recording their unique way of life. In England, as he had in rural America in the 1870s, Homer exploited his remarkable facility for watercolor, a challenging medium of which he became one of the most accomplished masters. He abandoned his residence in New York City in 1883, retiring to a small spit of land known as Prout's Neck, near Scarborough, Maine. He remained relatively isolated from the commercial aspects of art for the rest of his life. Living in this remote outpost, Homer discovered a new subject, the Atlantic Ocean, which he would come to know and represent in all its temperaments. Although he chose to live the life of a recluse, intentionally ignoring his growing acclaim, Homer enjoyed rustic summer vacations, fishing in the Adirondacks and Quebec, as well as winter excursions to tropical destinations in the Bahamas, Bermuda, and Florida. RA

FOR FURTHER READING

Cikovsky, Nicolai. *Winslow Homer.* New York: Rizzoli International, 1992.

Conrads, Margaret C. *Winslow Homer and the Critics: Forging a National Art in the 1870s.* Princeton, N.J.: Princeton University Press, 2001.

33

WINSLOW HOMER
Rab and the Girls (Over the Hills), 1875
Oil on canvas, 24 x 38 inches
The Parthenon, Nashville, Tennessee
The James M. Cowan Collection of
American Art
29.2.21

Thomas Hovenden

Born in Dunmanway, County Cork, Ireland, 1840

Died near Trenton, New Jersey, 1895

The warmth and familial intimacy that genre painter Thomas Hovenden so often depicted on his canvases was lacking in the artist's own childhood experience. The Irish potato famine claimed the lives of both of his parents when he was only six years old, leaving him to grow up in an orphanage in County Cork. In 1855 Hovenden began a seven-year apprenticeship under a master gilder and carver who recognized Hovenden's potential and urged him to enroll in the Cork School of Design in 1858.

Desiring to reunite with his older brother in New York City, Hovenden immigrated to the United States in 1863. He continued to foster his artistic talents through night classes at the National Academy of Design—where he would exhibit throughout his career—and as an illustrator for *Harper's*. In 1868 he relocated to Baltimore; six years later, he made his way to the Ecole des Beaux-Arts in Paris and the atelier of the respected academician Alexandre Cabanel. The artists' colony at Pont-Aven, Brittany, soon attracted the artist's attention. Between 1875 and 1880 he painted Breton subjects, made frequent trips back to Paris, and grew acquainted with his future wife, the painter Helen Corson. The couple were married in 1881 after returning to the United States and moving to Plymouth Meeting, Pennsylvania. In

1882, already a member of the Society of American Artists, Hovenden was granted the title academician by the NAD.

When Thomas Eakins was forced to resign from his teaching position at the Pennsylvania Academy of the Fine Arts in 1886, Hovenden succeeded him. While in this position, which he occupied until 1888, he became a mentor to Ashcan school founder Robert Henri. Hovenden served as a member of the New York jury for the 1889 Universal Exposition in Paris and exhibited his work abroad as well. He received his greatest acclaim during the 1893 World's Columbian Exposition in Chicago, when his *Breaking Home Ties,* 1890, was voted the most popular painting of the fair.

In 1895, in a tragic end to a brief but fruitful career, a locomotive struck and killed Hovenden while he attempted to rescue a child on the railway tracks. SJF

FOR FURTHER READING
Clark, Henry Nichols Blake. *Thomas Hovenden: Intimate Insights.* Norfolk, Va.: The Chrysler Museum, 1994.
Terhune, Anne Gregory, Sylvia Yount, and Naurice Frank Woods Jr. *Thomas Hovenden (1840–1894): American Painter of Hearth and Homeland.* Philadelphia: Woodmere Art Museum, 1995.

34

THOMAS HOVENDEN

Contentment, 1881

Oil on canvas, 20 x 26 inches

Collection of the Columbus Museum, Columbus, Georgia

Gift of Dr. Philip L. Brewer in honor of Dr. Delmar Edwards

93.23

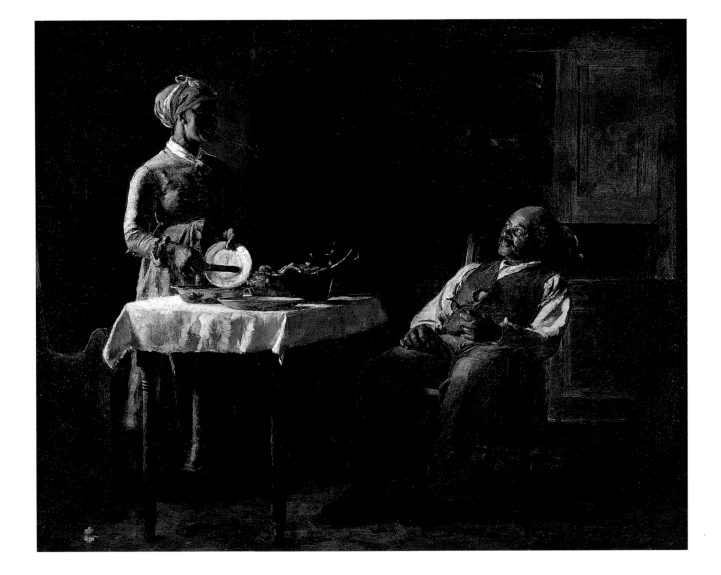

Marie Atkinson Hull

Born in Summit, Mississippi, 1890

Died in Jackson, Mississippi, 1980

arie Hull's interest in the visual arts can be attributed in part to an earlier passion for adventure and love of music. In 1910, after earning a degree in music from Belhaven College in Jackson, Mississippi, Hull enrolled in art classes taught by Aileen Phillips, who encouraged her to seek further training at the Pennsylvania Academy of the Fine Arts. Hull enrolled there in 1912 and studied with Daniel Garber and Hugh Breckenridge, both highly respected academicians. She returned to Jackson the following year and accepted a one-year teaching position at Hillman College. Afterwards, she began to teach art classes privately in her home, an activity she continued throughout her life. In 1917 she wed architect Emmett Johnston Hull and for a time worked as his assistant, rendering the buildings he designed in drawings and watercolors.

Following her marriage, Hull studied portraiture with Robert Reid and landscape painting with John Carlson at Colorado Springs Fine Arts Center. She began an intensive study of the figure in 1922 as a student of Frank Vincent Dumond at the Art Students League; while residing in New York, Hull also honed her skills in portraiture and landscape painting under the tutelage of Robert W. Vonnoh. In 1929 she joined a small coterie of art students led by George Elmer Browne and traveled to Europe in order to study the works of the old masters. Hull traveled extensively throughout her career, taking in exhibitions whenever possible in order to learn from the works on display. Known primarily for the remarkable character studies of impoverished sharecroppers and blacks that she produced during the 1930s and 1940s, Hull also experimented with abstract expressionism in later years. Although she professed a preference for painting, Hull also worked as a sculptor and printmaker, finding success in both media. RA

FOR FURTHER READING
Norwood, Malcolm M., Virginia McGehee Elias, and William S. Haynie. *The Art of Marie Hull.* Jackson: University Press of Mississippi, 1975.
Rankin, Tom, et al. *Marie Hull, 1890–1980: Her Inquiring Vision.* Cleveland, Miss.: Wright Art Center, Delta State University, 1990.

35

MARIE ATKINSON HULL
Sharecroppers, 1938
Oil on canvas, 40 x 40¼ inches
Collection of Mississippi Museum of Art, Jackson
Gift of the artist
1978.146

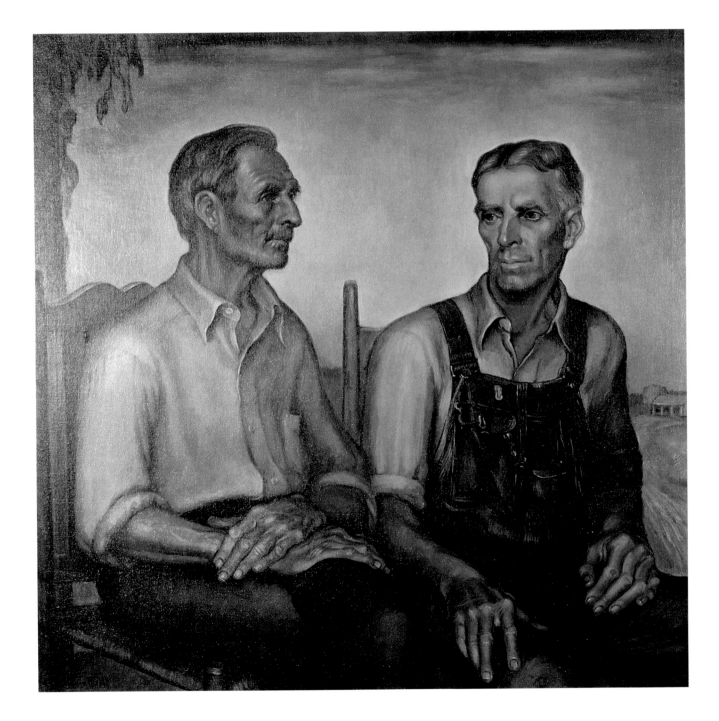

(Jonathan) Eastman Johnson

Born in Lovell, Maine, 1824

Died in New York, New York, 1906

Eastman Johnson developed his drawing skills as an apprentice in a Boston lithography firm from 1840 to 1842. In 1845 he moved to the nation's capital, where he limned portraits in chalk, crayon, and charcoal of such prominent figures as Dolly Madison, John Quincy Adams, and Mrs. Alexander Hamilton. He returned to Boston the following year and added to his roster of illustrious Americans such literary giants as Henry Wadsworth Longfellow, Nathaniel Hawthorne, and Ralph Waldo Emerson.

Accompanied by his close friend George Henry Hall (q.v.), Johnson sailed for Europe in 1849. His destination was the Düsseldorf Academy. Under the guidance of instructors at the academy, he learned to paint in the highly detailed naturalistic manner then prized by collectors back home. Broadening his education, Johnson traveled to the Netherlands, where he encountered works by Rembrandt and Frans Hals as well as the anecdotal genre paintings of the seventeenth-century Dutch school. He then spent two months studying with Thomas Couture in Paris before returning to the United States in 1855.

In 1859 Johnson submitted *Negro Life at the South* to the National Academy of Design in New York, where it was exhibited to great acclaim. He followed this success with other sympathetic depictions of black Americans. For much of the 1860s and early 1870s he concentrated on producing appealing genre paintings and portraits influenced by his European studies, works that earned him the sobriquet "the American Rembrandt." Contemporary critics praised Johnson for the truthfulness of his compositions and applauded their unmistakably American content: maple sugar camps in Maine, cranberry harvests in Nantucket, family life in fashionable, urban domestic interiors. Although Johnson was well respected during his lifetime, his reputation was eclipsed for a time by the prodigious talents of a slightly younger generation of American realists, especially Winslow Homer (q.v.) and Thomas Eakins, from whose shadows he has emerged in recent decades. RA

FOR FURTHER READING

Carbone, Theresa, and Patricia Hills. *Eastman Johnson: Painting America.* Brooklyn: Brooklyn Museum of Art, Rizzoli, 1999.

Hills, Patricia. *Genre Paintings of Eastman Johnson: The Sources and Development of His Style and Themes.* New York: Garland, 1977.

———. *Eastman Johnson.* New York: Whitney Museum of American Art, 1972.

Simpson, Marc. *Eastman Johnson: The Cranberry Harvest, Island of Nantucket.* San Diego: Timken Art Gallery, 1990.

36

JONATHAN EASTMAN JOHNSON

The Earnest Pupil (The Fifers), 1881

Oil on canvas, 26 x 22 inches

Collection of the Columbus Museum, Columbus, Georgia

Museum purchase made possible by an anonymous donor

98.26

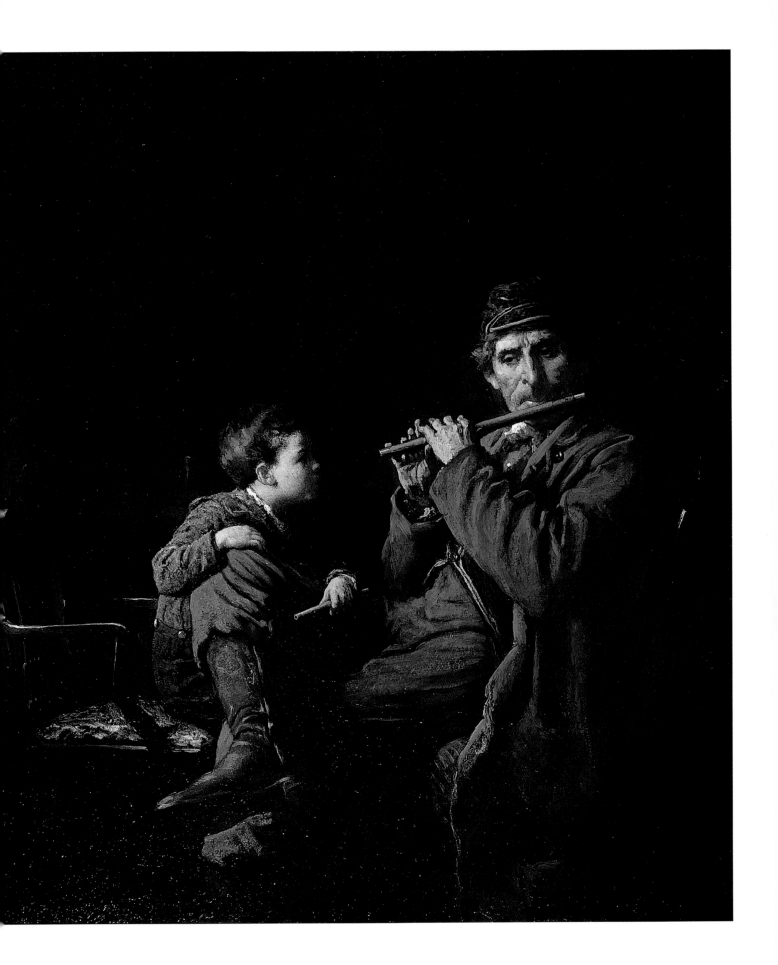

Rockwell Kent

Born in Tarrytown, New York, 1882

Died in Au Sable Forks, New York, 1971

*I*n 1937 Rockwell Kent asked, "Do you want my life in a nutshell? It's this: that I have only one life, and I'm going to live it as nearly possible as I want to live it."[1] From childhood, he was accustomed to adventure. When he was thirteen years old, his aunt, an accomplished ceramic painter, took him on a European tour. Upon their return, Kent enrolled in the Horace Mann School in New York City, where he exhibited proclivities for mechanical drawing.

In 1900 he matriculated at Columbia College's School of Architecture. That same year, he also spent the first of three summers at Shinnecock Hills, Long Island, taking painting lessons from William Merritt Chase. Chase was so impressed with his protégé that he awarded Kent a full scholarship to his art academy, the New York School of Art. For a brief period, Kent divided his time between Columbia and Chase's art school. After meeting painter Robert Henri, however, he abandoned his architectural studies.

When Kent was twenty-three, he heeded Henri's advice and spent the first of numerous summers at Monhegan Island, an artists' colony off the coast of Maine. Between 1914 and 1915, Kent and his wife lived in Newfoundland. This northern exposure ignited a desire that led him on an eight-month sojourn to Fox Island, Alaska, with his nine-year-old son in 1918. Repeated

trips to Greenland followed. Kent balanced his experiences in the northern hemisphere with a trip to Tierra del Fuego in 1922.

In the midst of his travels, Kent maintained a presence as an artist. He exhibited widely, wrote two books based on his Greenland adventures, and coauthored a book about his prints. He also illustrated several well-known volumes, most famously Herman Melville's *Moby-Dick* (1930), and received commissions for advertisements from industries such as General Electric and the Bituminous Coal Institute.

Kent was also a political activist. Because of his praise of the Soviet Union, his position as chair of the National Council of American-Soviet Friendship, and his donation of a large body of his work to the Soviet government, many of Kent's contemporaries shied away from the artist and what they believed to be his leftist leanings. In 1957 the Soviet Union embraced him with a major retrospective. Ten years later, Kent earned the Lenin Peace Prize; he donated part of the cash award to the South Korean Liberation Front.

In 1969 the home Kent had designed, nestled in the Adirondacks, was struck by lightning and consumed by fire. Just two years later, after rebuilding on the charred foundation, Kent passed away. SJF

NOTE

1. Quoted in Traxel, *An American Saga*, epigraph.

FOR FURTHER READING

Kent, Rockwell. *It's Me, O Lord; The Autobiography of Rockwell Kent.* New York: Dodd, Mead, 1955.

Kent, Rockwell, and Carl Zigrosser. *Rockwellkentiana: Few Words and Many Pictures.* New York: Harcourt, Brace, 1933.

Martin, Constance. *Distant Shores: The Odyssey of Rockwell Kent.* Berkeley: University of California Press, 2000.

Traxel, David. *An American Saga: The Life and Times of Rockwell Kent.* New York: Harper & Row, 1980.

37

ROCKWELL KENT

The Baker of the Bread of Abundance, 1945

Oil on canvas, 37$^{15}/_{16}$ x 44 inches

University of Kentucky Art Museum, Lexington

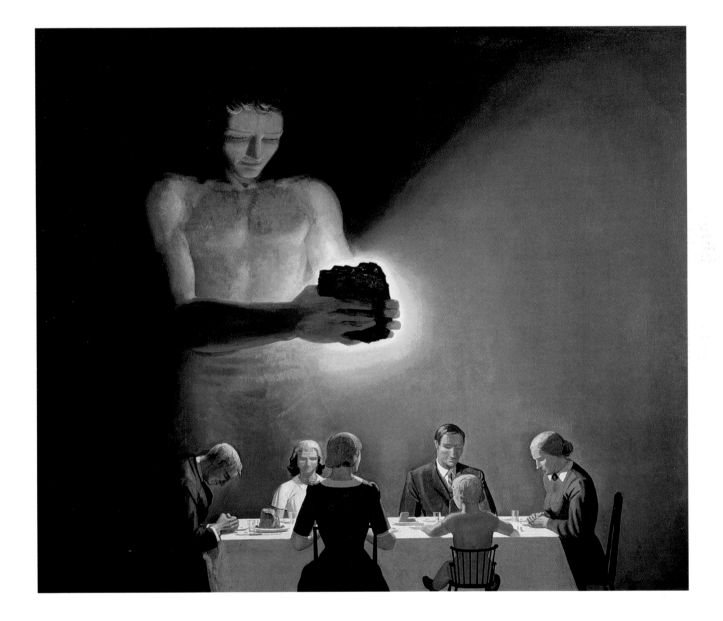

Jean-Hyacinthe Laclotte

Born in Bordeaux, France, 1766

Died in Bordeaux, France, 1829

A third-generation architect from Bordeaux, Jean-Hyacinthe Laclotte received his education at the Ecole des Beaux-Arts in Paris. He moved to New Orleans in 1804, one year after the United States purchased the Louisiana Territory from France. His earliest major commission there was for the Orleans Theater, designed in 1806–7 but not completed until 1814. Laclotte must have enjoyed this association with the theater, for he found subsequent employment in the entertainment industry as a scenery painter and interior decorator for several of the city's most prestigious theaters. He also achieved notice as a designer of fireworks displays, such as that ignited for New Year's Day 1807. That same year he published a notice in the local newspaper advertising his services as a teacher of architecture, drawing, and painting. There is no record of his activity in New Orleans between December 1807 and September 1810; it appears that he spent most of this period in Mexico, returning to New Orleans in late 1809 or early the following year.

With his fellow countryman Arsène Lacarrière Latour, a civil and military engineer, Laclotte opened an architectural firm in September 1810. At the same time, the two men founded an art school based on the instruction offered at the Paris Academy of Fine Arts.

Students were provided a well-rounded education in the applied arts and the fine arts, with classes in drawing, portraiture, landscape painting, architecture, and interior design, as well as instruction in a variety of building trades. After the partnership dissolved in bankruptcy three years later, Laclotte continued to find work as an architect, scene painter, and teacher.

Laclotte served as an engineer in the First Louisiana Militia during the Battle of New Orleans, and he recorded the conflict in sketches made on the battlefield. From these drawings he developed a formal composition titled *View of the Battle of New Orleans, with Key, 1815,* believed to be the most accurate representation of the combat. Known during the nineteenth century as *The Eighth of January 1815,* Laclotte's panoramic depiction of the fighting at Chalmette Plantation became his most popular work, overshadowing his success as an architect and teacher. Laclotte returned to Bordeaux in 1821 and entered another architectural firm, where he was probably employed until his death. RA

FOR FURTHER READING
Wolf, Peter Michael. "Jean-Hyacinthe Laclotte." M.A. thesis, Tulane University, 1963.

38
JEAN-HYACINTHE LACLOTTE
Battle of New Orleans, 1815
Oil on canvas, 29½ x 36 inches
New Orleans Museum of Art
Gift of Edgar William and Bernice Chrysler Garbisch
65.7

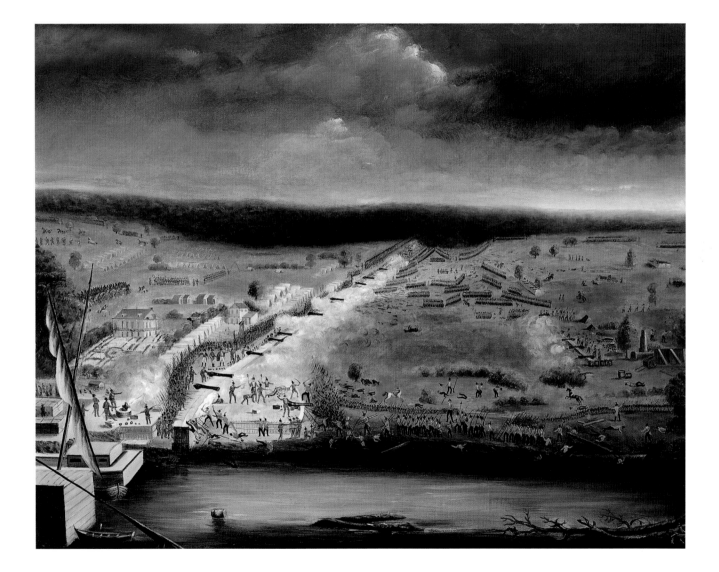

George Cochran Lambdin

Born in Pittsburgh, Pennsylvania, 1830

Died in Germantown, Pennsylvania, 1896

George Cochran Lambdin, genre and still-life painter, received his early artistic training from his father, the landscape and portrait painter James R. Lambdin. By the age of eighteen, young Lambdin had his work exhibited at the venerable Pennsylvania Academy of the Fine Arts, where the senior Lambdin was director. The son's paintings also received significant public exposure when they were exhibited in New York at the National Academy of Design in 1856.

After he returned to the United States following a period of study in Munich under William Henry Furness Jr., Lambdin created some of his best-known senti-mental genre scenes, including *The Last Sleep* (1858); nine years after it was exhib-ited at the Pennsylvania Academy, he sent the painting to Paris for exhibition at the Universal Exposition. In the years lead-ing up the 1867 Exposition, Lambdin's genre scenes garnered increased atten-tion. In 1859 John W. Ehninger, publisher of *Autograph Etchings by American Art-ists,* requested a work from Lambdin to include in his much-sought-after volume.

In the early 1860s, the tragedies and triumphs of the Civil War attracted Lambdin's artistic eye. He contributed works to Sanitary Commission fairs; he visited his enlisted brother, James Har-rison "Harry" Lambdin, at the front; and he made sketches in the South as hostili-ties drew to a close. Following the war, Lambdin moved into the famous Tenth Street Studio Building in New York City. By 1868 he had been elected an academi-cian by both the PAFA and the NAD. Dur-ing the next year, Louis Prang & Co., a Boston publisher of chromolithographs, issued a series of prints of Lambdin's in-creasingly popular flower paintings. SJF

FOR FURTHER READING
Weidner, Ruth Irwin. *George Cochran Lambdin, 1830–1896.* Chadds Ford, Pa.: Brandywine River Museum, 1986.

39

GEORGE COCHRAN LAMBDIN

The Last Sleep, ca. 1858

Oil on canvas, 40 x 54¾ inches

North Carolina Museum of Art, Raleigh

Gift of Peter A. Vogt

G.79.4.1

Jacob Lawrence

Born in Atlantic City, New Jersey, 1917

Died in Seattle, Washington, 2000

Jacob Lawrence, best known for his unique brand of social realism, grew up with his mother in Harlem during the heyday of the Harlem Renaissance. Steeped in this creative environment, Lawrence was encouraged to begin his art training at an early age. When he was fifteen years old, he enrolled in classes sponsored by the College Art Association. By the late 1930s, he was taking advantage of courses sponsored by the Works Progress Administration in conjunction with the Harlem Art Workshop and had earned a scholarship to the American Artists' School.

The dedication Lawrence showed to honing his talents paid off well. In 1941 *Fortune* magazine reproduced his Migration series of paintings dedicated to the African American exodus from the South, in which the artist's family had taken part. Lawrence received further recognition that year when his work became the first created by an African American artist to enter the prestigious collection of the Museum of Modern Art. It was also during this momentous year that Lawrence made his initial visit to the South.

Lawrence served with the United States Coast Guard between 1943 and 1945. Following World War II, the painter Josef Albers invited Lawrence to teach at Black Mountain College near Asheville, North Carolina. Lawrence continued to work with young and aspiring artists throughout much of his career. Between 1955 and 1970 he taught at Pratt Institute in New York. In 1964, however, he spent a year in Nigeria with his wife and fellow painter, Gwendolyn Knight Lawrence. His tenure at Pratt was also interrupted by teaching engagements elsewhere, including Brandeis University in Massachusetts, the New School for Social Research and the Art Students League in New York, and California State College in Hayward. In 1970 Lawrence moved to Seattle for a professorial position at the University of Washington. He remained in the Pacific Northwest, teaching and painting, until his death. SJF

FOR FURTHER READING

Nesbett, Peter T. *Jacob Lawrence: Paintings, Drawings, and Murals (1935–1999): A Catalogue Raisonné.* Seattle: University of Washington Press, 2000.

Powell, Richard J. *Jacob Lawrence.* New York: Rizzoli, 1992.

Wheat, Ellen Harkins, and Patricia Hills. *Jacob Lawrence, American Painter.* Seattle: University of Washington Press, 1986.

40

JACOB LAWRENCE

The Plowman, 1942

Tempera on board, 19½ x 23¾ inches

Collection of the

Greenville County Museum of Art,

Greenville, South Carolina

Museum purchase with funds

donated by the Arthur and Holly

Magill Foundation

GCMA 91.27.3 (2035)

Jack Levine

Born in Boston, Massachusetts, 1915

Lives in New York, New York

Throughout a long and productive career Jack Levine has remained steadfastly committed to creating art that is socially relevant, believing that most people prefer works of art that mirror their daily experiences. With a Daumier-like sensibility attuned to the inconsistencies of contemporary life, Levine has employed his brush and his wit to create satirical, sometimes caustic critiques of inept politicians, military leaders, and others who abuse power. Admittedly a moralist in his appraisals of society and its inherent weaknesses, Levine has also produced a series of small finely drawn paintings on biblical themes, as well as portraits of considerable warmth and tenderness.

A professional artist by the time he was eighteen years old, Levine received rigorous academic training in preparation for his career. He developed his skills as a draftsman at the Community Center in Roxbury, Massachusetts, studying drawing with Harold Zimmerman from 1924 to 1931. His introduction to painting came in 1929 when he enrolled at Harvard and for a time became the pupil of Denman Ross, who favored an impressionist style. From 1935 to 1937 Levine worked under the auspices of the Works Progress Administration, during which time his commitment to social realism firmly took root.

Levine's mature painting style can be described as a native-born version of expressionism informed by the art of the past, with which the artist feels a particular kinship. With an expressive handling of the material and the exaggeration and distortion of forms, Levine has always sought to express his own feelings for the subject. A trip to Europe in 1947 deepened his appreciation for such old masters as Rembrandt, El Greco, and Goya. He especially admired their technique, their handling of paint, which he adapted for his own purposes. This connection with tradition partially explains Levine's dislike for nonrepresentational art, specifically abstract expressionism, which he believes to be all surface and no substance. For Levine, art succeeds only when surface and substance have been brought into harmony. RA

FOR FURTHER READING

Henry, Gerrit. *Jack Levine: An Overview, 1930–1990.* New York: Midtown Payson Galleries, 1990.

Levine, Jack, and Milton Brown. *Jack Levine.* Ed. Stephen R. Frankel. New York: Rizzoli, 1989.

Prescott, Kenneth W. *Jack Levine: Retrospective Exhibition, Paintings, Drawings, Graphics.* New York: The Jewish Museum, 1978.

41

JACK LEVINE

City Lights, 1940

Oil on canvas, 54 x 36 inches

Memphis Brooks Museum of Art, Memphis, Tennessee

Gift of Edith and Milton Lowenthal

78.6

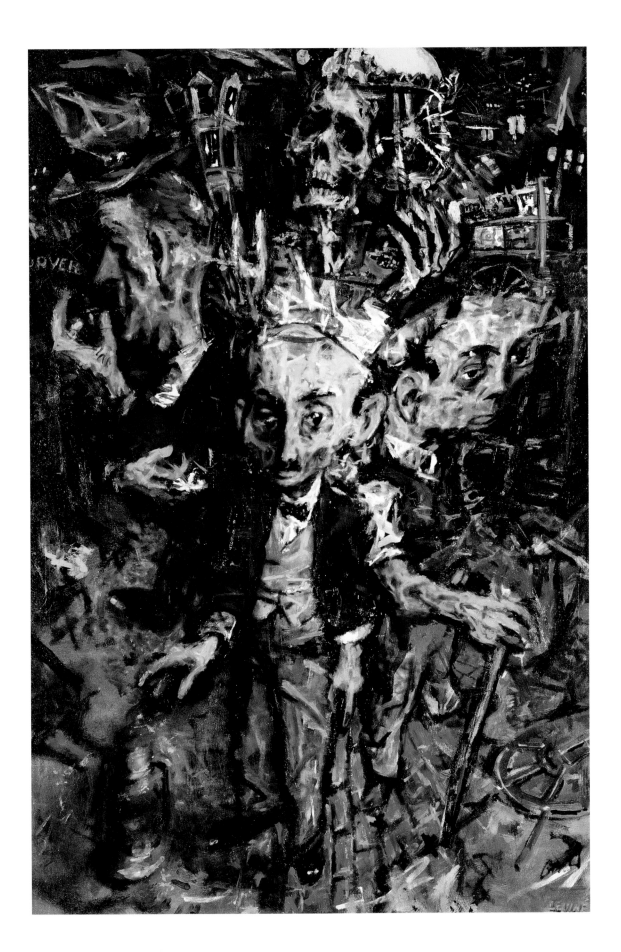

George Luks

Born in Williamsport, Pennsylvania, 1866

Died in New York, New York, 1933

*A*lthough a New York newspaper office and a vaudeville stage in Philadelphia sound worlds apart, both were once occupied by the painter George Luks. In 1883, while still a teenager, Luks moved from the small mining town of Shenandoah, Pennsylvania, to Philadelphia, where he performed with a vaudeville company and began to study art with Thomas Anshutz at the Pennsylvania Academy of the Fine Arts. As was common practice for young and aspiring artists, Luks traveled to Europe in 1885 to absorb the lessons in art offered by such late-nineteenth-century cultural centers as Munich, Düsseldorf, Paris, and London.

Although the period spent abroad proved inspirational, it was a stateside event that had the greatest influence in the development of Luks's art. In 1894 he met Robert Henri, the central figure of the Ashcan school of urban realists, and his associates John Sloan, Everett Shinn, and William Glackens (q.v.). Like other future members of the group, Luks was hired as a reporter by the *Philadelphia Press* and *Evening Bulletin.*

In 1896, after spending some time in Cuba, Luks relocated to New York City and accepted a position as a cartoonist for the *New York World.* It was not until a year later that he seriously took up the brush to document the urban environment around him. In 1904, when the National Arts Club displayed his paintings, Luks's unconventional style was not immediately appreciated. In 1907 the National Academy of Design rejected paintings by Luks, Shinn, and Glackens from its annual spring exhibition. In response, the following year the Macbeth Gallery mounted an exhibition, entitled "The Eight," that formally introduced to the public the gritty canvases of what a later critic disparaged as "the Ashcan school."

In the decades that followed, Luks offered private paintings lessons, taught at the Art Students League, and eventually established his own school in order to supplement the income he received from the sale of his paintings. Unfortunately, his career as an artist and a teacher was cut short in 1933 when he died as a result of injuries sustained in a barroom brawl. SJF

FOR FURTHER READING
George Luks, 1866–1933. Utica, N.Y.:
 Munson-Williams-Proctor Institute,
 Museum of Art, 1973.

42

GEORGE LUKS
Allen Street, ca. 1905
Oil on canvas, 32 x 45 inches
Hunter Museum of American Art,
Chattanooga, Tennessee
Gift of Miss Inez Hyder
HMAA.1956.1

Jacob Marling

Born in 1774

Died in Raleigh, North Carolina, 1833

Like many early American painters, Jacob Marling, whose origins are unknown, roamed the United States searching for hospitable locales in which to ply his trade. He served a lengthy apprenticeship with James Cox in Albany, New York, until 1795. Marling took up the life of an itinerant painter and found occasions to hone his teaching skills in New York, Philadelphia, and Richmond. In each of the cities he visited, Marling gave public and private classes, teaching drawing and painting to men and women alike, though not at the same time. In 1813 he finally settled in Raleigh, where he remained until his death.

One of only a few artists working in the area at the time, Marling found immediate success in the new state capital. He became the first director of the North Carolina Museum, founded in 1813. Marling also established a reputation as Raleigh's leading portraitist and miniaturist, painting the likenesses of some of the most powerful landowners in the region. Although his skills as a portraitist were limited, Marling was effective in capturing the most salient aspects of his subjects' personalities. Proud of his accomplishments, he constructed a small gallery inside his home in order to display his work to the public. Among his most important works is an 1818 painting of the first North Carolina State House, significant because it is the only visual record of the building, which was razed by a devastating fire in 1831. A busy man by most estimates, Marling also found time to teach in Raleigh, inspiring a spate of capable, though today mostly forgotten, successors. His wife, Louisa, was also an artist and taught drawing and painting to women students at the Raleigh Academy. RA

FOR FURTHER READING
Kolbe, J. Christian, and Lyndon H. Hart. "The Virginia Career of Jacob Marling." *Journal of Southern Decorative Arts* 22:1 (summer 1996): 91–104.
Williams, Ben F., ed. *Jacob Marling: Early North Carolina Artist.* Raleigh: North Carolina Museum of Art, 1964.

43

JACOB MARLING

The Crowning of Flora, 1816

Oil on canvas, 30⅛ x 39⅛ inches

Chrysler Museum of Art, Norfolk, Virginia

Gift of Edgar William and Bernice Chrysler

Garbisch

80.181.20

Photo © Chrysler Museum of Art

Reginald Marsh

Born in Paris, France, 1898

Died in Dorset, Vermont, 1954

Taking full advantage of his training as an illustrator, Reginald Marsh was able to capture the vitality of New York City and its environs in his often-amusing narrative scenes. He eschewed the city's picturesque locales in favor of its more raucous environments, such as the Bowery and Coney Island, where he haunted the burlesque theaters, dance halls, and nightclubs. There he encountered a variety of unconventional types, from buxom, partially clad showgirls to carnival performers and panhandlers, all of whom he packed into his energetic, densely cluttered compositions. A journalist by nature, Marsh charged his paintings with meaningful details that brought added depth to the stories he chose to relate.

After graduating from Yale University in 1920, Marsh worked as an illustrator for *Vanity Fair* and later the *New York Daily News.* He moved on to the *New Yorker* in 1925 but left the popular magazine shortly afterwards in order to travel. In Europe he studied the works of the old masters, developing a special appreciation for the loose drawing style of Rubens and Delacroix. Returning to New York in 1926, he enrolled at the Art Students League and attended classes taught by John Sloan and George Luks (q.v.). Marsh also studied with Kenneth Hayes Miller, who persuaded him to apply what he had gleaned from his European studies to documenting his immediate surroundings. Although he was a highly skilled printmaker and an avid photographer, Marsh's preferred painting medium was egg tempera.

Marsh began teaching summer classes at the Art Students League in 1935; in 1942 he signed on for the regular school year, and he stayed for the remainder of his life. In 1937 he created an impressive suite of murals for the Alexander Hamilton U.S. Custom House in New York. A product of the New Deal Treasury Relief Art Program, Marsh's sixteen frescoes continue to pay tribute to the shipping industry in the United States. RA

FOR FURTHER READING

Cohen, Marilyn. *Reginald Marsh's New York: Paintings, Drawings, Prints, and Photographs.* New York: Whitney Museum of American Art, 1983.

East Side, West Side, All around the Town: A Retrospective Exhibition of Paintings, Watercolors, and Drawings by Reginald Marsh. Tucson: University of Arizona Museum of Art, 1969.

Reginald Marsh, Coney Island. Fort Wayne, Ind.: Fort Wayne Museum of Art, 1991.

44
REGINALD MARSH
Lifeguards, 1933
Tempera on hardboard panel,
35½ x 23⅝ inches
Georgia Museum of Art,
University of Georgia
University purchase
GMOA 1948.205
Photo by Michael McKelvey

45
REGINALD MARSH
Subway—14th Street, 1930
Egg tempera on canvas, mounted on
masonite, 36 x 48 inches
Hunter Museum of American Art,
Chattanooga, Tennessee
Gift of the Benwood Foundation
HMAA.1976.3.22

Tompkins Harrison Matteson

Born in Peterboro, New York, 1813

Died in Sherburne, New York, 1884

*P*ortraitist, genre painter, and history painter Tompkins Harrison Matteson spent most of his life in the upstate New York town of Sherburne. He received his initial artistic training from the itinerant portraitist Alvah Brandish prior to a brief period of study at the National Academy of Design in New York City in the 1830s.

In 1841 the artist returned to New York, where he maintained a studio and took classes at the NAD's antique school. During this period, Matteson filled his canvases with patriotic sentiments such as those imbued within *The Spirit of '76* (circa 1845). This painting, which established the artist's reputation, was reproduced and disseminated by the American Art Union. In 1847 Matteson was elected an associate member of the NAD.

By 1850 Matteson had settled permanently in Sherburne. He continued to produce history paintings but also began to express his interest in giving visual form to literary subjects, such as his 1857 depiction of the turkey shoot episode from James Fenimore Cooper's best-selling novel *The Pioneers,* just as Charles Deas (q.v.) had done twenty-one years earlier. In the 1860s Matteson added another motif to his body of work: genre depictions of rural life. In addition to living out the remainder of his years painting in his Sherburne studio, Matteson also instructed young painters. Elihu Vedder (q.v.) was among Matteson's most noteworthy pupils. SJF

FOR FURTHER READING

Groeschel, Harriet Hoctor. "A Study of the Life and Work of the Nineteenth-Century Genre Artist, Tompkins Harrison Matteson (1813–1884)." M.A. thesis, Syracuse University, 1985.

Jones, Agnes Halsey. *Rediscovered Painters of Upstate New York, 1700–1875.* Utica, N.Y.: 1958.

Tompkins H. Matteson, 1813–1884. Sherburne, N.Y.: The Sherburne News for The Sherburne Art Society, 1949.

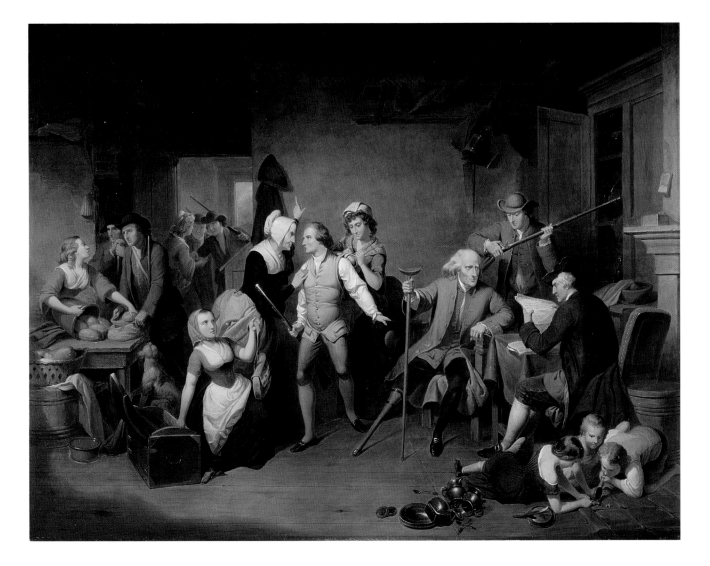

46

TOMPKINS HARRISON MATTESON
The Making of Ammunition, 1855
Oil on canvas, 36 x 48½ inches
Chrysler Museum of Art, Norfolk, Virginia
Gift of Walter P. Chrysler Jr.
71.2728
Photo © Chrysler Museum of Art

John McCrady

Born in Canton, Mississippi, 1911

Died in New Orleans, Louisiana, 1968

*I*n the late 1930s, John McCrady set himself apart from the mainstream midwestern regionalists by choosing to illustrate his experiences as a southerner. His works vary in subject matter but can be grouped into four broad categories: self-portraits, scenes of rural life, works based on Negro spirituals, and paintings inspired by the French Quarter in New Orleans.

The son of an Episcopalian clergyman, McCrady spent his youth moving from one parish to another. The family finally settled in Oxford, Mississippi, where the young McCrady attended the University of Mississippi. During summer breaks in 1931 and 1932 McCrady visited a brother living in Philadelphia. His brother encouraged him to take classes at the Pennsylvania Academy of the Fine Arts. Intent on becoming a cartoonist, McCrady left Oxford in 1932 in order to obtain formal training at the New Orleans Art School. The following year he received a scholarship to the Art Students League in New York. There he studied briefly with Thomas Hart Benton (q.v.) and, more significantly, with Kenneth Hayes Miller, from whom he learned the importance of design and a method for intensifying color.

Returning to Oxford, McCrady developed a southern regionalist style that soon found a large and appreciative audience. In 1937 *Life* devoted a five-page spread to McCrady, describing him as the most original voice that year.

The national exposure made him a celebrity, and in 1939 McCrady received a Guggenheim Fellowship to paint the life and religious faith of southern blacks. He is perhaps best remembered for his works on this theme, which were popular with the American public in the years preceding World War II. When his form of American scene painting was overshadowed by the vogue for New York school abstraction in the early 1950s, McCrady turned to corporate commissions and teaching for his livelihood. RA

FOR FURTHER READING
Marshall, Keith. *John McCrady, 1911–1968.*
 New Orleans: New Orleans Museum
 of Art, 1975.

160

47

Carlos Alpha (Shiney) Moon

Born in Birmingham, Alabama, 1906

Died in Florala, Alabama, 1953

Nicknamed "Shiney" for his pleasant disposition and brilliant compositions, Carlos Alpha Moon discovered a latent passion for painting one day while playing with his daughter's watercolor set. This newfound interest in the arts went largely unexplored until 1944, when Moon, a successful merchant specializing in women's apparel, accepted an invitation to visit the Dixie Art Colony near Wetumpka, Alabama. There Moon became acquainted with the director, Kelly Fitzpatrick, and the two men forged a lifelong friendship. With Fitzpatrick's encouragement Moon's weekend hobby became his primary vocation, and within two years he had staged his first one-person show at the Montgomery Museum of Fine Arts.

Moon worked primarily in oils until 1946, when, during a trip to the Carolinas and the Louisiana bayous, his interest turned to watercolors. He developed his skills in the new medium in Provincetown, Massachusetts, under the tutelage of Morris Davidson, and he eventually won several prestigious awards for his watercolors. After exploring a variety of approaches, Moon developed a signature style that can be described as realism infused with expressionist distortion and color. Paintings such as *Moonlight on Pickle Hill*, with its highly animated landscape, were popular with Moon's contemporaries and earned him considerable praise in the local press. In 1950, along with Genevieve Sutherland and Fitzpatrick, Moon helped establish the Bayou Art Colony in the picturesque fishing community of Bayou La Batre, Alabama. Sutherland assumed the role of director and Fitzpatrick and Moon acted as instructors. A dynamic figure in the local art scene, Moon served as president of the Watercolor Society of Alabama, and in 1953, shortly before his death, he was elected president of the Alabama Art League. RA

FOR FURTHER READING
Williams, Lynn Barstis. "Another Provincetown? Alabama's Gulf Coast Art Colonies at Bayou La Batre and Coden." *Gulf South Historical Review* 15:2 (spring 2000): 41–58.

48

CARLOS ALPHA (SHINEY) MOON
Moonlight on Pickle Hill, ca. 1948
Oil on canvas, 30 x 24 inches
Mobile Museum of Art
Gift from the Family of Carlos Alpha "Shiney" Moon in His Memory
G1999.08.08

Robert Loftin Newman

Born in Richmond, Virginia, 1827

Died in New York, New York, 1912

Robert Loftin Newman has earned a place in American art as one of the leading romantic-symbolist painters of his generation. Born in Virginia and raised in Clarksville, Tennessee, Newman was largely self-taught. As a young man, he read extensively on art and artists, and, like many American painters at the time, he supported himself as a portraitist. Endeavoring to expand his subject matter and develop his painting skills, he copied prints for a time. Desiring further training, Newman set out for Düsseldorf in 1850, but during a layover in Paris he became acquainted with William Morris Hunt. Hunt persuaded him to enter the studio of Thomas Couture, where he spent the next five months. During Newman's second trip to Paris in 1854, Hunt introduced him to Jean-François Millet in Barbizon. In later years Newman would claim that this meeting significantly influenced his development as a painter.

Newman, drafted into the Confederate army in 1864, served as a topographical draftsman for 15th Virginia Regiment at Richmond. He returned to Clarksville after the war and found work as a portraitist and teacher. After the death of his mother, Newman left Clarksville and settled in New York City in the 1870s. Although he was to make three more trips abroad in 1882, 1908, and 1909, Newman lived the life of a recluse in New York, preferring the isolation of his studio, where he composed many works on biblical and literary themes. His circle of friends was small but supportive. He formed a close friendship with Albert Pinkham Ryder (q.v.), with whom he shared a poetic and mystical temperament. Not one to associate with dealers or to submit works to academy exhibitions, Newman was supported largely by the beneficence of his friends, such as collector John Gellatly and sculptor Daniel Chester French, who came to acquire many of his dark, delicately tinted paintings. RA

FOR FURTHER READING
Boime, Albert. "Newman, Ryder, Couture, and Hero-Worship in Art History." *American Art Journal* 3:2 (fall 1971): 5–22.
Landgren, Marchal E. *Robert Loftin Newman, 1827–1912.* Washington, D.C.: National Collection of Fine Arts, 1974.

49

ROBERT LOFTIN NEWMAN
Rabboni, 1882–86
Oil on canvas, 16⅛ x 20⅛ inches
Morris Museum of Art, Augusta, Georgia

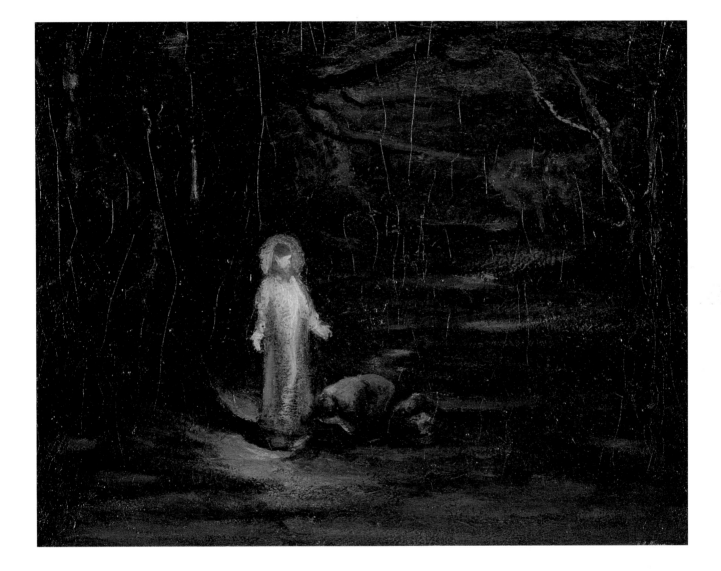

Thomas Satterwhite Noble

Born in Lexington, Kentucky, 1835

Died in New York, New York, 1907

Thomas Satterwhite Noble is remembered as one of Kentucky's most distinguished artists. It is to the narrative works of antebellum authors, such as the best-selling abolitionist tome *Uncle Tom's Cabin* by Harriet Beecher Stowe, that Noble's paintings of social injustice are often compared. Although the Noble family business of manufacturing hemp rope and cotton bagging in Louisville required slave labor, and although the artist served as a captain in the Confederate cavalry during the War Between the States, Noble was vehemently opposed to the institution of slavery. It is in canvases like *The Price of Blood,* painted during Reconstruction and greatly admired by northerners when it was exhibited in New York, Boston, Philadelphia, and Chicago, that Noble made his antislavery leanings as clear as any literary work could ever describe.

Noble's painting style was greatly influenced by his study in Paris with the renowned Thomas Couture between 1856 and 1859. Following the Civil War, Noble went to New York City and became an associate in the National Academy of Design. In the late 1860s, around the time he married, he was asked to head the McMicken School of Design (later the Art Academy of Cincinnati). Such well-known American artists as Gutzon Borglum, John Twachtman, and Kenyon Cox studied under Noble's tutelage at the McMicken School. Once he had ensconced himself in Cincinnati, Noble took occasional trips to Europe in the 1880s and 1890s. In 1904 Noble retired and relocated to Bensonhurst, New York. SJF

FOR FURTHER READING
Birchfield, James D., Albert Boime, and William J. Hennessey. *Thomas Satterwhite Noble, 1835–1907.* Lexington: University of Kentucky Art Museum, 1988.

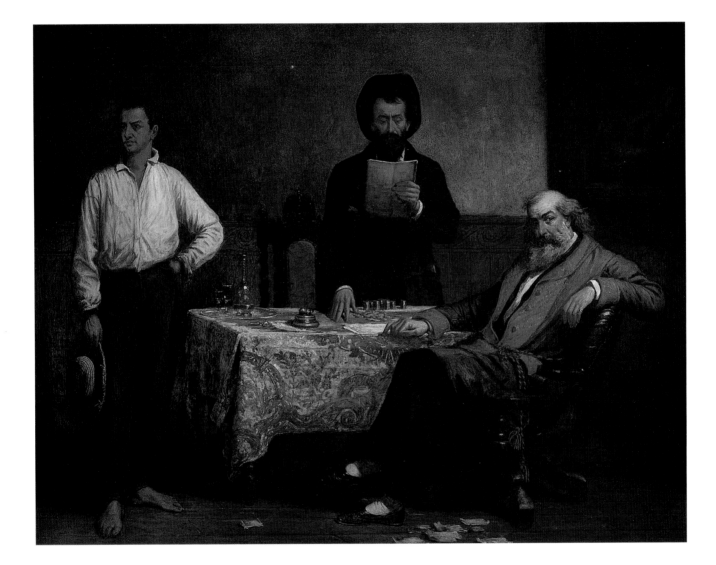

50

THOMAS SATTERWHITE NOBLE

The Price of Blood, 1868

Oil on canvas, 39¼ x 49½ inches

Morris Museum of Art, Augusta, Georgia

Edward Henry Potthast

Born in Cincinnati, Ohio, 1857

Died in New York, New York, 1927

Edward Potthast is best known for painting the pleasurable side of life; the figures inhabiting his compositions often cavort on sun-drenched Atlantic beaches or relax under a copse of shade trees in New York's Central Park. His impressionist painting style, characterized by brilliant hues and bravura brushwork, was particularly conducive to capturing the carefree happy moments that kindled his imagination.

Born to German immigrants in Cincinnati, Potthast was apprenticed to a lithography firm at the age of sixteen. It remained his primary form of financial support and artistic expression until his move to New York in 1896, when he embarked on a career as a full-time painter. Prior to that, he attended evening classes in painting and sculpture at the McMicken School of Design in Cincinnati, enrolling in classes taught by Frank Duveneck and Thomas Noble (q.v.). From 1882 to 1885, Potthast studied at the Royal Academy in Munich, and for a time he adopted the subdued color and painterly brushwork characteristic of the German school. He moved on to Paris, enrolling at the Académie Julian, where he studied with Gustave Boulanger and Jules-Joseph Lefebvre until 1890. Afterwards, while living in Barbizon, he became acquainted with plein air painting, from which his own style would emerge.

Following his return to the United States, Potthast settled in Manhattan and took temporary work as an illustrator for *Harper's, Scribner's,* and *Century Magazine.* While in New York, he claimed the high-keyed palette and subject matter of the impressionists for his own purposes. He traveled to Gloucester and Provincetown, Massachusetts, and extensively along the coast of Maine, capturing in his rich impasto style the light, color, and atmosphere of a specific moment. In 1911 Potthast was hired by the Santa Fe Railway, along with Thomas Moran, Elliott Daingerfield (q.v.), Frederick Ballard Williams, and De Witt Parshall, to paint the magnificence of the Grand Canyon. The resultant paintings helped to solidify his reputation in the New York art world. RA

FOR FURTHER READING
Edward Henry Potthast: American Impressionist. New York: Gerald Peters Gallery, 1998.
Jacobowitz, Arlene. *Edward Henry Potthast: 1857–1927.* New York: Chapellier Galleries, 1969.

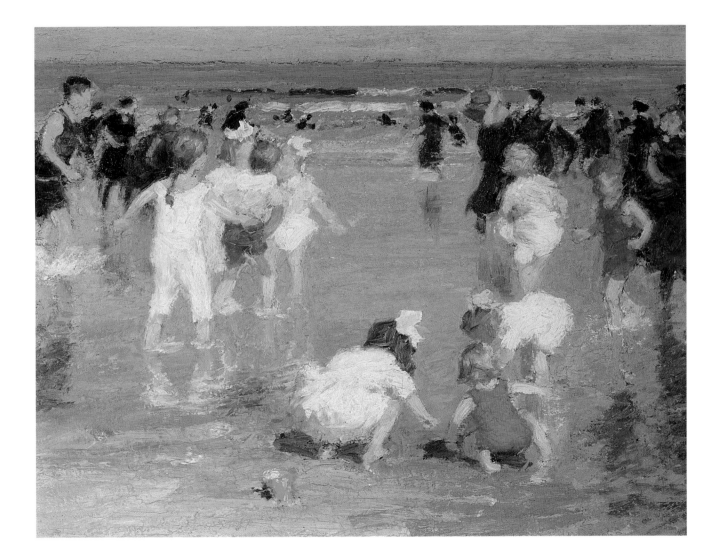

51

EDWARD HENRY POTTHAST

Happy Days, ca. 1910–20

Oil on panel, 12½ x 16 inches

Collection of the

Art Museum of Western Virginia, Roanoke

Acquired with funds provided by the

Horace G. Fralin Charitable Trust

Andrée Ruellan

Born in New York, New York, 1905

Lives in Woodstock, New York

Andrée Ruellan created art that is deeply influenced by personal experiences. Her American scene paintings serve as souvenirs of her observations and her travels and act as a visual diary of her life. "My work can be no better than I am myself, as a person, and no deeper than my understanding of life as a whole," the artist has stated.[1]

Ruellan's life was intertwined with art at a very early age. When she was just eight years old, she commenced her study of art under family friend Dr. Ben Liber and visited the famed Armory Show. Robert Henri, the influential leader of the Ashcan school, soon noticed Ruellan's work and invited her to exhibit at Saint Mark's in the Bowery. In 1920 she received a scholarship from the Art Students League. Although she desired training as a sculptor, her age and her gender prohibited her from enrolling in the necessary life-drawing courses. Nevertheless, Maurice Sterne took Ruellan under his wing, and in 1922 both teacher and pupil (along with Ruellan's mother) traveled to Italy. From there, Ruellan went to France, her parents' original home, and she worked in Paris until 1929.

Ruellan grew acquainted with the director of the Weyhe Gallery, Carl Zigrosser; he gave the artist her first solo show in 1928, which the press greeted as the work of a "girl prodigy."[2] In 1929 she married the painter John Taylor and moved with her husband to Shady, New York, near the famed Woodstock artists' colony. By the early 1930s, Ruellan took an increased interest in regional subjects. She toured Virginia, South Carolina, Georgia, and Louisiana and sketched quotidian scenes that later in her studio she developed into oil paintings. As was the case with many painters who were drawn to regional subjects, Ruellan received WPA commissions to create post office murals in the early 1940s. In 1950 the artist revisited France with the aid of a prestigious Guggenheim Fellowship. SJF

NOTES
1. Keyes and Park, *Andrée Ruellan*, 64.
2. *Chicago Evening Post*, April 17, 1928.

FOR FURTHER READING
Keyes, Donald D., and Marlene Park. *Andrée Ruellan*. Athens: Georgia Museum of Art, 1993.

52
ANDRÉE RUELLAN
Children's Mardi Gras, 1949
Oil on canvas, 30 x 35 inches
Collection of the Columbus Museum, Columbus, Georgia
Museum purchase made possible by Norman S. Rothschild in honor of his parents, Aleen and Irwin B. Rothschild
98.2

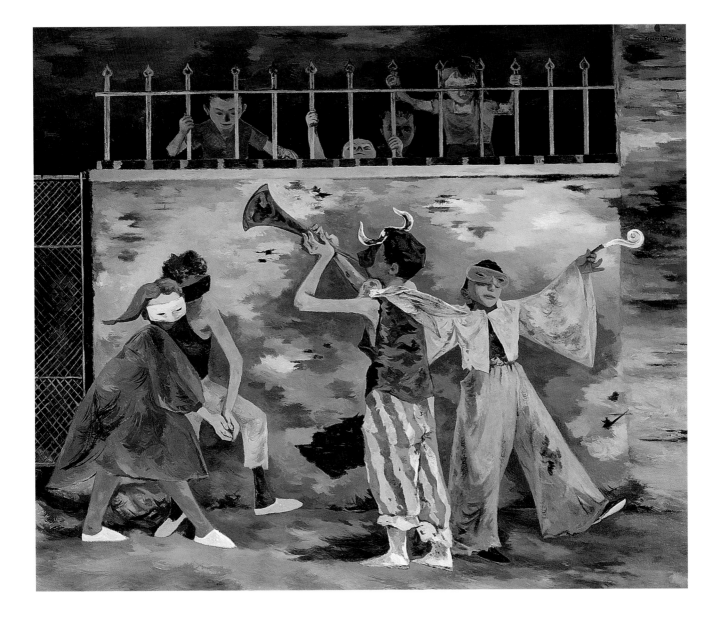

Albert Pinkham Ryder

Born in New Bedford, Massachusetts, 1847

Died in Elmhurst, New York, 1917

*P*ossessing a romantic sensibility and guided by a remarkable inner vision, Albert Pinkham Ryder was predisposed to choosing literary themes for his technically daring compositions. Although his interests were wide-ranging, Ryder's subjects mirrored his penchant for the evocative and the mysterious. Ryder's visionary paintings were inspired by the works of such authors as Geoffrey Chaucer, Edgar Allen Poe, and William Shakespeare, as well as by the Bible, but rarely were they literal illustrations of a specific text. His literary preferences ally Ryder with the symbolist generation, though his paintings contain little of the decadence often associated with the movement.

Relatively little is known of Ryder's early life. He moved with his family to New York in 1870 and enrolled in art classes at the National Academy of Design. Independent in thought and deed and known for his experimental painting techniques, Ryder attended classes infrequently, preferring the instruction he received through his friendship with William E. Marshall. Prior to 1880, when he began to explore literary themes in his paintings, Ryder produced mostly bucolic landscapes of farm animals grazing in lush tranquil pastures at dawn or dusk, the low light of that hour simplifying and softening their forms. Compositionally, such paintings have an affinity with works of the Barbizon school, in particular the dreamlike "Souvenirs" of Jean-Baptiste-Camille Corot.

In 1873 Ryder made the acquaintance of his future dealer Daniel Cottier, who was instrumental in persuading him to make four trips to Europe between 1877 and 1896. The journey of 1882 was the most extensive; Ryder traveled to England, the Continent, and the coast of North Africa. As Ryder matured, he adopted a tonalist palette and, frustrated by the complexity he found in nature, began to refine away cumbersome details to the point where simplified shapes and expressive colors conveyed the narratives he composed on the canvas. His works from this period, including a series of evocative seascapes, would have a considerable influence on twentieth-century modernists, including Arthur B. Davies, Marsden Hartley, and Jackson Pollock. RA

FOR FURTHER READING

Broun, Elizabeth. *Albert Pinkham Ryder.* Washington, D.C.: National Museum of American Art, Smithsonian Institution Press, 1989.

Homer, William Innes, and Lloyd Goodrich. *Albert Pinkham Ryder, Painter of Dreams.* New York: Harry N. Abrams, 1989.

53

ALBERT PINKHAM RYDER

Childe Harold's Pilgrimage, ca. 1895

Oil on canvas, 10½ x 8¼ inches

Birmingham Museum of Art

Gift of EBSCO Industries, Inc.

1990.43

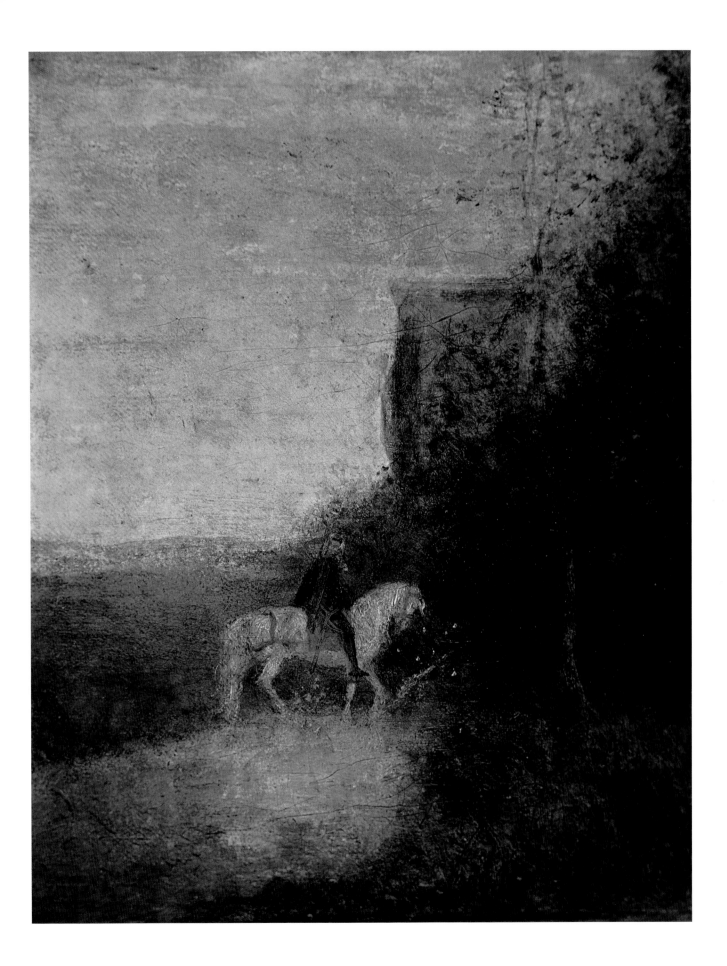

W. T. Russell Smith

Born in Glasgow, Scotland, 1812

Died near Jenkintown, Pennsylvania, 1896

Russell Smith emigrated with his family from Glasgow to the Legonier Valley in western Pennsylvania when he was seven years old. In 1822 his family moved to Pittsburgh, and it was there that Smith first exhibited his facility for drawing by executing meticulous copies from *Delaplaine's Repository of the Lives and Portraits of Distinguished American Characters*. In 1827 Smith's older brother, founder of Pittsburgh's Thespian Society, enlisted his younger sibling to paint scenery for the society's productions. Smith later gained recognition as this country's foremost painter of theater scenery and curtains.

While painting for the Thespian Society, Smith honed his craft under painter James R. Lambdin (father of George Cochran Lambdin, q.v.). By 1833 Smith was painting scenery for the newly established theater company of Francis Courtney Wemyss, whom he followed to Philadelphia when the company relocated there in 1835. His reputation soon spread and the artist earned work in theater companies in Washington, D.C., as well as Boston. Later in his career, Smith's touch was ubiquitous in theaters in New York, North Carolina, Massachusetts, Pennsylvania, and Georgia.

In 1838 Smith married Mary Priscilla Wilson, and the couple settled in Philadelphia. The next year, he invented a box for his paints that allowed him to work away from the studio. This invention was put to use in the 1840s when he accompanied prominent geologist William Barton Rogers on an expedition to Virginia. Other natural scientists, such as Sir Charles Lyell and Benjamin Silliman, also employed Smith to illustrate their lectures during this period.

In 1850 Smith traveled with his wife and two sons—artists all—to Europe, where they sketched together for two years. Following the family's return to Philadelphia, Smith continued his painting-related travels, exploring New Hampshire's White Mountains and upstate New York. He continued to receive commissions for his theatrical work as well. SJF

FOR FURTHER READING

Lewis, Virginia E. *Russell Smith, 1812–1896: Romantic Realist*. Pittsburgh: Department of Fine Arts, University of Pittsburgh, 1948.

Torchia, Robert Wilson. *The Smiths: A Family of Philadelphia Artists*. Philadelphia: Schwarz Gallery, 1999.

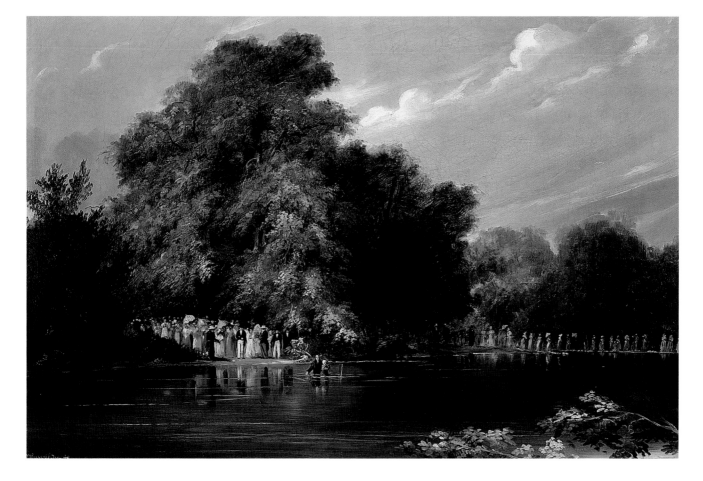

54

W. T. RUSSELL SMITH

Baptism in Virginia, 1836

Oil on canvas, 19¼ x 28¼ inches

Morris Museum of Art, Augusta, Georgia

Lilly Martin Spencer

Born in Exeter, England, 1822

Died in New York, New York, 1902

As a wife and the mother of thirteen children, Lilly Martin Spencer was never short of inspiration or models for her popular, often humorous, domestic genre scenes. Now recognized as one of the leading nineteenth-century genre painters in America, Spencer immigrated to this country when she was eight years old. After the Martin family's arrival in New York City, they settled in Marietta, Ohio. In 1841 the artist and her father moved to Cincinnati, where she took painting lessons from John Insco Williams and James Beard and exhibited her work in the rectory of Saint Luke's Episcopal Church. Three years later, she married Benjamin Rush Spencer and the couple moved to New York City. Even after the Spencers relocated to Newark, New Jersey, in 1858, the artist retained her studio in the city.

Spencer led an unusual life for a woman in the mid-1800s. She was as dedicated to her artistic career as she was to her family, becoming the principal breadwinner of the household, while Benjamin Spencer adopted the role of househusband and his wife's assistant. This arrangement allowed Spencer to enroll in drawing classes at the National Academy of Design, to which she was elected an honorary member in 1850 after two years of study. During this period, she was also a participant in the Western Art Union of Cincinnati, New York's American Art Union, and the Cosmopolitan Art Union. These art unions provided Spencer with the opportunity to disseminate her domestic genre scenes to a wide audience. The public also grew familiar with Spencer's work through its distribution in lithographic form by the French publishing firm Goupil, Vibert and Co., as well as through exhibitions, including the showing of her work at the Philadelphia Centennial Exposition in 1876. SJF

FOR FURTHER READING
Bolton-Smith, Robin, and William Truettner. *Lilly Martin Spencer, 1822–1902: The Joys of Sentiment*. Washington, D.C.: Smithsonian Institution Press, 1973.

55
LILLY MARTIN SPENCER
The Young Husband: First Marketing,
ca. 1854
Oil on canvas, 29½ x 24¾ inches
Hunter Museum of American Art,
Chattanooga, Tennessee
Gift of Mr. and Mrs. Scott L. Probasco Jr.
HMAA.1987.24

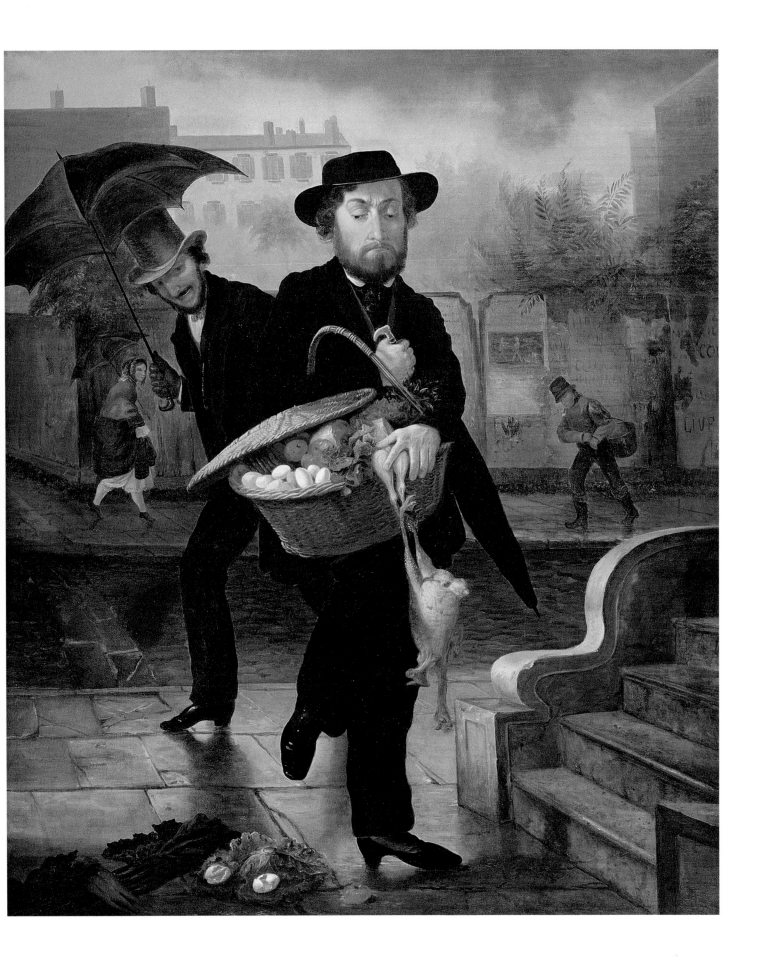

Junius Brutus Stearns

Born in Arlington, Vermont, 1810

Died in Brooklyn, New York, 1885

*L*ittle is known of Junius Stearns's early life. He surfaced in New York around 1838, when he enrolled in painting classes at the National Academy of Design. Judged a clever student by his teachers and colleagues, Stearns rose quickly within the ranks of the academy and, with his acquired skills and penchant for self-promotion, soon carved out a place for himself in the New York art world.

Stearns was elected an associate member of the NAD in 1848 and an academician the following year, receiving more votes than any other candidate considered, including such contemporaries as Frederic Church and John F. Kensett. Stearns's favorable position with the academy and its members was solidified during his lengthy tenure as recording secretary from 1850 to 1866. A devoted member of this august institution, Stearns contributed paintings to the NAD's annual exhibitions from 1838 to 1884. His reputation extended beyond the boundaries of New York City, for in 1854 Stearns was made an honorary member of the Pennsylvania Academy of the Fine Arts.

Although he favored genre and historical subjects, economic considerations often forced Stearns to work as a portraitist. When free of such concerns he explored numerous themes in his painting, including a series of eleven works devoted to the sport of fishing. Stearns also created many fine history paintings illustrating notable battles and honorable deaths, works that attest to his academic training. Among the most noteworthy of these is a series of five paintings depicting events in the life of George Washington (1848–56). Lithographic reproductions of these works, produced by the printing firm of Goupil-Knoedler (1853–54), contributed to making them among Stearns's most celebrated achievements. RA

FOR FURTHER READING

Rogers, Millard. "Fishing Subjects of Junius Stearns." *Antiques* 98 (August 1970): 246–50.

Thistlethwaite, Mark. "Picturing the Past: Junius Brutus Stearns's Paintings of George Washington." *Arts of Virginia* 25:2 (spring 1985): 12–23.

———. *The Image of George Washington: Studies in Mid-Nineteenth-Century American History Painting.* New York: Garland, 1979.

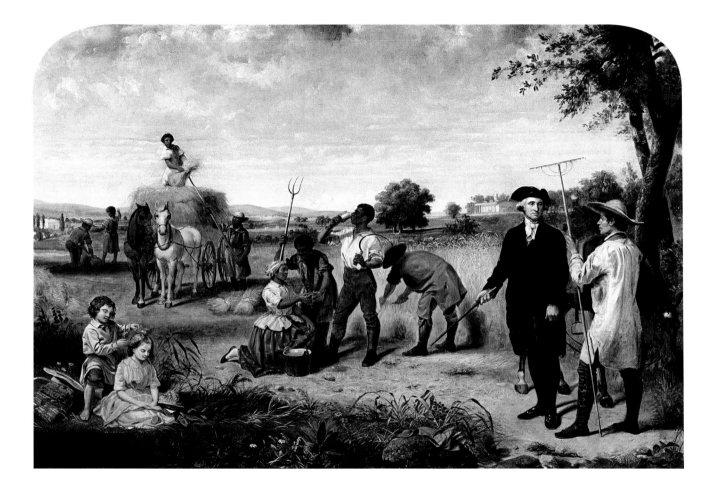

56

JUNIUS BRUTUS STEARNS

Washington as a Farmer at Mount Vernon,

1851

Oil on canvas, 37½ x 54 inches

Virginia Museum of Fine Arts, Richmond

Gift of Edgar William and Bernice Chrysler

Garbisch

50.2.4

Photo: Wen Hwa Ts'ao, © Virginia

Museum of Fine Arts

Thomas Sully

Born in Horncastle, Lincolnshire, England, 1783

Died in Philadelphia, Pennsylvania, 1872

When Thomas Sully was only nine years old, he and his family immigrated to the United States and settled in Charleston, South Carolina. The Sullys were circus and theater performers, and in 1794 Thomas entered the family business as an acrobat. Perhaps realizing their son was better suited to things closer to the ground, Sully's parents apprenticed him to an insurance broker. This profession did not appear right for the young Sully either, and soon he traded his ledgers for the tools of a miniature portraitist. He learned the trade under the supervision of his brother-in-law, Jean Belzons. By 1799 Sully was working in Richmond, Virginia, with his older brother Lawrence, who was also well versed in the precise techniques required of a miniaturist.

In 1801 the Sully family relocated to Norfolk, Virginia, but they returned to Richmond two years later. There, Thomas eventually opened his own studio. Three years after opening the studio, he married Sarah Annis Sully, his brother's widow, and moved to New York City with his bride. Ever peripatetic, the Sullys moved again, this time to Hartford, Connecticut, in July 1807. Soon they made their way to Boston, where Sully frequented the painting room of the famed Gilbert Stuart. In 1808 he uprooted his family one last time and moved them to Philadelphia. He had barely spent a year painting in his studio there when he went to England to study with Benjamin West, copy the artworks in the artist's vast collection, and draw from the sculpture housed in the Antique Room of the Royal Academy.

He learned his lessons well, and following the death of Stuart in 1828, Sully was generally regarded as "the prince of American portrait painters." In addition to portraits, he also painted genre scenes, theatrical subjects, and occasional historical motifs. By 1855 the artist's health had begun to decline, and with it, the quality of his paintings. SJF

FOR FURTHER READING

Biddle, Edward, and Mantle Fielding. *The Life and Works of Thomas Sully (1783–1872)*. 1921. Reprint: Charleston, S.C.: Garnier, 1969.

Fabian, Monroe H. *Mr. Sully, Portrait Painter: The Works of Thomas Sully (1783–1872)*. Washington, D.C.: National Portrait Gallery, 1983.

Flynn, Elizabeth L. *Thomas Sully, 1783–1872*. Farmville, Va.: Longwood College, 1973.

57
THOMAS SULLY
Juvenile Ambition, 1825
Oil on canvas, 36¼ x 28¾ inches
Hunter Museum of American Art,
Chattanooga, Tennessee
Gift of Mrs. Roana B. Hayes in memory
of her husband, Henry H. Hayes
HMAA.1968.10

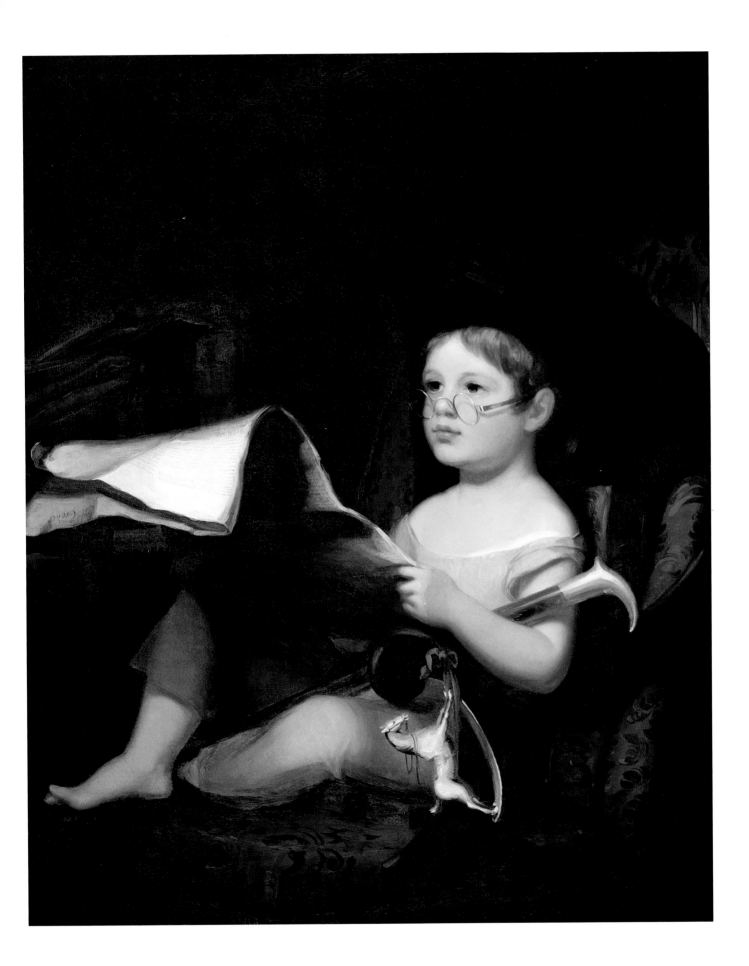

Maltby Sykes

Born in Aberdeen, Mississippi, 1911

Died in Montgomery, Alabama, 1992

Maltby Sykes received his eclectic artistic training in three different countries and under several different instructors. In 1934 he painted in Elizabethtown, New York, under the tutelage of Wayman Adams and worked as an assistant to the lithographer George C. Miller. During the summer of 1936, he also assisted the renowned muralist Diego Rivera on his project for the Hotel de la Reforma in Mexico City at the height of the Mexican mural movement. In the late 1930s, Sykes studied in New York City with John Sloan, one of the prominent early-twentieth-century urban realists.

While World War II interrupted Sykes's artistic training, he served as a combat artist in the U.S. Air Force. By 1951, as war-ravaged Europe gradually recovered, the well-traveled Sykes was in Paris studying with Fernand Léger. Following his return to the United States, Sykes took a position as an art professor at Auburn University in Alabama in 1954. In 1966 Sykes earned a sabbatical award from the National Endowment for the Arts; he used this respite from teaching to experiment with fine art applications for multimetal laminated plates, a medium widely used in the commercial printing industry.

In 1977 Sykes retired as professor emeritus from Auburn. In 1989 he coauthored *Advancing American Art: Painting, Politics, and Cultural Confrontation at Mid-Century*, providing commentary on thirty-six historically significant works, now in the collection of Auburn University, from a controversial Cold War exhibition of modern American art. Until his death in 1992, Sykes remained active as a painter and innovative printmaker. SJF

FOR FURTHER READING
Littleton, Taylor D., and Maltby Sykes. *Advancing American Art: Paintings, Politics, and Cultural Confrontation at Mid-Century*. Tuscaloosa: University of Alabama Press, 1989.

58
MALTBY SYKES
The Ascension, ca. 1940
Oil on canvas, 60 x 33 inches
Collection of the Montgomery Museum of Fine Arts, Montgomery, Alabama
1940.0024

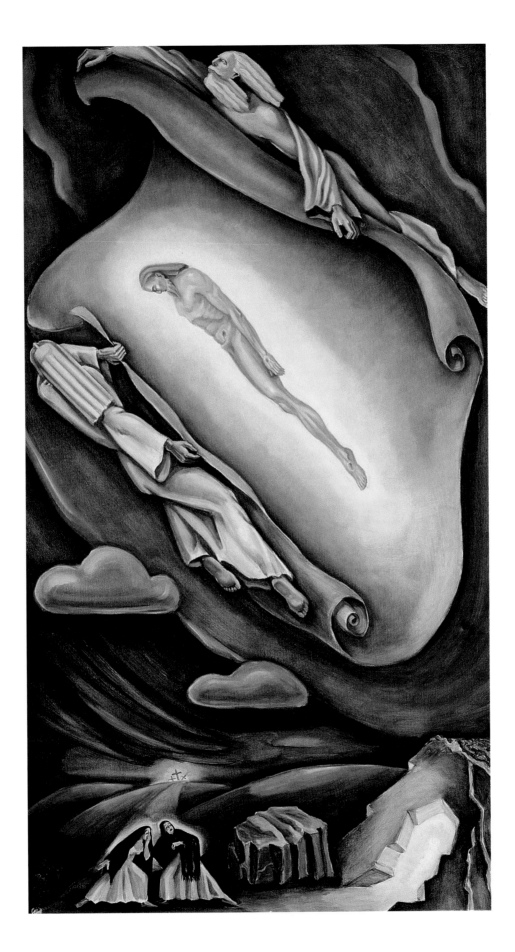

Henry Ossawa Tanner

Born in Pittsburgh, Pennsylvania, 1859

Died in Paris, France, 1937

Son of a minister in an African Methodist Episcopal Church, Henry Ossawa Tanner is celebrated today for his paintings of biblical themes. From 1880 to 1882 Tanner studied under Thomas Eakins, a photographer and realist painter, at the Pennsylvania Academy of the Fine Arts. During the mid- to late 1880s, Tanner worked in both Philadelphia and Atlanta, where, perhaps following the example of Eakins, he ran a photography studio and taught painting at Clark College. In 1891 word of Tanner's talents reached Paris and encouraged the generosity of Rodman Wanamaker, a wealthy Philadelphian expatriate. He sponsored Tanner when he traveled to Paris to refine his technique at the Académie Julian and to train with Benjamin Constant and Jean-Paul Laurens.

It did not take long for the jury of the Paris Salon to notice Tanner's paintings. His work was first exhibited at the Salon in 1894. Two years later, *Daniel in the Lion's Den*, a canvas (now lost) that bore Tanner's hallmark biblical subject matter, graced the Salon's walls. His specialization in sacred scenes earned him a medal in the 1897 Salon. Later the French government purchased the award-winning painting, *The Raising of Lazarus,* for the national collections in the Luxembourg Museum.

Tanner was very concerned with the accuracy of his biblical scenes. Following the Salon of 1897, he visited Palestine to document the sacred landscape, its people, and their customs. Tanner spent most of his career abroad, where he found the racial climate more comfortable than in the United States. Despite his long expatriation in France, in 1909 he was elected an associate member of the National Academy of Design. SJF

FOR FURTHER READING

Mathews, Marcia. *Henry Ossawa Tanner, American Artist.* Chicago: University of Chicago Press, 1969.

Mosby, Dewey F. *Across Continents and Cultures: The Art and Life of Henry Ossawa Tanner.* Kansas City, Mo.: Nelson-Atkins Museum of Art, 1995.

Mosby, Dewey F., and Darrel Sewell. *Henry Ossawa Tanner.* Philadelphia: Philadelphia Museum of Art, 1991.

59

HENRY OSSAWA TANNER

The Destruction of Sodom and Gomorrah,

1929–30

Tempera and varnish on cardboard,

20⅜ x 36 inches

High Museum of Art, Atlanta, Georgia

J. J. Haverty Collection

49.32

Dorothea Tanning

Born in Galesburg, Illinois, 1910

Lives in New York, New York

My early memories surfaced, wavered through time, riled the stream— . . . I was born, yes, and ran fast but never away. When I was seven I drew a figure with leaves for hair. Was I a tiny surrealist? Are all children surrealists, visually? Maybe surrealist painters were children with years, playing with the irrational. Maybe they knew that antic imagination is fun."[1] These early memories of which Dorothea Tanning wrote in her memoirs were centered in her hometown of Galesburg, Illinois. Following studies there at Knox College, in 1932 she matriculated at the School of the Art Institute of Chicago. However, she lasted at the school only three weeks.

It was renowned gallery owner Julien Levy who later discovered Tanning's talents while she was creating advertisements for Macy's department store in New York City. By 1941 she had signed on with his pioneering gallery, where many European émigrés and American modernists found a welcome. The following year she met her husband-to-be, the German surrealist Max Ernst. After their marriage, the couple lived in Sedona, Arizona, from 1946 to 1949. They spent the next few decades dividing their time between France and the United States until Ernst's death in 1976. In 1979 Tanning returned permanently to New York, the city in which she was discovered.

Tanning has let her "antic imagination" run throughout her long career, becoming immersed in various creative projects. Never did she limit her energies strictly to painting and sculpture. She animated marionettes at the 1931 Chicago World's Fair; designed sets for ballets choreographed by the legendary George Balanchine; made her film debut in Hans Richter's *That Money Can Buy* (1942); and designed the interiors of several homes in both France and the United States. After retiring from art making, Tanning, one of the last survivors of the surrealist movement, continued to let her boundless imagination run as a writer and a poet. SJF

NOTE

1. Tanning, *Between Lives*, 16.

FOR FURTHER READING

Bailly, Jean Christophe. *Dorothea Tanning.* Trans. Richard Howard and Robert C. Morgan. New York: George Braziller, 1995.

Tanning, Dorothea. *Between Lives: An Artist and Her World.* New York: W. W. Norton, 2001

———. *Birthday.* Santa Monica, Calif.: Lapis, 1986.

60

DOROTHEA TANNING

Guardian Angels, 1946

Oil on canvas, 48 x 36 inches

New Orleans Museum of Art

Museum purchase, Kate P. Jourdan Memorial Fund

49.15

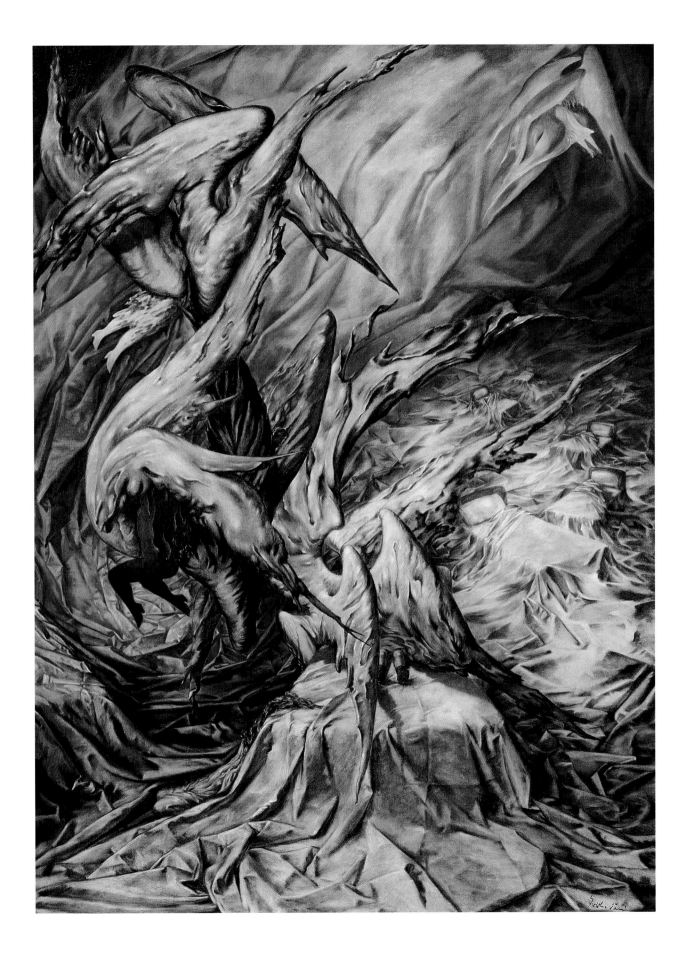

Jerome Thompson

Born in Middleboro, Massachusetts, 1814

Died in Glen Gardner, New Jersey, 1886

Jerome Thompson was discouraged from entering the painting trade by his father, portraitist Cephas Thompson, who wanted him to take over the family farm. Despite parental disapproval, the son pursued his dream of becoming an artist and, accompanied by a sister, moved to Barnstable, Massachusetts, in 1831. There he supported himself as a sign and carriage painter. He arrived in New York in 1835; there, he advertised his services as a portrait painter and exhibited some of his more successful works at the American Academy of Fine Arts and the National Academy of Design.

From 1842 to 1844 Thompson worked as an itinerant painter, traveling throughout the South in search of portrait commissions. Upon his return to New York he opened a studio and published a notice proclaiming that he was now an artist with a new focus, genre painting. Following in the footsteps of such painters as William Sidney Mount, he concentrated on typically American subjects. Today he is best known for his highly detailed multifigural compositions, which generally depict a large group of people in a pristine landscape taking in nature's bounty, whether at a summertime picnic or an autumn harvest.

In 1851 he exhibited the first of these outdoor genre paintings, *Pic Nic* (1850), at the NAD. Following a two-year stay in England from 1852 to 1854, where he studied the works of Claude, Hogarth, and Victorian genre artists, he committed himself to representations of rural life, in which he could combine his loves of landscape and storytelling. In several works he chose to illustrate popular songs and verse, such as *The Old Oaken Bucket* and *Home Sweet Home.* Many of these nostalgic and endearing "pencil ballads," as they were called, enjoyed a wide circulation, being reproduced as lithographs and chromolithographs. In the 1860s Thompson traveled to the Midwest collecting subject matter for future works. During the last decades of his life, he maintained a low profile in order to focus his attentions on creating allegorical works, including a series of paintings inspired by Thomas Cole. RA

FOR FURTHER READING
Edwards, Lee M. "The Life and Career of Jerome Thompson." *American Art Journal* 14:4 (autumn 1982): 5–30.

61

JEROME THOMPSON
Noonday in Summer, 1852
Oil on canvas, 38½ x 49¾ inches
The Mint Museums, Charlotte,
North Carolina
Museum purchase: Mint Museum
Auxiliary Purchase Fund and Exchange
Funds from the Gift of Mr. and Mrs.
J. Herbert Bridges
1998.15

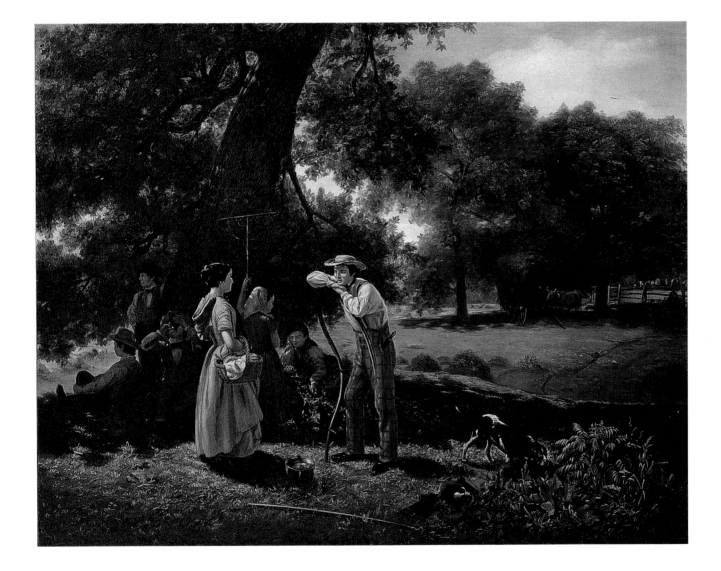

Walter Ufer

Born in Louisville, Kentucky, 1876

Died in Taos, New Mexico, 1936

The son of German immigrants, Walter Ufer was apprenticed to a commercial lithographer in 1892, and the following year he accompanied his employer to Germany. While working in Dresden as a journeyman printer and engraver, Ufer attended painting classes at the Royal Applied Art School and the Royal Academy. He returned to the United States in 1899 and settled in Chicago, where he worked as a commercial lithographer. He supplemented his income by painting portraits and furthered his studies at the Art Institute and J. Francis Smith Art School. After their marriage in 1911, Ufer and his bride returned to Europe, where he studied with Walter Thor in Munich; before returning to the United States in 1914, Ufer also traveled to Italy, Paris, and North Africa.

Soon after his return to Chicago, Ufer and close friend Victor Higgins set out for Taos, New Mexico, at the urging of his patron Carter Harrison. Ufer, captivated by the light and atmosphere and inspired by the Native Americans living in the area, decided to settle there permanently, becoming one of the leading members of the Taos art colony. Unlike his contemporaries E. Irving Couse and Joseph Henry Sharp, who specialized in romantic representations of Native Americans, Ufer, an ardent socialist, created paintings that told of their adaptation and assimilation into modern U.S. society. An innovative artist, Ufer abandoned studio painting entirely soon after arriving in Taos, preferring to work out of doors, where he developed an impressionist style characterized by brilliant color. His success was short-lived, however. Although he had earned as much as fifty thousand dollars a year in the early 1920s, Ufer fell on hard times later in the decade due in part to bad advice from his dealer—advice that resulted in a series of unsuccessful paintings. These failures, combined with Ufer's penchant for gambling and excessive drinking, led to an extended period of inactivity. Down but not out, Ufer rallied with *Bob Abbott and His Assistant,* which he considered one of his finest paintings. RA

FOR FURTHER READING
Porter, Dean A. "Reevaluating Walter Ufer." *Southwest Art* 29:1 (April 2000): 84–87, 136.

62

WALTER UFER

Bob Abbott and His Assistant, 1935

Oil on canvas, 50¼ x 50¼ inches

Collection of the Speed Art Museum, Louisville, Kentucky

Gift of Mrs. Walter Ufer

1947.13

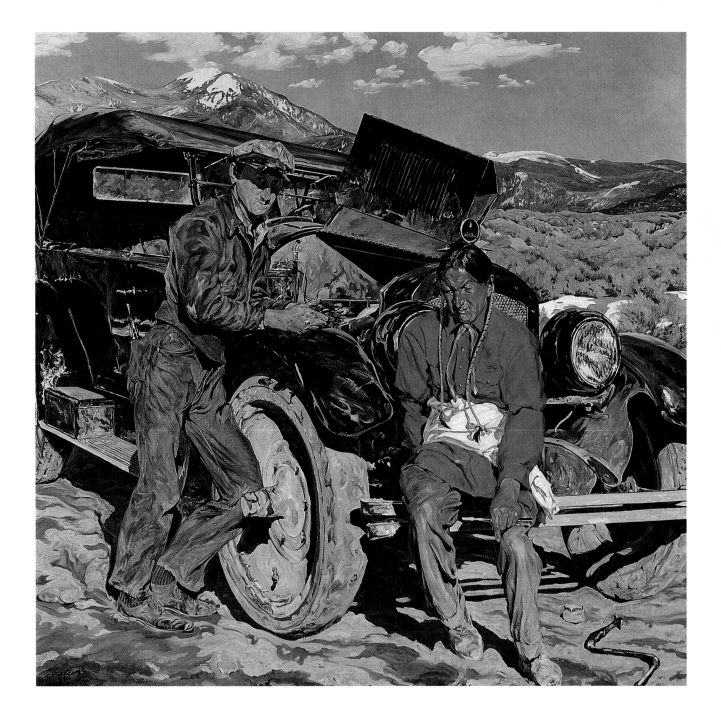

Unknown Artist

American, active mid–nineteenth century

*T*he artist has not been identified. Provenance information provided by a previous owner suggests that the portrait may have been painted in Ohio.

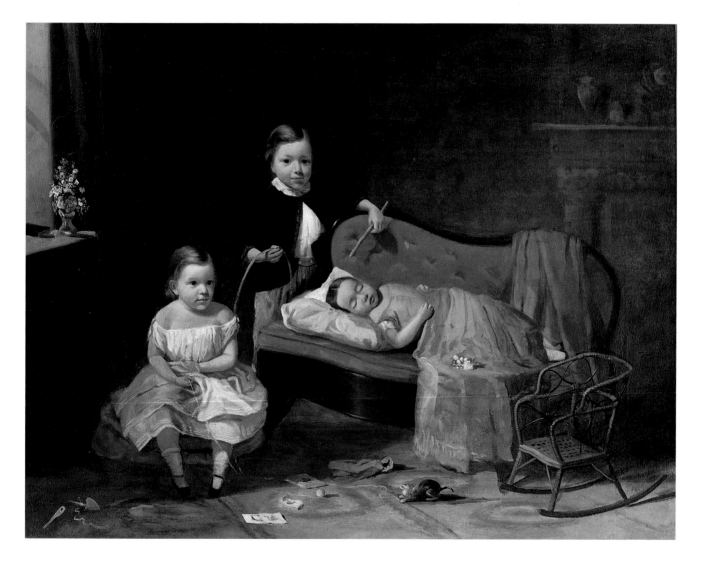

63
UNKNOWN ARTIST
Untitled Genre Painting, Three Children,
ca. 1840s
Oil on canvas, 28¾ x 36⅜ inches
Gibbes Museum of Art/Carolina Art
Association, Charleston, South Carolina
2000.28.01

Elihu Vedder

Born in New York, New York, 1836

Died in Rome, Italy, 1923

Elihu Vedder's artistic imagination was inflamed by the exotic, the supernatural, and the mystical. These he encountered in his extensive travels or in contemporary literature, particularly tales of adventure. Vedder's European training began in Paris in 1856, when he joined the studio of François-Edouard Picot. He stayed with Picot's studio for approximately eight months. More influential was his subsequent sojourn in Florence, where he fell under the spell of quattrocento painters and sculptors and their revival of the classical ideal. During this first visit abroad, he also traveled to the Tyrrhenian coast, the Roman Campagna, Capri, and Egypt, journeys that fostered a lifelong fascination with distant times and places.

Vedder returned to New York in 1861, and during the Civil War he worked there as an illustrator for *Vanity Fair* and *Leslie's Illustrated News*. Around this time he began to paint works inspired by tales of exotic locales that were in vogue at midcentury, such as Fitz Hugh Ludlow's *The Hashish Eater* (1857) and the *Arabian Nights* (1840). At the close of the war Vedder returned to Europe and joined his countrymen William Morris Hunt and Charles Caryl Coleman for a painting expedition to Brittany. Vedder preferred to spend most of each year at his residence in Rome, where he settled in 1868. His work in the decorative arts occasioned frequent travels for numerous commissions, including stained-glass window designs for Louis Comfort Tiffany. Even more memorable are the fifty-six illustrations he produced for Edward Fitzgerald's translation of *The Rubaiyat of Omar Khayyam*, which initiated a new era in American art publishing with its appearance in 1884. Around the turn of the century Vedder received many important mural commissions, requiring extended stays in Maine, New York, and Washington, D.C. After 1900 Vedder retired to his villa on Capri, where he entertained other American expatriates and devoted increasingly more time to writing, including his memoirs and two volumes of poetry. RA

FOR FURTHER READING

Soria, Regina. *Elihu Vedder: American Visionary Artist in Rome (1836–1923)*. Rutherford, N.J.: Fairleigh Dickinson University Press, 1970.

Taylor, Joshua C., et al. *Perceptions and Evocations: The Art of Elihu Vedder*. Washington, D.C.: National Collection of Fine Arts, Smithsonian Institution Press, 1979.

Vedder, Elihu. *The Digressions of V.* Boston: Houghton Mifflin, 1910.

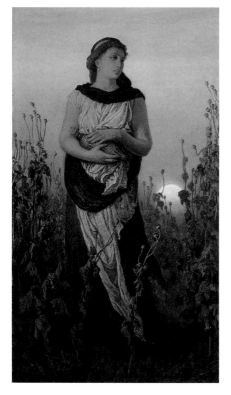

64

ELIHU VEDDER

Memory (Girl with Poppies), 1877

Oil on canvas, 28¾ x 15¹⁵⁄₁₆ inches

High Museum of Art, Atlanta, Georgia

Gift of Julie and Arthur Montgomery

1980.59

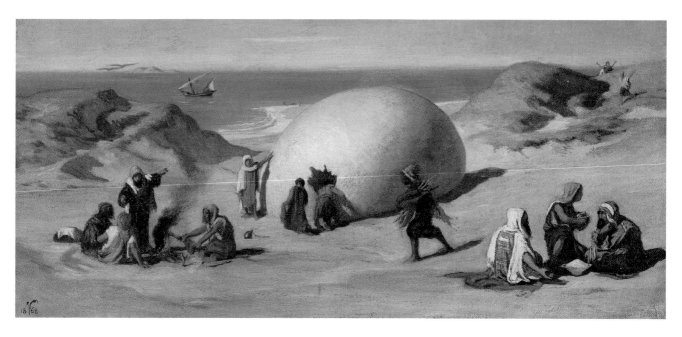

65

ELIHU VEDDER

The Roc's Egg, 1868

Oil on canvas, 7½ x 16 inches

Chrysler Museum of Art, Norfolk, Virginia

Gift of Alpheus J. Chewning

71.2369

Photo © Chrysler Museum of Art

William Aiken Walker

Born in Charleston, South Carolina, 1838

Died in Charleston, South Carolina, 1921

William Aiken Walker was a leading chronicler of the "Deep South." A prolific painter, he was distinctly devoted to his subject matter. "I am like a machine: I paint and repaint these subjects so that many can share the feelings I have for this magnificent world of ours. . . . I shall do my best to see that all can afford it, to the extent that I shall paint and paint and paint until the brush runs dry."[1] His long career began with inclusion of his work in the South Carolina Institute Fair when the artist was only twelve years old. In 1858 his paintings received further notice when they were displayed in the window of Courtenay's Bookstore in Charleston. Then, and in the decades that followed, Walker dedicated himself to the portrayal of the South and its people.

During the Civil War, Walker enlisted in the Confederate army. Wounded while fighting in Virginia in the Battle of Seven Pines, Walker nevertheless continued to serve the Confederate cause as a cartographer with the Engineer Corps in his hometown of Charleston. Following the war, he moved to Baltimore and again took up painting. Not able to make a living from the sale of his work alone, Walker found ways to augment his income; he composed songs, wrote poetry, and instructed pupils in the foreign languages he had learned while a boy in private school.

By the late 1860s the artist succumbed to a wanderlust that he would indulge until late in life. He spent two months in Cuba in 1869 and traveled to Europe the following year. In succeeding decades, the artist was rather nomadic, often traveling through the Carolinas, Tennessee, Georgia, Louisiana, Mississippi, and Florida. Charleston, however, remained Walker's home until his death in 1921. SJF

NOTE

1. Quoted in Trovaioli and Toldedano, *William Aiken Walker*, 3.

FOR FURTHER READING

Seibels, Cynthia. *The Sunny South: The Life and Art of William Aiken Walker.* Spartanburg, S.C.: Saraland, 1995.

Trovaioli, August P., and Roulhac B. Toldedano. *William Aiken Walker: Southern Genre Painter.* Baton Rouge: Louisiana State University Press, 1972.

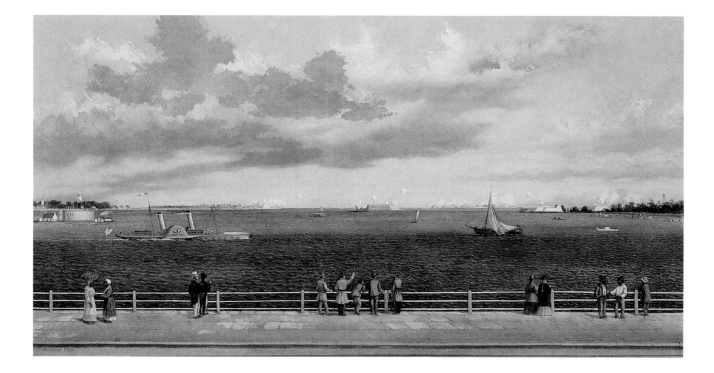

66

WILLIAM AIKEN WALKER

Bombardment of Fort Sumter, Charleston

Harbor, Charleston, South Carolina, 1863, 1886

Oil on canvas, 20¼ x 36⁵⁄₁₆ inches

Gibbes Museum of Art/Carolina Art Association,

Charleston, South Carolina

2001.32.01

Richard Wilt

Born in Tyrone, Pennsylvania, 1915

Died in Ann Arbor, Michigan, 1981

As an artist, Richard Wilt preferred to follow his own course rather than concern himself with changing fashions in the art world. Early in his career he worked as an illustrator and wrote two children's books, *E-Tooka-Shoo* (1941) and *Too Big Feet* (1945). He was inclined toward experimentation as an artist, and his painting style underwent constant change throughout his career. Inspired by the midwestern regionalists in the early 1940s and by his friendship with Robert Gwathmey (q.v.), he created a series of paintings drawn from his experiences in the South. The following decade, he produced more abstract compositions known for their rich, dense, textural surfaces; at the time, they were compared to the "action paintings" of Jackson Pollock. Yet in contrast to many abstract expressionists, Wilt was unashamedly concerned with recognizable subject matter, producing many portraits, figural compositions, landscapes, and works of social commentary.

Wilt, who once described himself as "depression-trained," graduated from the Carnegie Institute of Technology (now Carnegie-Mellon University) in 1938. Drafted into the military two years later, he entered the Air Force. He flew B-25 bombers during World War II, completing fifty-five missions in the Mediterranean theater. After his discharge, Wilt moved to New York and enrolled at the New School for Social Research, where he studied with Stuart Davis. He joined the faculty at the University of Michigan in 1947, and in 1953 he earned an M.A. in art history from the University of Pittsburgh. Taking a break from his teaching duties in 1958, he traveled to Maine with his family and stayed for three months. Sparse living conditions there encouraged him to develop his skills with watercolors. He returned to them again two years later on a trip to the Caribbean island of Antigua, where he created many watercolors of the lush tropical landscape. In later years Wilt devoted much of his time to creating socially relevant works, as well as holograms that reflected his personal interest in the Apollo program of lunar exploration. RA

FOR FURTHER READING
Richard Wilt. Pontiac, Mich.: Creative Center for Art, 1998.
Wilt: A Comprehensive Presentation of Richard Wilt, 1958–64. Ann Arbor, Mich.: Forsythe Gallery, 1964.

67
RICHARD WILT
Low Altitude Formation (Farewell), ca. 1943
Oil on canvas, 28 x 28 inches
The Ogden Museum of Southern Art,
University of New Orleans
Gift of the Roger H. Ogden Collection

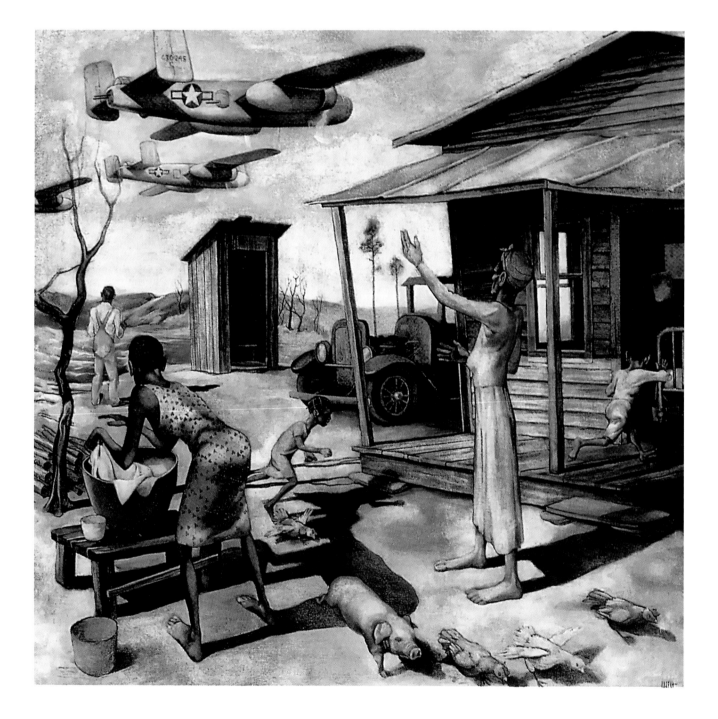

Thomas Waterman Wood

Born in Montpelier, Vermont, 1823

Died in New York, New York, 1903

It is not clear whether genre painter Thomas Waterman Wood was a self-taught artist or received training of some sort from painter Chester Harding of Boston, who perhaps assisted Wood in the development of his technique and the perfection of his style. What is apparent, however, is that Wood was involved with projects of an artistic bent throughout most of his long life.

Wood made his foray into art and object making while assisting his father in the family cabinet studio, where he worked until 1846. Wood married in 1850, by which time he had become a jack-of-all-trades. Harking back to his years with the family business, Wood created his own furniture designs; he built a summer home, christened "Athenwood," in Montpelier; he sketched livestock; and he was commissioned by the Vermont Central Rail Road to paint signage. He also managed to become a successful painter of genre scenes and portraits.

The year 1858 was a banner year for Wood. The artist made the obligatory pilgrimage to Europe and England to admire the works of the old masters. While there, he also painted portraits of other Americans who were traveling abroad. Upon his return to the United States later that year, Wood initiated a series of paintings with African Americans as their subject. Sensitive portrayals of southern blacks, free blacks in the North, and black soldiers from the Civil War occupied Wood for some thirty-five years.

Wood was especially renowned for a three-painting series depicting free blacks fighting for the Union cause, a series he entitled A Bit of War History, 1865–66 (Metropolitan Museum of Art). In 1867 he exhibited the trio to great acclaim at the National Academy of Design, an organization he served as president from 1890 to 1900. In 1897 Wood established Montpelier's T. W. Wood Art Gallery, which is located on the Vermont College campus and houses more than two thousand of the artist's works. SJF

68

THOMAS WATERMAN WOOD
His First Vote, 1868
Oil on board, 20 x 12½ inches
Collection of the
Cheekwood Museum of Art,
Nashville, Tennessee
1991.2.2

FOR FURTHER READING
Catalogue of the Pictures in the Art Gallery in Montpelier. Montpelier, Vt.: Wood Art Gallery, 1913.
Lipke, William, ed. *Thomas Waterman Wood, PNA, 1823–1903.* Montpelier, Vt.: Wood Art Gallery, 1972.

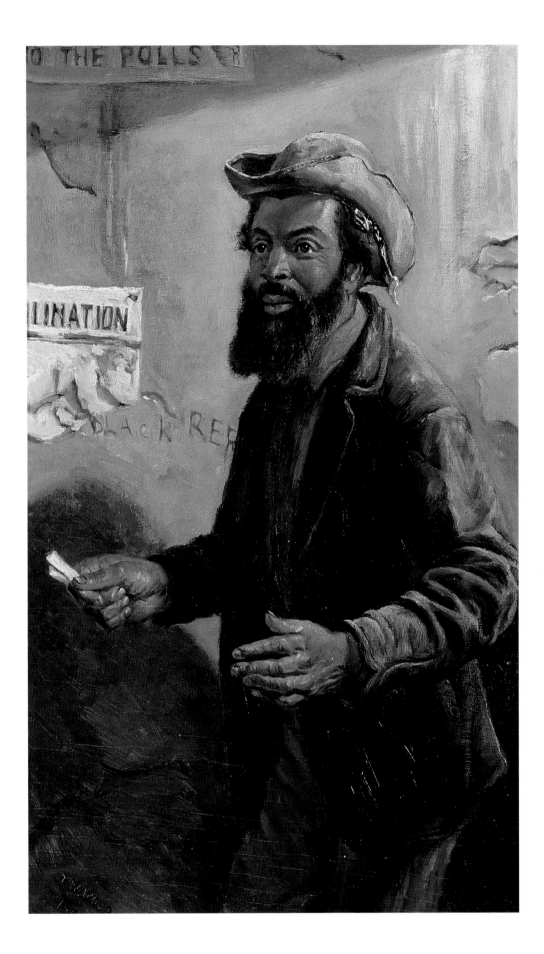

William Wallace Wotherspoon

Born in New York, New York, 1821

Died in Utica, New York, 1888

Little is known of William Wotherspoon's early life or training. His formal education began at the National Academy of Design in the early 1840s, and he exhibited paintings there often between 1844 and 1888. Although Wotherspoon also worked as a sculptor, he found success with his landscape paintings, in which he blended a classical framework with his own innate sense of the picturesque.

His early landscapes showcased the pristine beauty of the White Mountains in New Hampshire. Many of these and subsequent compositions were populated with figures whose presence suggests an anecdotal element.

Wotherspoon traveled to Europe in 1846 and, with a pilgrim's reverence for the old masters, roamed Britain and the Continent. His extended journey of six years, much of which was spent in Rome, inspired paintings of Lake Nemi and the ruins littering the Roman Campagna, which critics praised for their delicious blending of romance and reality. Upon his return to New York Wotherspoon was elected an associate member of the NAD. The gregarious artist was also one of the founders of the Artists' Fund and among the original members of the Sketch Club. RA

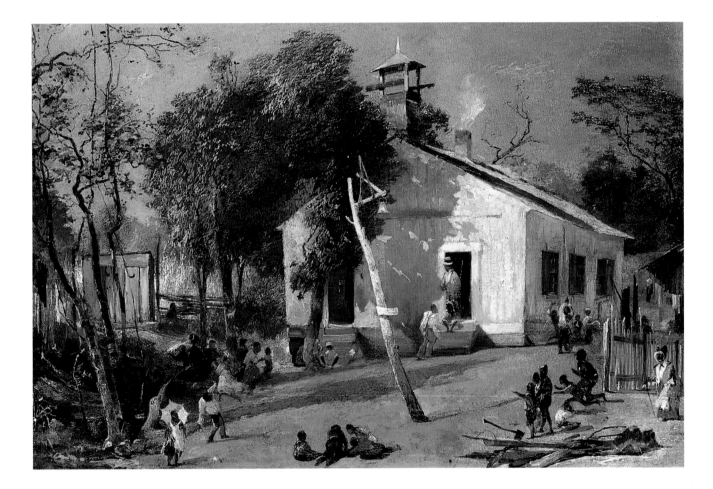

69

WILLIAM WALLACE WOTHERSPOON

Scene outside a Southern Schoolhouse

Oil on canvas, 12½ x 18½ inches

Hunter Museum of American Art,

Chattanooga, Tennessee

Museum purchase with funds donated

anonymously

HMAA.1969.1

Andrew Wyeth

Born in Chadds Ford, Pennsylvania, 1917

Lives in Chadds Ford, Pennsylvania

Andrew Wyeth is part of a multigenerational family of artists long associated with the Northeast. He is the youngest son of renowned illustrator Newell Convers Wyeth and the father of the painter Jamie Wyeth; two of Andrew's sisters pursued careers as painters as well. Reportedly because of his delicate health as a child, Wyeth was tutored at home and practiced his drafting skills under the watchful eye of his father, who took Andrew on as an apprentice when he was fifteen years old.

A year later, in 1933, the young Wyeth was introduced to the watercolors of Winslow Homer, an experience that fueled his interest in the medium. In 1936 his forays into watercolor were rewarded by an invitation from the Philadelphia Art Alliance to participate in his first exhibition. Only one year later, the Macbeth Gallery in New York City gave the twenty-year-old artist his first solo show, an exhibition that sold out in a single day.

In the early 1940s, Wyeth commenced work in his signature medium, egg tempera. Peter Hurd, a New Mexico painter and Wyeth's brother-in-law, introduced him to the demanding technique. Throughout the 1940s and 1950s, Wyeth repeatedly turned for inspiration to the landscapes that surrounded him at Chadds Ford and at the family's summer home in Cushing, Maine. In the decades that followed, he also produced numerous portraits of friends and neighbors. His most frequent sitters, forever immortalized in paint, included his neighbors, the Kuerners and the Olsons.

Wyeth has received numerous honors and accolades. In 1955 he was awarded an honorary doctorate from Harvard University. In 1963 he was chosen by President John F. Kennedy to receive the prestigious Medal of Freedom. Four years later, the Whitney Museum of American Art presented a retrospective exhibition of his work. The Metropolitan Museum of Art followed suit in 1976 with a retrospective that marked the first time the institution had recognized a living American artist in this manner. SJF

FOR FURTHER READING

Corn, Wanda. *The Art of Andrew Wyeth.* Greenwich, Conn.: New York Graphic Society, 1973.

Meryman, Richard. *Andrew Wyeth: A Secret Life.* New York: HarperCollins, 1996.

Wyeth, Andrew. *Andrew Wyeth: Autobiography.* Boston: Little, Brown, 1995.

70

ANDREW WYETH

Winter 1946, 1946

Tempera on composition board,

31⅜ x 48 inches

North Carolina Museum of Art, Raleigh

Purchased with funds from the State of

North Carolina

72.1.1